Cover page:
Al-Qastal, detail of carved stone,
al-Badiya.

JORDAN International Museum With No Frontiers Exhibition Cycles

ISLAMIC ART IN THE MEDITERRANEAN

THE UMAYYADS
THE RISE OF ISLAMIC ART

EUROPEAN UNION
Euromed Heritage
Programme

The realisation of the Museum With No Frontiers Exhibition "THE UMAYYADS. The rise of Islamic art" has been co-financed by the European Union within the frame work of the MEDA-Euromed Heritage Programme
and received the support of the following Jordanian and international institutions:

Ministry of Tourism, Department of Antiquities, Amman, Jordan.

Ministry of Culture, Amman, Jordan.

MINISTERIO DE EDUCACIÓN, CULTURA Y DEPORTE — DIRECCIÓN GENERAL DE BELLAS ARTES Y BIENES CULTURALES

Ministry of Education, Culture and Sports of Spain which has financed the scientific co-ordination of the international cycle "Islamic Art in the Mediterranean" and has contributed in the scientific process of different exhibitions, in collaboration with:

Federal Ministry of Foreign Affairs, Austria
Ministry of Cultural and Environmental Heritage (National Museum for Oriental Arts, Rome), Italy
State Secretary for Tourism, Portugal
Museum of Mediterranean and Near Eastern Antiquities, Sweden

Information:
www.mwnf.org

Local contact:
Department of Antiquities
P.O. Box. 88 Amman
Jordan
Tel: + 962 6 4644336
Fax: + 962 6 4615848
e-mail: msf-jo@nol.com.jo

International Secretariat
Museo Sin Fronteras
Barquillo 15B-4°C
28004 Madrid
Spain
Tel: + 34 91 5312824
Fax: + 34 91 5235775
e-mail: msf.madrid@teleline.es

Idea and overall concept of Museum With No Frontiers Programme
Eva Schubert

Head of the project
Fawwaz al-Khraysheh
Director of the Department of Antiquities

Co-ordinator
Rabiha Dabbas
Advisor and co-ordinator of the Euro-Mediterranean partnership projects at the Department of Antiquities

Co-ordinator of the scientific committee
Ghazi Bisheh, Amman

Scientific Committee
Ghazi Bisheh, Amman
Fawzi Zayadine, Amman
Mohammad al-Asad, Amman
Ina Kehrberg, Amman
Lara Tohme, Beirut – USA

Catalogue

Introductions
Mohammad al-Asad, Amman
Ghazi Bisheh, Amman

Presentation of the itineraries
Scientific Committee

With the collaboration of
'Abdel Qader al-Husan, Amman

Technical texts
Lubna Hashem, Amman

Editing
Ina Kehrberg, Amman

Technical editing
Lubna Hashem, Amman

Photographer
Bill Lyons, Amman

General map and sketches
Atalla Design, Amman

Plans
Sophie Vattéoni, Damascus (IFAPO)

General introduction
"Islamic Art in the Mediterranean"

Text
Jamila Binous, Tunis
Mahmoud Hawari, East-Jerusalem
Manuela Marín, Madrid
Gönül Öney, Izmir

Plans
Şakir Çakmak, Izmir
Yekta Demiralp, Izmir
Ertan Daş, Izmir

Lay-out and design
Agustina Fernández, Madrid

Producción
Electa (Grijalbo Mondadori, S.A.)

Technical co-ordination
Production Manager
Lubna Hashem, Ammán

International co-ordination
of the cycle "Islamic Art in the Mediterranean"

Head of the project
Eva Schubert, Vienna-Madrid-Rome

Scientific Committees, translations, editing and production of the catalogues
Sakina Missoum, Madrid

Administrative proceedings and documentation
Silvia Victoria Ronza, Rome

Acknowlededegements

We thank the following institutions for their support to the project:

Archaeological Mission at Qastal
Archaeological offices and museums of the Department of Antiquities in all districts of Jordan
Archaeological Park & Mosaic School of Madaba
Central Bank of Jordan
Darat al-Funoun
French Institute of Archaeology for the Near East (IFAPO)
Friends of Archaeology (FoA) with its branches in all districts of Jordan
German Protestant Institute of Archaeology in Amman (DEI)
Jordan Tourism Board
Ministry of Religious Affairs
Municipality of Greater Amman
Nebo Tours
Royal Jordanian Geographic Centre
Spanish Agency for International Co-operation (AECI)
Stadium Biblicum Franciscanum, Jerusalem
Swiss Archaeological Mission in Jordan (Max van Berchem Foundation)
Tourism information centre of Umm al-Jimal
UNESCO
Yarmouk University (The Institution of Archaeology and Anthropology)

as well as:

'Aqel Beltaji, Minister of Tourism
Fawwaz al-Khraysheh, Director of the Department of Antiquities
Nidal al-Hadid, Mayor of the Municipality of Greater Amman.
Fernando Garcés de los Fayos (Chargé d'Affaires a.i., Delegation of the European Commission in Jordan)

In addition the Museum With No Frontiers would like to thank the Spanish Ministry of Foreign Affairs for its support throughout the project via the Spanish Agency for International Co-operation (AECI) and the Spanish Embassies in the participating Mediterranean countries and the Regional Government of Tyrol (Austria) – where the Museum With No Frontiers' pilot project was first set up – for its financial support in the training of Directors of Production in charge of the technical co-ordination of exhibitions in participating countries in the "Islamic Art in the Mediterranean" exhibition cycle.

Photographic references

See page 5, as well as
'Abdel Qader al-Husan (Umayyad objects "n.p")
Antonio Almagro & Ignacio Arce (CD-ROM of the Umayyad Palace of Amman)
Jane Taylor (Umm Qays)
Fr. Michele Piccirillo (Madaba and Umm al-Rasas)
Nayef Goussous (Umayyad coins)
Salem al-Da'ja (Baptism Site "Wadi al-Kharrar")
Zohrab

General introduction "Islamic Art in the Mediterranean"
Ann & Peter Jousiffe (London), page 20 (Aleppo)
Archives of Oronoz Photographs (Madrid), page 23 (Alhambra, Granada)

Plan references

German Protestant Institute "DEI" (Umm Qays)
Jacques Bujard (reconstruction plans of Umm al-Walid)
Robert Bewley (Jerash)

General introduction "Islamic Art in the Mediterranean"
R. Ettinghaussen and O. Grabar (Madrid, I, 1997), page 26 (Damascus Mosque)
Z. Sönmez (Ankara, 1995), page 27 (Mosques of Divriği & Istanbul) and page 28 (Mosque of Sivas)
Sergio Viguera (Madrid), page 28 (Minarets type)
R. Ettinghaussen and O. Grabar (Madrid, II, 1999), Page 29 (Sultan Hassan Madrasa)
R. Ettinghaussen and O. Grabar (Madrid, I, 1997), Page 30 (Qasr al-Khayr al-Sharqi)
A. Kuran (Istanbul, 1986), page 31 (Sultan Khan Aksaray)

We would like to thank all those who, while too numerous to name individually, gave their unfailing support and sound advice during the preparation of this project.

Preface

Great art exhibitions represent far reaching scientific and cultural events which over the years have turned Art, in all its forms and manifestations, into an essential element in the creation of the image of a country. In this way, cultural events have come to be the privileged stage of important civic accomplishments and large companies invest in art in order to give their products a better position in the global market place.

The objective of the Museum With No Frontiers programme and of its exhibition cycle "Islamic Art in the Mediterranean" is to obtain the active participation of the Mediterranean countries in this process of political and economic enhancement of their cultural heritage.

This programme, based on a new exhibition format where the works of art remain in their places to be exhibited in their true context, combines research on specific topics with raising awareness about artistic heritage and aims to promote investment in the fields of restoration and preservation.

The Museum With No Frontiers Exhibitions are conceived around a special theme and for a particular geographic area (the exhibition "venue") and are organised along specific itineraries (exhibition "halls"). Each one deals with a particular aspect of the general theme. The visitor no longer moves within an enclosed space, but travels to find the artistic objects, monuments, archaeological sites, urban centres, landscapes and places that have been the theatre of transcendental historical events. The visitor follows an exhibition guide and a signposting system created by the Museum With No Frontiers to facilitate the identification of the works displayed.

The financial support of the European Union, within the framework of the MEDA-Euromed Heritage Programme (the regional programme for the enhancement of Euro-Mediterranean cultural heritage), has made possible the creation of the exhibition cycle "Islamic Art in the Mediterranean" and the exhibitions carried out in Algeria, Palestine, Egypt, Israel, Jordan, Morocco, Tunisia and Turkey; Spain, Italy and Portugal, providing their own finance for the project, have joined this effort. Other European Union Community finance allocated by the Community's policies covering tourism, heritage (RAPHAEL programme) and inter-regional co-operation (a pilot project involving co-operation by Spain, Portugal and Morocco) has enabled specific activities to be carried out at different stages of the project.

On behalf of the Museum With No Frontiers, I would like to express my sincerest gratitude to those who, personally or as representatives of numerous institutions, support our organisation and this project, and who have participated in the creation of this museum with no frontiers on Islamic Art in the Mediterranean.

Eva Schubert
General Secretary
Museum With No Frontiers

Transliteration of the Arabic

We have retained the common spelling for Arabic words in common use and included those in the English dictionary, such as "suq". We have maintained the phonetic spelling of the words in Arabic as determined by the authors and in accordance with Jordanian standards. For all other words, we have simplified the transcription. We do not transcribe the initial *hamza* but kept the initial *'Ayn* in personal nouns as in 'Ali, 'Abd al-Malik, etc. We did not differentiate between short and long vowels, which are written as *a, i, ou*. Some of the proper nouns are transliterated in the text according to the Oxford Dictionary. The transcription for the 28 Arabic consonants are provided in the table below as well as "a" or "at" for the *ta' marbuta*.

ء	'	ح	h	ز	z	ط	t	ق	q	ة	h
ب	b	خ	kh	س	s	ظ	z	ك	k	و	u/w
ت	t	د	d	ش	sh	ع	'	ل	l	ي	y/i
ث	th	ذ	dh	ص	s	غ	gh	م	m		
ج	j	ر	r	ض	d	ف	f	ن	n		

Words in itallics in the text without an accompanying translation or explanation can be found in the glossary.

The Muslim era

The Muslim era began with the exodus of the Prophet Muhammad from Mecca to Yathrib. Then the name was changed to *Madina*, "The City" or "town of the Prophet". With his small community of followers (70 people and members of his family) recently converted to Islam, the Prophet undertook the *al-hijra* (literally "the emigration") and the new era began.

The date of the emigration is the first of the month of *Muharram* in year 1 of the *Hijra*, which corresponds to the 16th July of the year 622 of the Christian era. The Muslim year is made up of twelve lunar months, each month having 29 or 30 days. Thirty years form a cycle in which the 2nd, 5th, 7th, 10th, 13th, 16th, 18th, 21st, 24th, 26th and 29th are leap years having 355 days; the others are normal years with 354 days. The Muslim lunar year is 10 or 11 days shorter than the Christian solar year. Each day begins immediately after sunset, i.e. at dusk rather than after midnight. Most Muslim countries use both the *Hijra* Calendar (which indicates all the religious events) and the Christian Calendar.

Dates

Dates are given according to the *Hijra* calendar followed by their equivalent date on the Christian calendar after an oblique stroke. The *Hijra* date is not indicated in references derived from Christian sources, European historical events, those occurring in Europe, Christian Dynasties, those prior to the Muslim era or those after 1917, the end of Ottoman domination in Jordan.

Exact correspondence between years in one calendar and another is only possible when the day and month are given. To facilitate reading, we chose to avoid intermediate years and, in the case of *Hijra* dates falling between the beginning and the end of a century, the two centuries are mentioned. Dates prior to the beginning of the Christian era are indicated with BC. To avoid confusion, the use of the abbreviation AD is used for periods beginning before the birth of Christ and finishing after his birth.

Abbreviations:
AD = in the year of our Lord; BC = before Christ; d = death; f.h. = first half; r. = reign.

Practical advice

The best months to visit Jordan are April, May, June, August, September and October. Mid-July to August is a good season for local festivals and cultural events (the Jerash Festival, Fuheis Festival etc). First and last months of the year are risky as it is the vary season and the weather can be cold and inclement.

Various cultural events taking place in Jordan during the year are usually mentioned under "What's going on" in the daily news paper *Jordan Times*.
For more information about cultural events contact:
Ministry of Tourism & Antiquities, Department of Public Relations: tel.: 06-4642311
Ministry of Culture, Directorate of Public Relations and Activities: tel.: 06-5696218

Whereas visiting Jordan during the holy month of Ramadan presents no difficulties as such, it is a month of fasting and inadvertent restrictions could arise (lack of catering and other services, early closing times, etc) causing inconveniences while touring the country. As the dates of Ramadan change each year, it is advisable to be informed of them prior to planning a trip.

A local bus service is available from the main towns to the villages during working hours. As it is difficult to return by bus in the afternoon from remote villages, it is strongly advised to hire a car instead of taking a bus to visit remote areas. Opening times, rates and entrance fees in local currency are subject to change.

The offices of the Dept. of Antiquities, including museums and visitor centres, in all districts serve as information points and will provide the visitor with all possible help and support.

Lubna Hashem
Production Manager

INDEX

ISLAMIC DYNASTIES IN THE MEDITERRANEAN

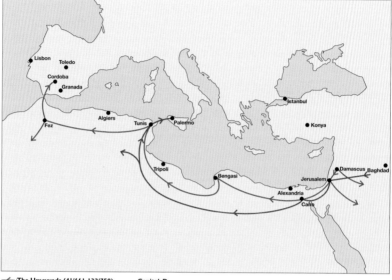

←─ The Umayyads (41/661-132/750) Capital: Damascus
←─ The Abbasids (132/750-656/1258) Capital: Baghdad

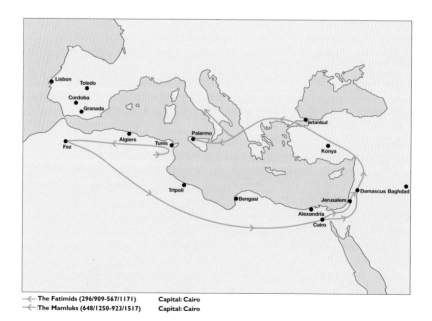

←─ The Fatimids (296/909-567/1171) Capital: Cairo
←─ The Mamluks (648/1250-923/1517) Capital: Cairo

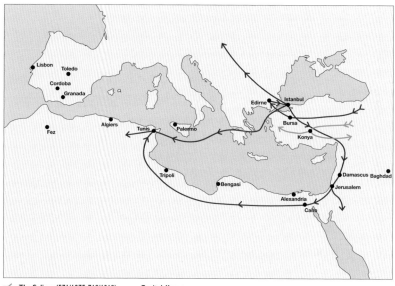

← The Seljuqs (571/1075-718/1318) **Capital: Konya**
← The Ottomans (699/1299-1340/1922) **Capital: Istanbul**

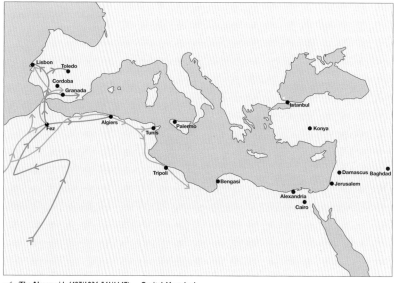

← The Almoravids (427/1036-541/1147) **Capital: Marrakesh**
← The Almohads (515/1121-667/1269) **Capital: Marrakesh**

13

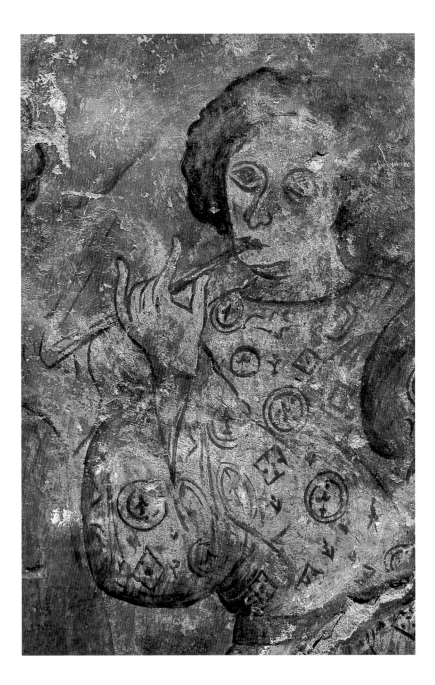

Qusayr 'Amra, mural in
the Audience Hall, Badiya
of Jordan.

ISLAMIC ART IN THE MEDITERRANEAN

Jamila Binous
Mahmoud Hawari
Manuela Marín
Gönül Öney

The Legacy of Islam in the Mediterranean

Since the first half of the $1^{st}/7^{th}$ century, the history of the Mediterranean Basin has belonged, in remarkably similar proportion, to two cultures, Islam and the Christian West. This extensive history of conflict and contact has created a mythology that is widely diffused in the collective imagination, a mythology based on the image of the other as the unyielding enemy, strange and alien, and as such, incomprehensible. It is of course true that battles punctuated those centuries from the time when the Muslims spilled forth from the Arabian Peninsula and took possession of the Fertile Crescent, Egypt, and later, North Africa, Sicily, and the Iberian Peninsula, penetrating into Western Europe as far as the south of France. At the beginning of the $2^{nd}/8^{th}$ century, the Mediterranean came under Islamic control.

This drive to expand, of an intensity seldom equalled in human history, was carried out in the name of a religion that considered itself then heir to its two immediate antecedents: Judaism and Christianity. It would be a gross over-simplification to explain the Islamic expansion exclusively in religious terms. One widespread image in the West presents Islam as a religion of simple dogmas adapted to the needs of the common people, spread by vulgar warriors who poured out from the desert bearing the *Qur'an* on the blades of their swords. This coarse image does away with the intellectual complexity of a religious message that transformed the world from the moment of its inception. It identifies this message with a military threat, and thus justifies a response on the same terms. Finally, it reduces an entire culture to only one of its elements, religion, and in doing so, deprives it of the potential for evolution and change.

The Mediterranean countries that were progressively incorporated into the Muslim world began their journeys from very different starting points. Forms of Islamic life that began to develop in each were quite logically different within the unity that resulted from their shared adhesion to the new religious dogma. It is precisely the capacity to assimilate elements of previous cultures (Hellenistic, Roman, etc.), which has been one of the defining characteristics of Islamic societies. If one restricts his observations to the geographical area of the Mediterranean, which was extremely diverse culturally at the time of the emergence of Islam, one will discern quickly that this initial moment does not represent a break with previous history in the least. One comes to realise that

15

it is impossible to imagine a monolithic and immutable Islamic world, blindly following an inalterable religious message.

If anything can be singled out as the *leitmotiv* running through the area of the Mediterranean, it is diversity of expression combined with harmony of sentiment, a sentiment more cultural than religious. In the Iberian Peninsula —to begin with the western perimeter of the Mediterranean— the presence of Islam, initially brought about by military conquest, produced a society clearly differentiated from, but in permanent contact with Christian society. The importance of the cultural expression of this Islamic society was felt even after it ceased to exist as such, and gave rise to perhaps one of the most original components of Spanish culture, Mudejar art. Portugal maintained strong Mozarab traditions throughout the Islamic period and there are many imprints from this time that are still clearly visible today. In Morocco and Tunisia, the legacy of al-Andalus was assimilated into the local forms and continues to be evident to this day. The western Mediterranean produced original forms of expression that reflected its conflicting and plural historical evolution.

Lodged between East and West, the Mediterranean Sea is endowed with terrestrial enclaves, such as Sicily, that represent centuries-old key historical locations. Conquered by the Arabs established in Tunisia, Sicily has continued to perpetuate the cultural and historical memory of Islam long after the Muslims ceased to have any political presence on the island. The presence of Sicilian-Norman aesthetic forms preserved in architectural monuments clearly demonstrates that the history of these regions cannot be explained without an understanding of the diversity of social, economic and cultural experiences that flourished on their soil.

In sharp contrast, then, to the immutable and constant image alluded to at the outset, the history of Mediterranean Islam is characterised by surprising diversity. It is made up of a mixture of peoples and ethnicities, deserts and fertile lands. As the major religion has been Islam since the early Middle Ages, it is also true that religious minorities have maintained a presence historically. The Classical Arabic language of the *Qur'an,* has coexisted side-by-side with other languages, as well as with other dialects of Arabic. Within a setting of undeniable unity (Muslim religion, Arabic language and culture), each society has evolved and responded to the challenges of history in its own characteristic manner.

The Emergence and Development of Islamic Art

Throughout these countries, with ancient and diverse civilisations, a new art permeated with images from the Islamic faith emerged at the end of the 2nd/8th century and which successfully imposed itself in a period of less than a hundred years. This art, in its own particular manner, gave rise to creations and innovations based on unifying regional formulas and architectural and decorative processes, and was simultaneously inspired by the artistic traditions that proceeded it: Greco-Roman and Byzantine, Sasanian, Visigothic, Berber or even Central Asian.

The initial aim of Islamic art was to serve the needs of religion and various aspects of socio-economic life. New buildings appeared for religious purposes such as mosques and sanctuaries. For this reason, architecture played a central role in Islamic art because a whole series of other arts are dependent on it. Apart from architecture a whole range of complimentary minor arts found their artistic expressions in a variety of materials, such as wood, pottery, metal, glass, textiles and paper. In pottery, a great variety of glaze techniques were employed and among these distinguished groups are the lustre and polychrome painted wares. Glass of great beauty was manufactured, reaching excellence with the type adorned with gold and bright enamel colours. In metal work, the most sophisticated technique is inlaying bronze with silver or copper. High quality textiles and carpets, with geometric, animal and human designs, were made. Illuminated manuscripts with miniature painting represent a spectacular achievement in the arts of the book. These types of minor arts serve to attest the brilliance of Islamic art.

Figurative art, however, is excluded from the Islamic liturgical domain, which means it is ostracised from the central core of Islamic civilisation and that it is tolerated only at its periphery. Relief work is rare in the decoration of monuments and sculptures are almost flat. This deficit is compensated with a richness in ornamentation on the lavish carved plaster panelling, sculpted wooden panelling, wall tiling and glazed mosaics, as well as on the stalactite friezes, or *muqarnas*. Decorative elements taken from nature, such as leaves, flowers and branches, are generally stylised to the extreme and are so complicated that they rarely call to mind their sources of origin. The intertwining and combining of geometric motifs such as rhombus and etiolated polygons, form interlacing networks that completely cover the surface, resulting in shapes often called arabesques. One innovation within the decorative repertoire is the introduction of epigraphic elements

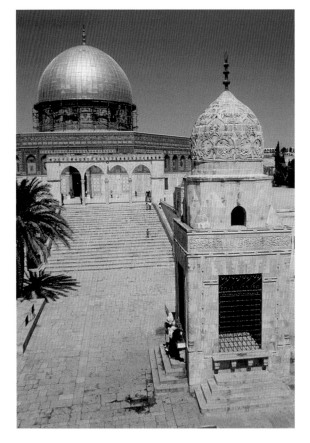

Dome of the Rock, Jerusalem.

in the ornamentation of monuments, furniture and various objects. Muslim craftsmen made use of the beauty of Arabic calligraphy, the language of the sacred book, the *Qur'an,* not only for the transcription of the Qur'anic verses, but in all of its variations simply as a decorative motif for the ornamentation of stucco panelling and the edges of panels.

Art was also at the service of rulers. It was for patrons that architects built palaces, mosques, schools, hospitals, bathhouses, *caravanserais* and mausoleums, which would sometimes bear their names. Islamic art is, above all, dynastic art. Each one contributed tendencies that would bring about a partial or complete renewal of artistic forms, depending on historical conditions, the prosperity enjoyed by their states, and the traditions of each people. Islamic art, in spite of its relative unity, allowed for a diversity that gave rise to different styles, each one identified with a dynasty.

The Umayyad dynasty (41/661-132/750), which transferred the capital of the caliphate to Damascus, represents a singular achievement in the history of Islam. It absorbed and incorporated the Hellenistic and Byzantine legacy in such a way that the classical tradition of the Mediterranean was recast in a new and innovative mould. Islamic art, thus, was formed in Syria, and the architecture, unmistakably Islamic due to the personality of the founders, would continue to bear a relation to Hellenistic and Byzantine art as well. The most important of these monuments are the Dome of the Rock in Jerusalem, the earliest existing monumental Islamic sanctuary, the Great Mosque of Damascus, which served as a model for later mosques, and the desert palaces of Syria, Jordan and Palestine.

When the Abbasid caliphate (132/ 750-656/1258) succeeded the Umayyads, the political centre of Islam was moved from the Mediterranean to Baghdad in Mesopotamia. This factor would influence the development of Islamic civilisation and the entire range of culture, and art would bear the mark of that change. Abbasid art and architecture were influenced by three major traditions: Sassanian, Central Asian and Seljuq. Central Asian influence was already present in Sassanian architecture, but at Samarra this influence is represented by the stucco style with its arabesque ornamentation that would rapidly spread throughout the Islamic world. The influence of the Abbasid monuments can be observed in the buildings constructed during this period in the other regions of the empire, particularly Egypt and Ifriqiya. In Cairo, the Mosque of Ibn Tulun (262/876-265/879) is a masterpiece, remarkable for its plan and unity of conception. It was modelled after the Abbasid Great Mosque of Samarra, particularly its spiral minaret. In Kairouan, the capital of Ifriqiya, vassals of the Abbasid caliphs, the Aghlabids (184/800-296/909) expanded the Great Mosque of Kairouan, one of the most venerable congregational mosques in the Maghrib. Its *mihrab* was covered by ceramic tiles from Mesopotamia.

Kairouan Mosque, mihrab, Tunisia.

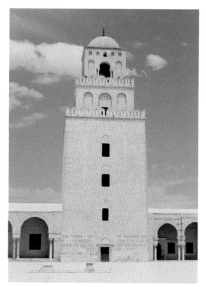

Kairouan Mosque, minaret, Tunisia.

19

*Citadel of Aleppo, view
of the entrance, Syria.*

*Complex of Qaluwun,
Cairo, Egypt.*

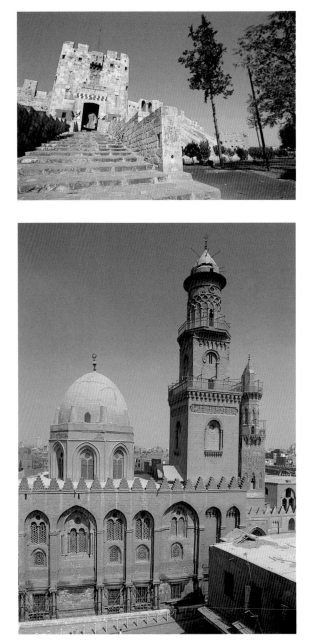

The reign of the Fatimids (297/909-567/1171) represents a remarkable period in the history of the Islamic countries of the Mediterranean: North Africa, Sicily, Egypt and Syria. Of their architectural constructions, a few examples remain that bear witness to their past glory. In the central Maghrib, the Qal'a of the Bani Hammad and the Mosque of Mahdiya; in Sicily, the Cuba (*Qubba*) and the Zisa (*al-'Aziza*) in Palermo, constructed by Fatimid craftsmen under the Norman king William II; in Cairo, the Azhar Mosque is the most prominent example of Fatimid architecture in Egypt.

The Ayyubids (567/1171-648/1250), who overthrew the Fatimid dynasty in Cairo, were important patrons of architecture. They established religious institutions *(madrasas, khanqas)* for the propagation of *Sunni* Islam, mausoleums and welfare projects, as well as awesome fortifications pertaining to the military conflict with the Crusaders. The Citadel of Aleppo in Syria is a remarkable example of their military architecture.

The Mamluks (648/1250-923/1517) successors to the Ayyubids who had successfully resisted the Crusades and the Mongols, achieved the unity of Syria and Egypt and created a formidable empire. The wealth and luxury of the Mamluk sultan's court in Cairo motivated artists and architects to achieve an extraordinarily elegant style

of architecture. For the world of Islam, the Mamluk period marked a rebirth and renaissance. The enthusiasm for establishing religious foundations and reconstructing existing ones place the Mamluks among the greatest patrons of art and architecture in the history of Islam. The Mosque of Hassan (757/1356), a funerary mosque built with a cruciform plan in which the four arms of the cross were formed by four *iwan*s of the building around a central courtyard was typical of the era. Anatolia was the birthplace of two

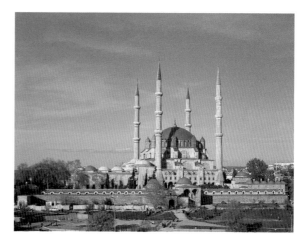

Selimiye Mosque, general view, Edirne, Turkey.

great Islamic dynasties: the Seljuqs (571/1075-718/1318), who introduced Islam to the region; and the Ottomans (699/1299-1340/1922), who brought about the end of the Byzantine Empire upon capturing Constantinople, and asserted their hegemony throughout the region.

A distinctive style of Seljuq art and architecture flourished with influences from Central Asia, Iran, Mesopotamia and Syria, which merged with elements deriving from Anatolian Christian and antiquity heritage. Konya, the new capital in Central Anatolia, as well as other cities, were enriched with buildings in the newly developed Seljuq style. Numerous mosques, *madrasas*, *turbe*s and *caravanserai*s, which were richly decorated by stucco and tiling with diverse figural representations, have survived to our day.

Tile of Kubadabad Palace, Karatay Museum, Konya, Turkey.

As the Seljuq emirates disintegrated and Byzantium declined, the Ottomans expanded their territory swiftly changing their capital from Iznik to Bursa and then again to Edirne. The conquest of Constantinople in 858/1453 by Sultan Mehmet II provided the necessary impetus for the transition of an emerging state into a great empire. A superpower that extended its boundaries to Vienna including the Balkans in the West and to Iran in the East, as well

Great Mosque of Cordoba, mihrab, Spain.

Madinat al-Zahra', Dar al-Yund, Spain.

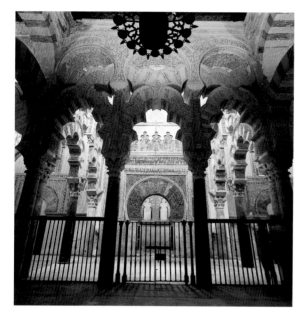

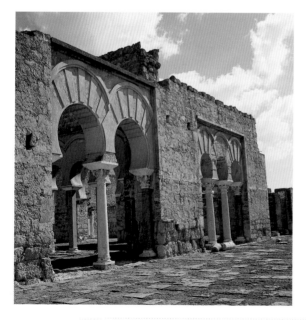

as North Africa from Egypt to Algeria, turning the Eastern Mediterranean into an Ottoman sea. The race to surpass the grandeur of the inherited Byzantine churches, exemplified by the Hagia Sophia, culminated in the construction of great mosques in Istanbul. The most significant one is the Mosque of Süleymaniye, built in the 10th/16th century by the famous Ottoman architect Sinan, epitomises the climax in architectural harmony in domed buildings. Most major Ottoman mosques were part of a large building complex called *kulliye* that also consisted several *madrasa*s, a *Qur'an* school, a library, a hospital (*darussifa*), a hostel (*tabhane*), a public kitchen, a *caravanserai* and mausoleums (*turbe*s). From the beginning of the 12th/18th century, during the so-called Tulip Period, Ottoman architecture and decorative style reflected the influence of French Baroque and Rococo, heralding the westernisation period in arts and architecture.

Al-Andalus at the western part of the Islamic world became the cradle of a brilliant artistic and cultural expression. 'Abd al-Rahman I established an independent Umayyad caliphate (138/750-422/1031) with Cordoba as its capital. The Great Mosque of Cordoba would pioneer innovative artistic tendencies such as the double tiered arches with two alternating

colours and panels with vegetal orna-
mentation which would become part
of the repertoire of al-Andalus artistic
forms.

In the $5^{th}/11^{th}$ century, the caliphate
of Cordoba broke up into a score of
principalities incapable of preventing
the progressive advance of the recon-
quest initiated by the Christian states
of the Northwestern Iberian
Peninsula. These petty kings, or Taifa
Kings, called the Almoravids in
479/1086 and the Almohads in

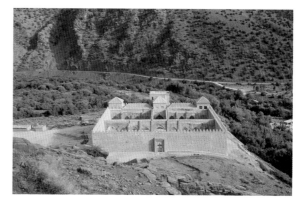

Tinmal Mosque, aerial view, Morocco.

540/1145, repelled the Christians and reestablished partial unity in al-Andalus.
Through their intervention in the Iberian Peninsula, the Almoravids (427/1036-
541/1147) came into contact with a new civilisation and were captivated
quickly by the refinement of al-Andalus art as reflected in their capital,
Marrakesh, where they built a grand mosque and palaces. The influence of the
architecture of Cordoba and other capitals such as Seville would be felt in all
of the Almoravid monuments from Tlemcen, Algiers to Fez.

Under the rule of the Almohads (515/1121-667/1269), who expanded their
hegemony as far as Tunisia, western Islamic art reached its climax. During
this period, artistic creativity that originated with the Almoravid rulers was
renewed and masterpieces of Islamic art were created. The Great Mosque of

Ladies Tower and Gardens, Alhambra, Granada, Spain.

Seville with its minaret the Giralda,
the Kutubiya in Marrakesh, the
Mosque of Hassan in Rabat and the
Mosque of Tinmal high in the Atlas
Mountains in Morocco are notable
examples.

Upon the dissolution of the Almohad
Empire, the Nasrid dynasty
(629/1232-897/1492) installed it-
self in Granada and was to experi-
ence a period of splendour in the
$8^{th}/14^{th}$ century. The civilisation of
Granada would become a cultural

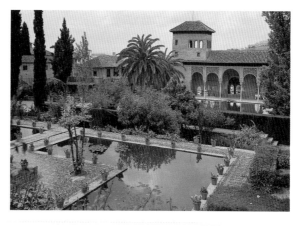

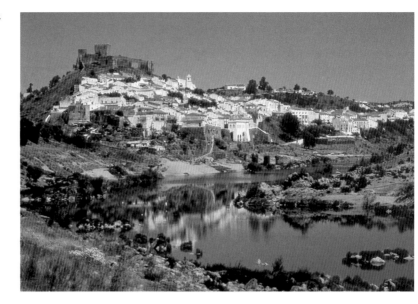

Mertola, general view, Portugal.

model in future centuries in Spain (Mudejar Art) and particularly in Morocco, where this artistic tradition enjoyed great popularity and would be preserved until the present day in the areas of architecture and decoration, music and cuisine. The famous palace and fort of *al-Hamra'* (the Alhambra) in Granada marks the crowning achievement of al-Andalus art, with all features of its artistic repertoire.

Decoration detail, Abu Inan Madrasa, Meknes, Morocco.

At the same time in Morocco, the Merinids (641/1243-876/1471) replaced the Almohads, while in Algeria the 'Abd al-Wadid's reigned (633/1235-922/1516), as did the Hafsids (625/1228-941/1534) in Tunisia. The Merinids perpetuated al-Andalus art, enriching it with new features. They embellished their capital Fez with an abundance of mosques, palaces and *madrasas*, with their clay mosaic and *zellij* panelling in the wall decorations, considered

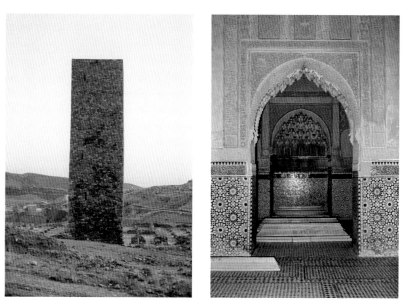

to be the most perfect works of Islamic art. The later Moroccan dynasties, the Sa'adians (933/1527-1070/1659) and the 'Alawite (1077/1659 – until the present day), carried on the artistic tradition of al-Andalus that was exiled from its native soil in 897/1492. They continued to build and decorate their monuments using the same formulas and the same decorative themes as had the preceding dynasties, adding innovative touches characteristic of their creative genius. In the early $11^{th}/17^{th}$ century, emigrants from al-Andalus (the *Moriscos*), who took up residence in the northern cities of Morocco, introduced numerous features of al-Andalus art. Today, Morocco is one of the few countries that has kept traditions of al-Andalus alive in its architecture and furniture, at the same time modernising them as they incorporated the architectural techniques and styles of the $15^{th}/20^{th}$ century.

ARCHITECTURAL SUMMARY

In general terms, Islamic architecture can be classified into two categories: religious, such as mosques, *madrasas*, mausoleums, and secular, such as palaces, *caravanserais*, fortifications, etc.

Religious Architecture

Mosques

The mosque for obvious reasons lies at the very heart of Islamic architecture. It is an apt symbol of the faith that it serves. That symbolic role was understood by Muslims at a very early stage, and played an important part in the creation of suitable visual markers for the building: minaret, dome, *mihrab*, *minbar*, etc.

The first mosque in Islam was the courtyard of the Prophet's house in Medina, with no architectural refinements. Early mosques built by the Muslims as their empire was expanding were simple. From these buildings developed the congregational or Friday mosque (*jami'*), essential features of which remain today unchanged for nearly 1400 years. The general plan consists of a large courtyard surrounded by arched porticoes, with more aisles or arcades on the side facing Mecca (*qibla*) than the other sides. The Great Umayyad Mosque in Damascus, which followed the plan of the Prophet's mosque, became the prototype for many mosques built in various parts of the Islamic world.

Umayyad Mosque of Damascus, Syria.

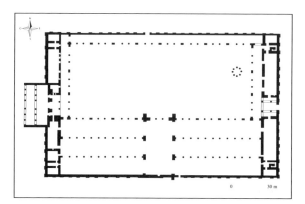

0 30 m

Two other types of mosques developed in Anatolia and afterwards in the Ottoman domains: the basilical and the dome types. The first type is a simple pillared hall or basilica that follows late Roman and Byzantine Syrian tradition, introduced with some modifications in the 5th/11th century. The second type, which developed during the Ottoman period, has its organisation of interior space under a single dome. The Ottoman

architects in great imperial mosques created a new style of domed construction by merging the Islamic mosque tradition with that of dome building in Anatolia. The main dome rests on hexagonal support system, while lateral bays are covered by smaller domes. This emphasis on an interior space dominated by a single dome became the starting point of a style that was to be introduced in the 10th/16th century. During this period, mosques became multipurpose social com-

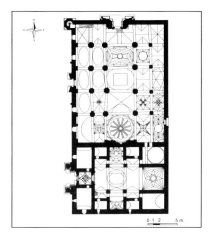

Great Mosque, Divriği, Turkey.

plexes consisting of a *zawiya*, a *madrasa*, a public kitchen, a bath, a *caravanserai* and a mausoleum of the founder. The supreme monument of this style is the Sülaymeniye Mosque in Istanbul built in 965/1557 by the great architect Sinan.

The minaret from the top of which the *muezzin* calls Muslims to prayer, is the most prominent marker of the mosque. In Syria the traditional minaret consists of a square-plan tower built of stone. In Mamluk Egypt minarets are each divided into three distinct zones: a square section at the bottom, an octagonal middle section and a circular section with a small dome on the top. Its shaft is richly decorated and the transition between each section is covered with a band of *muqarnas* decoration. Minarets in North Africa and Spain, that share the square tower form with Syria, are decorated with panels of motifs around paired sets of windows. During the Ottoman period the octagonal or cylindrical minarets replaced the square tower. Often these are tall pointed minarets and although mosques generally have only one minaret, in major cities there are two, four or even six minarets.

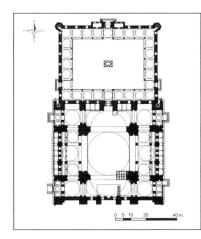

Sülaymeniye Mosque, Istanbul, Turkey.

27

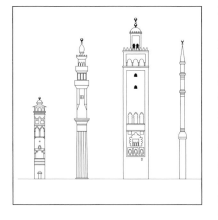

Madrasas

It seems likely that the Seljuqs built the first *madrasa*s in Persia in the early 5th/11th century when they were small structures with a domed courtyard and two lateral *iwan*s. A later type developed has an open courtyard with a central *iwan* and surrounded by arcades. During the 6th/12th century in Anatolia, the *madrasa* became multifunctional and was intended to serve as a medical school, mental hospital, a hospice with a public kitchen (*imaret*) and a mausoleum. The promotion of *Sunni* (orthodox) Islam reached a new zenith in Syria and Egypt under the Zengids and the Ayyubids (6th/12th–early 7th/13th centuries). This era witnessed the introduction of the *madrasa* established by a civic or political leader for the advancement of Islamic jurisprudence. The foundation was funded by an endowment in perpetuity (*waqf*), usually the revenues of land or property in the form of an orchard, shops in a market (*suq*), or a bathhouse (*hammam*). The *madrasa* tradi-

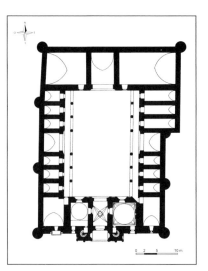

tionally followed a cruciform plan with a central court surrounded by four *iwan*s. Soon the *madrasa* became a dominant architectural form with mosques adopting a four-*iwan* plan. The *madrasa* gradually lost its sole religious and political function as a propaganda tool and tended to have a broader civic function, serving as a congregational mosque and a mausoleum for the benefactor.

The construction of *madrasa*s in Egypt and particularly in Cairo gathered new momentum with the coming of the Mamluks. The typical

28

Cairene *madrasa* of this era was a multifunctional gigantic four-*iwan* structure with a stalactite (*muqarnas*) portal and splendid façades. With the advent of the Ottomans in the 10th/16th century, the joint foundation, typically a mosque-*madrasa*, became a widespread large complex that enjoyed imperial patronage. The *iwan* disappeared gradually and was replaced by a dominant dome chamber. A substantial increase in the number of domed cells used by students is a characteristic of Ottoman *madrasa*s.

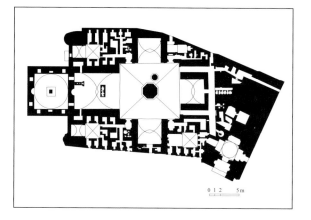

Mosque and madrasa Sultan Hassan, Cairo, Egypt.

One of the various building types that by virtue of their function and of their form can be related to the *madrasa* is the *khanqa*. The term indicates an institution, rather than a particular kind of building, that houses members of a Muslim mystical (*sufi*) order. Several other words used by Muslim historians as synonyms for *khanqa* include: in the Maghrib, *zawiya*; in Ottoman domain, *tekke*; and in general, *ribat*. *Sufism* permanently dominated the *khanqa*, which originated in eastern Persia during the 4th/10th century. In its simplest form the *khanqa* was a house where a group of pupils gathered around a master (*shaykh*), and it had the facilities for assembly, prayer and communal living. The establishment of *khanqa*s flourished under the Seljuqs during the 5th/11th and the 6th/12th centuries and benefited from the close association between *Sufism* and the *Shafi'i madhhab* (doctrine) favoured by ruling elite.

Mausoleums

The terminology of the building type of the mausoleum used in Islamic sources is varied. The standard descriptive term *turbe* refers to the function of the building as for burial. Another term is *qubba* that refers to the most identifiable, the dome, and often marks a structure commemorating Biblical prophets, companions of the Prophet Muhammad and religious or military notables. The function of mausoleums is not limited simply to a place of burial

Qasr al-Khayr al-Sharqi, Syria.

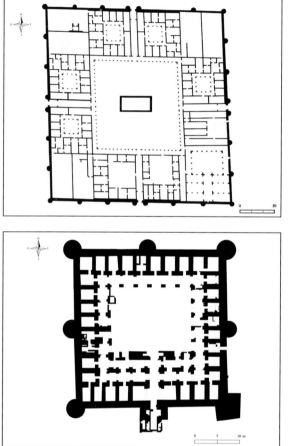

Ribat of Sousse, Tunisia.

and commemoration, but also plays an important role in "popular" religion. They are venerated as tombs of local saints and became places of pilgrimage. Often the structure of a mausoleum is embellished with Qur'anic quotations and contains a *mihrab* within it to render it a place of prayer. In some cases the mausoleum became part of a joint foundation. Forms of Medieval Islamic mausoleums are varied, but the traditional one has a domed square plan.

Secular Architecture

Palaces

The Umayyad period is characterised by sumptuous palaces and bathhouses in remote desert regions. Their basic plan is largely derived from Roman military models. Although the decoration of these structures is eclectic, they constitute the best examples of the budding Islamic decorative style. Mosaics, mural paintings, stone or stucco sculpture were used for a remarkable variety of decorations and themes. Abbasid palaces in Iraq, such as those at Samarra and Ukhaidir, follow the same plan as their Umayyad forerunners, but are marked by increase in size, the use of the great *iwan*, dome and courtyard, and the extensive use of stucco decorations. Palaces in the later Islamic period developed a distinctive style that was more decorative and less monumental. The most remarkable example of royal or princely palaces is the Alhambra. The vast area of the palace is broken up into a series of separate units: gardens, pavilions

and courts. The most striking feature of Alhambra, however, is the decoration that provides an extraordinary effect in the interior of the building.

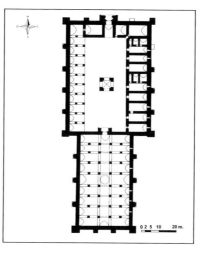

Aksaray Sultan Khan, Turkey.

Caravanserais

A *caravanserai* generally refers to a large structure that provides a lodging place for travellers and merchants. Normally, it is a square or rectangular floor plan, with a single projecting monumental entrance and towers in the exterior walls. A central courtyard is surrounded by porticoes and rooms for lodging travellers, storing merchandise and for the stabling of animals.

The characteristic type of building has a wide range of functions since it has been described as *khan, han, funduq, ribat*. These terms may imply no more than differences in regional vocabularies rather than being distinctive functions or types. The architectural sources of the various types of *caravanserais* are difficult to identify. Some are perhaps derived from the Roman *castrum* or military camp to which the Umayyad desert palaces are related. Other types, in Mesopotamia and Persia, are associated with domestic architecture.

Urban organisation

From about the 3rd / 10th century every town of any significance acquired fortified walls and towers, elaborate gates and a mighty citadel (*qal'a* or *qasba*) as seat of power. These are massive constructions built in materials characteristic of the region in which they are found; stone in Syria, Palestine and Egypt, or brick, stone and rammed earth in the Iberian Peninsula and North Africa. A unique example of military architecture is the *ribat*. Technically, this is a fortified palace designated for the temporary or permanent warriors of Islam who committed themselves to the defence of frontiers. The *ribat* of Sousse in Tunisia

31

bears resemblance to early Islamic palaces, but with a different interior arrangement of large halls, mosque and a minaret.

The division of the majority of Islamic cities into neighbourhoods is based on ethnic and religious affinity and it is also a system of urban organisation that facilitates the administration of the population. In the neighbourhood there is always a mosque. A bathhouse, a fountain, an oven and a group of stores are located either within or nearby. Its structure is formed by a network of streets, alleys and a collection of houses. Depending on the region and era, the home takes on diverse features governed by the historical and cultural traditions, climate and construction materials available.

The market (*suq*), which functions as the nerve-centre for local businesses, would be the most relevant characteristic of Islamic cities. Its distance from the mosque determines the spatial organisation of the markets by specialised guilds. For instance, the professions considered clean and honourable (bookmakers, perfume makers, tailors) are located in the mosque's immediate environs, and the noisy and foul-smelling crafts (blacksmith, tanning, cloth dying) are situated progressively further from it. This geographic distribution responds to imperatives that rank on strictly technical grounds.

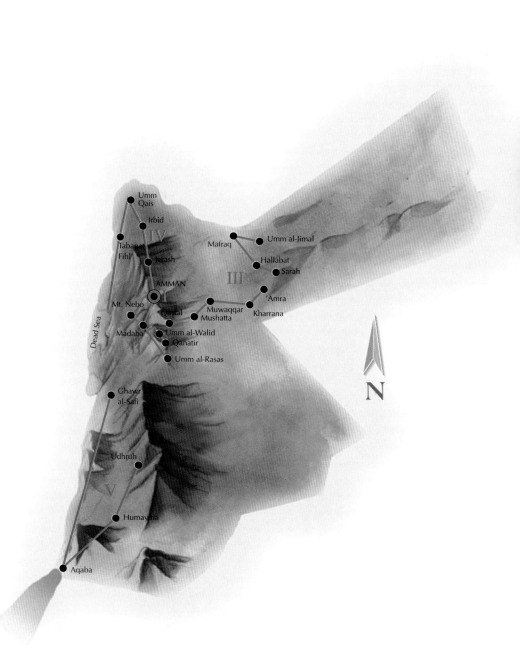

Umm
Qais

Irbid

IV

Tabaqat
Fihl

Jerash

Mafraq

Umm al-Jimal

Hallabat

Sarah

AMMAN

III

Mt. Nebo

'Amra

Qastal

Muwaqqar

Kharrana

Madaba

Mushatta

Umm al-Walid

Qanatir

Umm al-Rasas

Dead Sea

Ghawr
al-Safi

Udhruh

V

Humayma

Aqaba

N

Khirbat al-Mafjar,
mosaic floor near
bathing hall, Jericho,
(Ettinghausen, 1977).

Mohammad al-Asad

The rule of the Umayyad dynasty lasted or less than 90 years (41/661-132/750). During this relatively brief period the rules changed the political and cultural maps of the Mediterranean World and of Western and Central Asia. Fuelled by the new religion of Islam, they created a vast empire that extended from southern France in the west, to India and to the borders of China in the east. It was the largest empire up to that time, larger than that of the Romans, and only to be equalled and outdone by the modern British and Russian empires. Although the Umayyads created their empire in a very short time, its effects were long-lasting, and the vast majority of the lands that comprised the Muslim Umayyad empire in the $2^{nd}/8^{th}$ century are still part of the Islamic world today.

The rise of the Umayyad dynasty is very closely related to the rise of Islam. In fact, the Umayyad dynasty came into being less than 40 years after the Prophet Muhammad (570-11/632) established the first Muslim State in 1/622. The Islamic religion was born in 611 in Mecca, a city located in the region of the *Hijaz* in the western part of the Arabian Peninsula. According to tradition, the Prophet Muhammad received the call of revelation from Allah through the angel Gabriel. Initially, a very small number of people followed Muhammad. In fact, the Meccans persecuted him and his followers, partly because the citizens benefited greatly from the city's position as the centre of Arabian paganism, and saw Muhammad's message of the "unity of God" as a threat to their way of life and to their economic interests.

It was the people of Madina, a city located about 400 km. northeast of Mecca, who were the first sizeable group to accept the Prophet Muhammad and the Islamic religion. Madina was suffering from feuds between its two main Arab tribes, the Aws and the Khazraj, and its inhabitants saw the Prophet Muhammad as a man of discipline, power and spirituality who would bring unity to their city. Consequently, they accepted Muhammad as their spiritual and political leader and invited him to move there from his hometown of Mecca, which he did in 1/622 with a small group of his followers.

This event is known as the *Hijra* (Arabic for migration), and marks the beginning of the Muslim calendar. Who would ever guess that out of this small city state, under the banner of the new religion of Islam, would emerge one of the greatest military, political and cultural forces of history.

From Madina, the Prophet and his followers were able to spread Islam

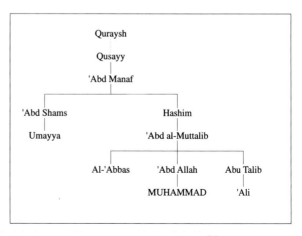

Genealogical relationship of the Umayyads with Prophet Muhammad.

throughout the Arabian Peninsula. In 8/630, he entered his hometown of Mecca as a victorious conqueror, and by the time of his death in 10/632, the whole Arabian Peninsula had come under the rule of Islam.

The "Orthodox" *Caliphs*

After the death of the Prophet Muhammad, a successor had to be elected among his close followers. A number of his companions nominated Abu Bakr, his oldest and most trustworthy companion. Consequently, Abu Bakr became Islam's first *caliph* (from the Arabic word *Khalifa* meaning successor). He proved to be a most capable successor of the Prophet. He was renowned for his gentleness and modesty and was a very effective leader. A number of Arabian tribes had renounced their allegiance to Islam following the Prophet's death, but Abu Bakr was able to impose his authority, thus saving the newly formed Muslim State from early disintegration. During his short two years in power, Muslim forces began advancing into the Syrian territories of the Byzantine Empire and the Iraqi and Persian territories of the Sassanian Empire. Before his death in 13/634, Abu Bakr nominated 'Umar Ibn al-Khattab, another companion of the prophet, to succeed him, and the leaders of the Muslim community in Madina unanimously accepted 'Umar's nomination.

'Umar also showed himself to be a competent ruler, known for his piety, simplicity and sense of justice. During his 10-year rule, Muslim expansion outside Arabia continued. The Sassanian Empire was brought to an end, and through a series of defeats that resulted in the loss of Syria and Egypt to the advancing Muslims, the Byzantine Empire was weakened greatly. 'Umar laid the foundations for an effective administrative system (see The Umayyad Administrative System) that allowed the Arab Muslims to rule the complex of communities that came under their sceptre.

Through this system, the Christian, Jewish and Zoroastrian groups living under Muslim rule were granted considerable freedom in running their own affairs, but were expected to pay a yearly poll tax to the Muslim treasury. Most of the inhabitants of these regions, who had suffered under the cruel and corrupt Byzantine and Sassanian administrations, however, welcomed the new Arab-Muslim rulers.

Umar was assassinated in 23/644, and 'Uthman Ibn 'Affan, a companion and son-in-law of the Prophet, was elected as *caliph*. During his 12-year rule, Muslim conquests into Byzantine territories and into Central Asia were pursued with vigour. 'Uthman was known for his mild manners and piety but, unlike his predecessors, was unable to maintain unity among the Arab-Muslim elite. Some accused him of favouring his kinsmen in appointments to leading positions in the empire and tensions that arose eventually lead to his murder in 35/656.

'Ali Ibn Abi Talib was elected to succeed 'Uthman. 'Ali was a highly esteemed pious

Muslim who was also a cousin and son-in-law of the Prophet. As with 'Uthman, tensions between the Arab-Muslim elite mounted during his rule. His political rivals attacked him for not punishing those responsible for the murder of 'Uthman, and a number of them openly disputed his caliphate.

The most serious challenge to 'Ali came from Mu'awiya Ibn Abi Sufyan, the governor of Syria, and a member of the Umayyad family, a rich Meccan family to which 'Uthman also belonged. Mu'awiya accused 'Ali of condoning the murder of 'Uthman and refused to acknowledge 'Ali's authority. In 36/657 they met at the battle of Siffin along the Euphrates, but the battle ended in a stalemate. The struggle between 'Ali and Mu'awiya only came to an end with the assassination of 'Ali in 41/661, carried out by a member of the *Kharijite* movement, a puritanical and highly militant religious Muslim sect that opposed both 'Ali and Mu'awiya. 'Ali's oldest son, Hassan, half-heartedly accepted nomination as *caliph* while Mu'awiya was also proclaimed *caliph*.

Mu'awiya reached an agreement with Hassan to renounce the title of *caliph* in return for a generous pension from the Muslim treasury. Consequently, Mu'awiya became the sole ruler of the Muslim empire, and was proclaimed *caliph* in a ceremony at Jerusalem in 41/661. He chose Damascus as his capital ('Ali had already moved the capital of the Muslim state from Madina to the city of Kufa in southern Iraq). Thus, the Umayyad dynasty was born.

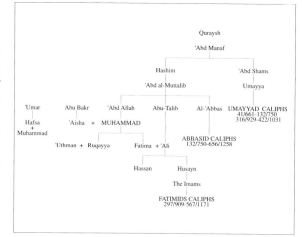

Connection of the lines of caliphs.

The Orthodox *caliphs,* Abu Bakr, 'Umar, 'Uthman and 'Ali, are known among Muslims as the "Rightly Guided" *caliphs,* and their rule is regarded as the golden age of Islam. They were all companions of the Prophet who were known for their piety and were all elected to their positions by the leaders of the Muslim community. In contrast, Mu'awiya, who did not convert to Islam until the conquest of Mecca in 8/630, replaced the electoral system of government established during the rule of the Orthodox *caliphs* with more absolute authority of the *caliphs* based on hereditary succession.

The Umayyads

As the preceding Orthodox *caliphs,* Mu'awiya was a member of the Meccan Quraysh tribe to which the Prophet Muhammad also belonged. He, however, was not as closely related to the

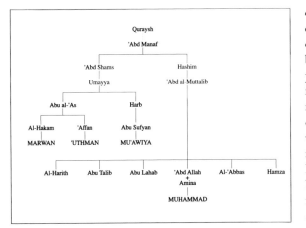

```
                          Quraysh
                         'Abd Manaf

          'Abd Shams                    Hashim
             Umayya                 'Abd al-Muttalib

     Abu al-'As              Harb

  Al-Hakam      'Affan    Abu Sufyan
  MARWAN       'UTHMAN    MU'AWIYA

    Al-Harith   Abu Talib   Abu Lahab   'Abd Allah   Al-'Abbas   Hamza
                                          +
                                        Amina

                                     MUHAMMAD
```

Genealogy of Prophet Muhammad and of the Umayyads.

decades of power. He was a skilled politician who preferred persuasion to the use of force. Before becoming *caliph,* he had been governor of Syria for almost 20 years. During that period, he transformed the initially anarchist tribal Arab fighters under his command into an efficient and disciplined army that was able to deal effectively with the Byzantine forces to the north. As *caliph,* he established an efficient administrative system based on Byzantine models, and surrounded himself with competent advisors and administrators, both Muslim and Christian. He ruled through consulting with the notables of Arab tribes and even organised a consultative body of these notables.

Prophet as 'Ali, his cousin, and belonged to the same Quraysh family branch of the Umayyads as 'Uthman. These relationships played a very important role in the rise of the Umayyad dynasty and its eventual downfall nine decades later.

One of Mu'awiya's main objections to 'Ali as *caliph* was that 'Ali had failed to punish the murderers of 'Uthman. On the other hand, the majority thought that 'Ali, a cousin of the Prophet and his son-in-law, and his descendants, the grandchildren of the Prophet, where the only legitimate candidates for the caliphate. According to this group, Mu'awiya was a usurper of the caliphate and it was from this opposition that the important *Shi'a* (properly *Shi'at 'Ali,* meaning "the party of 'Ali") sect of Islam grew. The *Shi'a* evolved as an important force that helped bring about the end of the Umayyad dynasty.

Mu'awiya, however, was firmly in control of the Muslim empire during his two

One of Mu'awiya's most controversial acts was to introduce, by designating his son Yazid as his successor, succession by heredity to the caliphate. Accession by right of birth was alien to both Arab tribal tradition and to the early Muslim practice of electing the *caliph,* but Mu'awiya managed to persuade the tribal notables to accept his son as successor. To ensure their consent, Mu'awiya gave the tribal notables the right to confirm his choice of successor. This process of confirmation proved to be no more than a formality in later years .

Mu'awiya died in 60/680 and was succeeded by his son Yazid (for the chronological succession of the *caliph*s of the Umayyad dynasty, see list on page 39). Although a capable leader, his rule did not go unchallenged. Husayn, the second son of 'Ali, contested Yazid's legitimacy as *caliph* and in 60/680, he and a small

group of family members and supporters from Madina marched to Kufa against Yazid. In the town of Karbala, the group was intercepted by an Umayyad force and when Husayn refused to surrender (some accounts state that he was ordered to return to Madina), he and his followers were massacred. The event was of no military and little political significance but in time it emerged as the single and most important event for the *Shi'a* Muslims. The date of the battle became a day of mourning, and Karbala a most holy place. The eventual overthrow of the Umayyads was partly the result of the *Shi'a*'s determination to avenge the murder of Husayn.

'Abd Allah Ibn al-Zubayr, a grandson of Abu Bakr through his daughter Asma', also challenged the legitimacy of Yazid's rule. Yazid sent a contingency to deal with him but the expedition came to an end by the premature death of Yazid in Damascus. The commander of Yazid's army returned to Syria to deal with any trouble that might ensue and fighting did in fact break out. Yazid's son Mu'awiya II was weak and his brief reign was marked by considerable political instability. This gave Ibn al-Zubayr the opportunity to press ahead with his claim for the caliphate, which he obtained by being declared *caliph* in the Arabian Peninsula, Iraq, Iran, Egypt and even parts of Syria, the Umayyad stronghold.

Umayyad rule was saved, however, by the accession of the aged Marwan Ibn al-Hakam, who belonged to the Marwanid branch of the Umayyad dynasty. Marwan managed to consolidate

his rule over Syria before his death, and was succeeded by his son 'Abd al-Malik, who is considered the most important ruler of the Umayyads after Mu'awiya. After a long struggle, 'Abd al-Malik was able to put down al-Zubayr's revolt through his ruthless governor al-Hajjaj, who defeated and killed Ibn al-Zubayr in Mecca in 73/692. With that, the Umayyads were once again in control.

The significance of 'Abd al-Malik rule extends beyond re-establishing Umayyad power and bringing stability. Once firmly in control, he resumed the expansion of the Muslim empire on all fronts and began the important task of "Arabising" the state's public registers, which up to then had been in Greek, in Syria, and Pahlavi in Iraq and Iran. Having made Arabic the single official language, 'Abd al-Malik created Arabic coinage (see Early Islamic Coinage).

Four of the five *caliphs* who succeeded 'Abd al-Malik were his sons. The fifth was his nephew, 'Umar Ibn 'Abd al-'Aziz. The period of these five *caliphs*, ending with the death of Hisham Ibn 'Abd al-Malik,

Sufyanid branch of the Umayyad dynasty in its relation to the founder of the Marwanid branch.

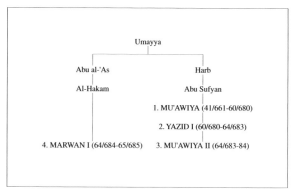

	Umayya	
Abu al-'As		Harb
Al-Hakam		Abu Sufyan
		1. MU'AWIYA (41/661-60/680)
		2. YAZID I (60/680-64/683)
4. MARWAN I (64/684-65/685)		3. MU'AWIYA II (64/683-84)

39

was the great era of Umayyad rule. The borders of the empire were extended further to territories in three continents. It was a period of tremendous building activity, especially under the rule of 'Abd al-Malik's immediate successor and son, al-Walid I, who built three magnificent mosques in Madina, Jerusalem and Damascus. Al-Walid I built and introduced the first endowed institutions for the care of lepers, the lame and the blind.

Hisham Ibn 'Abd al-Malik was the last of the great Umayyad rulers. After his death, the Umayyad State deteriorated quickly. Opposition to Umayyad rule had been growing steadily and one major resistance group was the non-Arab converts to Islam. These converts had expected social and economic equality with Arab-Muslims but in most cases had received neither. In fact, the converts, of whom many were Persians, could at best hope to be affiliated as clients to an Arabian tribe with a status as second-degree citizens. Moreover, they were not always exempted from the poll tax imposed on non-Muslims. The number of *Shi'as* opposing Umayyad rule grew rapidly in Iraq and Persia. They never forgave the Umayyads for their treatment of 'Ali and Husayn, and thought them too worldly and impious to lead the Muslim world.

These factions objecting to the Umayyad's for economic, social, religious and political reasons united under the leadership of the Abbasid family. This family descended from al-'Abbas, an uncle of the Prophet Muhammad. Although 'Ali was the son of another uncle (Abu Talib), the Abbasids felt they were much closer to

the family of the Prophet than the Umayyads and had a greater right to the caliphate.

The Umayyads were unable to face the Abbasid-led alliance against them. For one, the Arab tribes in Syria who were the Umayyad's main support, split into two feuding groups, the Arabs of southern Arabia, or the Yemen, and the Arabs of northern Arabia. They fought each other even during the critical period when the Abbasids were mounting their campaign against the Umayyads.

To make matters worse, the three *caliphs* who succeeded Hisham were incompetent and their combined rule lasted barely one year. Al-Walid II, for example, was more interested in wine, poetry and music than in affairs of state. By the time the more capable Marwan II assumed power, the situation had deteriorated beyond repair, and Marwan spent the six years of his rule fighting what was clearly a loosing battle.

The Abbasids were led by Abu al-'Abbas, a great-grandson of al-'Abbas, an uncle of the Prophet. The Abbasid armed revolt began in Persia, in the region of Khurasan, in 126/744, and was led by a Persian agent of the Abbasids by the name of Abu Muslim. Kufa fell in 131/749 and Abu al-'Abbas declared himself *caliph*. Marwan II was defeated in a battle near the Tigris in 132/750. Soon after, Damascus fell and Marwan II became a fugitive until the Abbasids tracked him down and murdered him in Egypt a few months later. In fact, they carried out a systematic campaign exterminating all members of the Umayyad family. One Umayyad

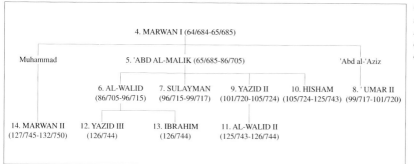

Genealogical relationship of the Marwanid caliphs of the Umayyad dynasty.

4. MARWAN I (64/684-65/685)

Muhammad 5. 'ABD AL-MALIK (65/685-86/705) 'Abd al-'Aziz

6. AL-WALID 7. SULAYMAN 9. YAZID II 10. HISHAM 8. ' UMAR II
(86/705-96/715) (96/715-99/717) (101/720-105/724) (105/724-125/743) (99/717-101/720)

14. MARWAN II 12. YAZID III 13. IBRAHIM 11. AL-WALID II
(127/745-132/750) (126/744) (126/744) (125/743-126/744)

prince, 'Abd al-Rahman, a grandson of Hisham, managed to escape to Spain where he established a brilliant Umayyad dynasty. In the heartland of the Islamic world, however, the Umayyads came to a bloody and tragic end.

The main events of Umayyad history related above, are believed to be correct, however, there remain considerable gaps and difficulties in piecing together the past to present a comprehensive history of the Umayyad period.

Lack of accurate contemporary sources are exasperated by the fact that almost none of the earliest historical texts predate the year 235/850, a century after the fall of the dynasty. As these texts were written under the Abbasids, almost all of the information available concerning the Umayyads has to be treated with circumspection.

Still much insight into the Umayyad period and early Islamic history has been gained which resulted in some far reaching changes. These include expansion of the Muslim state, the foundations of an efficiently administered empire for which Islam was the religion and Arabic was the language, new coinage and an efficient postal system that connected the vast Muslim territories. To achieve all this, the Umayyads replaced the system of election with hereditary accession to the caliphate. The Umayyads were the inheritors of the old system and founders of a civilisation that was to make great contributions in different fields of knowledge in the following centuries, especially the $2^{nd}/8^{th}$ and $3^{rd}/9^{th}$, spreading their knowledge and cultivating arts across three continents.

The areas under their control represented the accumulated cultural heritage of Greece and Rome (in Syria, Asia Minor, Egypt and North Africa), and of the Assyrians, Babylonians, Achaemenids, Parthians, and Sassanians (in Iraq, Iran and Central Asia). To this "new culture", they added the unifying forces of the Islamic faith and the Arabic language. As the new masters, the Umayyads readily and quickly assimilated these cultures with the new Islamic Culture evolving under their rule and patronage.

The Umayyads chose greater Syria, also known as *Bilad al-Sham* (Lebanon, Syria,

41

Jordan, Palestine and Israel), as their political centre. Mu'awiya, the founder of the dynasty and governor of Syria for almost 20 years before becoming *caliph,* made Syria his power base. *Bilad al-Sham* was a very rich province with significant agricultural wealth that had proved to be of great importance to the Greek, Roman and Byzantine empires. Syria found a rival, however, in Iraq that was emerging gradually during the Umayyad period as the single and most important region of the Islamic Empire. Once stability was assured under 'Abd al-Malik, the agricultural potential of Iraq began to be exploited. The agricultural riches of parts of Iraq had been neglected before the advent of Islam since they were in the boundaries marking the frontiers between the Byzantine and Sassanian states. From 'Abd al-Malik's time, these areas became part of the empire's heartland and 'Abd al-Malik's governor of Iraq, al-Hajjaj (who had previously ended Ibn al-Zubayr's revolt in the *Hijaz*) built an extensive irrigation network in Iraq to exploit the agricultural terrain. Consequently, the revenues of Iraq eventually surpassed those of Syria and Iraq gradually emerged as the economic centre of the Umayyad Empire. An affirmation of Iraq's growing importance was that the Umayyad's last *caliph,* Marwan II, moved his capital from Damascus to Harran in Mesopotamia. The fact that the succeeding Abbasids established themselves in Iraq, first in Kufa and soon afterwards in the newly established city of Baghdad, represents more the conclusion of a trend, that began during the Umayyads, with the establishment of a new policy.

As part of greater Syria, the areas of what is now Jordan were of considerable interest to the Umayyads, especially as they were the geographical link between their capital, Damascus, and the religiously and politically important region of the *Hijaz.* The relatively large number of palaces and country estates alone that the Umayyads built in the Jordanian *badiya* (or semidesert) is evidence of the importance of the area for them. There has been considerable discussion about these buildings, which will be dealt with below.

Jordan's role in the Umayyad period is revealed in the events that took place in two small towns located in the southern part of the country, Udhruh and al-Humayma. While events in Udhruh played a part in Mu'awiya's becoming *caliph* and thus the founding of the Umayyad dynasty, incidents at al-Humayma contributed to bringing about their downfall.

The battle of Siffin near the Euphrates between 'Ali and Mu'awiya was indecisive. Sources indicate that Mu'awiya convinced 'Ali that each of them should select an arbiter to settle the appointment of a new *caliph.* It was in Udhruh that the famous arbitration session was held in public. Modern historians have questioned the accuracy of the conflicting accounts in historical sources stating they reflect the biased view of Abbasid historians. It seems that not much came of the arbitration attempt and no matter which account is true, the events at Udhruh left 'Ali in a weaker position and showed Mu'awiya, then Syrian governor and

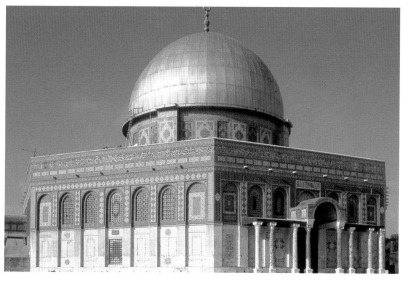

*Dome of the Rock,
general view,
Jerusalem.*

theoretically, at least, under the command of 'Ali, but almost equal to 'Ali.

The events that occurred at al-Humayma were of a different nature. Although the armed Abbasid revolt against the Umayyads began in Khurasan, Iran, the Abbasid family eventually occupied the Umayyad stronghold in *Bilad al-Sham* and made it their headquarters. Al-Humayma was a fairly isolated and, therefore, a seemingly insignificant town. It was, however, strategically well placed and close to the pilgrimage and trade routes connecting *Bilad al-Sham* to the *Hijaz*.

Umayyad Art

Although a good number of the works of art and architecture of the Umayyads have been lost, some very important examples have survived the passage of time. This is especially true of architecture, of which over 60 monuments have come down to us. As historical texts from the Umayyad period are lost, these monuments are the only contemporary evidence left. The vast majority of the monuments created, as well as those that have survived are in Syria but none of the existing remains belong to the first 30 years of Umayyad rule. The earliest ruins date from about 70/690, when 'Abd al-Malik restored order to the Umayyad state and the 60 years that followed, a period of tremendous building activity.

The renowned art historians, Oleg Grabar and Richard Ettinghausen, divided Umayyad art and architecture into five groups: the Dome of the Rock, the early congregational mosques, the mosques of al-Walid, the secular buildings and the minor arts. As expected, four of the five categories consist of works of architecture.

43

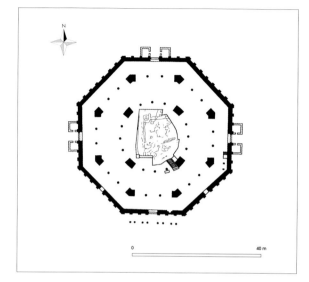

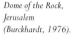
Dome of the Rock,
Jerusalem
(Burckhardt, 1976).

destroyed the Herodian temple in 71, and the site was left abandoned until the Muslims took control of Jerusalem in 16/637. Soon afterwards, they built a simple mosque on the southern part of the platform.

The building, which was constructed over a natural rock formation, is octagonal and marked by a large central dome rising to a height of about 25 m. The diameter of the octagon is about 60 m. and that of the dome about 20 m. To Muslims, it marks the place from which the Prophet Muhammad ascended to heaven during his miraculous "Night Journey". The rock holds, also, other important meanings for Muslims, Christians and Jews. It is traditionally associated with the story of the Creation and with Abraham's near sacrifice of his son Isaac. Some early Muslim historical sources have indicated that 'Abd al-Malik intended the Rock to replace the *Ka'ba* in Mecca as the first place of Muslim pilgrimages. This opinion, however, seems to reflect the biased tendencies during the Abbasid era and modern historians have shown it to be inaccurate.

Much of the edifice has survived as built by 'Abd al-Malik. The plans and overall mass are more or less as they were at the end of the $1^{st}/7^{th}$ century. The dome and its decoration, however, are the result of later rebuilding and restoration works. The interior and exterior walls were originally covered with mosaics, of which about 280 square metres have survived, but the exterior mosaics were removed during the $10^{th}/16^{th}$ century and replaced with glazed tiles.

The building was modelled on Byzantine architecture and decoration. It, also,

Clearly, the Umayyads, beginning with 'Abd al-Malik, were passionate builders. It is of interest to note that the arts directly related to architecture, mosaics, fresco painting and figural sculpture, were favoured by the Umayyads.

Mosques

The Dome of the Rock in Jerusalem, built by 'Abd al-Malik Ibn Marwan and completed in 72/691-692, is the earliest surviving monument of Islamic art.

The building is majestically placed on the vast artificial platform known as *al-Haram al-Sharif,* "the Noble Sanctuary", that continues to dominate the skyline in Jerusalem. The site is believed to have been that of the Temple of Solomon, and later of the temple built in 18 BC by Herod the Great (d. 4 BC). The Roman general and later emperor, Titus (d. 81),

includes some Sassanian influence shown in the jewels, crowns, palmettos and flowers depicted in its mosaics. As seen in Umayyad art in general, these borrowed motifs were used in new variations and compositions. The Dome of the Rock reflected a number of features that were to become characteristic of later traditions in Islamic art and architecture. This is evident in the mosaics, which are void of human or animal scenes, thus showing at an early stage the Muslims' aversion to depicting images in religious buildings.

Writing appeared in the Dome of the Rock as an integral part of the building's decoration, its long interior mosaic inscriptions consisted primarily of verses from the *Qur'an*. The calligraphy of the Dome of the Rock is one of the earliest surviving texts in Islam and the writings obviously served an ornamental role. They were also commemorative since part of the text states that 'Abd al-Malik completed the building in the year 72/691-692.

Interestingly enough, the Abbasid *caliph* al-Ma'mun (r. 197/813-218/833) substituted his name in the inscription for that of 'Abd al-Malik, but left the original date intact. In addition, the writings served a political purpose. Many of their "Quranic" verses deal with Islam's relationship to Christianity. The choice for this important building to be located in one of Christendom's holiest cities emphasised the final revelation and victory of Islam over the two other monotheistic religions.

Finally, this building shows the beginning of a new relationship between

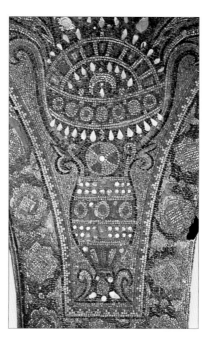

Dome of the Rock, detail of interior mosaics, Jerusalem, (Ettinghausen, 1977).

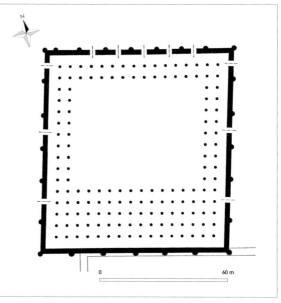

Great Mosque, rebuilt in 50/670, Kufa (Grabar, 1973).

House and Mosque of the Prophet, Madina (Grabar, 1973).

Mosque of the Prophet, rebuilt 91/710, Madina (Grabar, 1973).

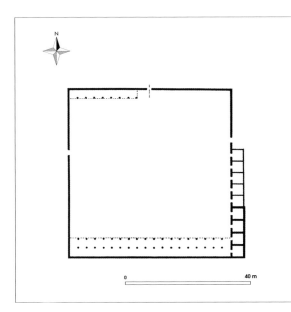

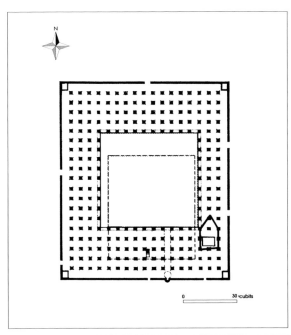

architecture and surface decoration that was to become characteristic of later traditions in Islamic architecture. In general, Greek tradition, from Hellenistic to Byzantine art and architecture, used surface decoration to enhance architectural forms. In the Dome of the Rock, surface decoration is given a visual role that equals, and sometimes even surpasses the architectural forms it envelops.

Much knowledge of mosque architecture from the Umayyad period is based on the mosques built by al-Walid I. Almost nothing survived of Umayyad mosques predating al-Walid's reign and historians must depend largely on the information provided in texts. The Umayyads built, rebuilt, or expanded upon congregational mosques in established centres and in newly founded Muslim towns such as Basra, Kufa and Wasit in Iraq, Fustat (now part of Cairo) in Egypt and Kairouan in Tunisia.

The congregational mosques predating al-Walid, generally, had a square floor plan and consisted of an open courtyard surrounded by a covered prayer hall at one side (the side facing the direction of Mecca, which is also known as the *qibla*) and covered porticoes on the three remaining sides. The prayer hall was arranged according to what is known as the hypostyle plan, which consists of columns distributed along a grid of squares or rectangles. When used in large numbers, the colonnaded grid created a powerful effect resulting from the direction less occupied by columns. The plan originated from the house and mosque that the Prophet Muhammad built in

Al-Aqsa Mosque, general view, Jerusalem.

Al-Aqsa Mosque, view of the dome, Jerusalem.

Al-Aqsa Mosque, 96/715, Jerusalem (Grabar, 1973).

Madina after emigrating there from Mecca in 1/622. These congregational mosques functioned as the major mosques of each town, and were more than merely religious buildings. They, also, served political and social functions as a wide variety of activities such as teaching and the dispensing of justice took place in them.

Two important features seem to have developed in these mosques, although their exact origins remain uncertain. The first is the *maqsura,* the special enclosure reserved for the use of the ruler and placed usually in the middle of the *qibla* wall. The *maqsura* was built to protect the prince from assassination and for his glorification, since it separated him from his subjects. It is also believed that the minaret "tower", the most widely used architectural symbol of Islam, came into being during this period. Texts indicate that it came from Egypt or Syria, but the date of origin is uncertain.

Al-Walid's reign was marked by a period of great expansion and consolidation. He was responsible, completely or partly, for three monumental mosques at Damascus (96/715), Madina (91/710) and Jerusalem (96/715). Unfortunately, the mosques at Madina and Jerusalem have been extensively rebuilt, and what is seen today is very different from Al-Walid's construction.

The Damascus mosque, however, retains much of its original character in spite of the 1310/1893 fire, which caused considerable damage. The site of the mosque originally housed the Roman Temple of Jupiter, which during the Byzantine era,

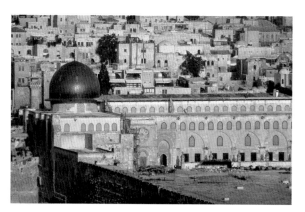

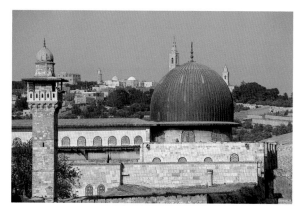

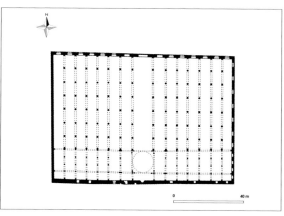

*Umayyad Mosque,
view of courtyard,
Damascus.*

*Umayyad Mosque,
view of dome from the
courtyard, Damascus.*

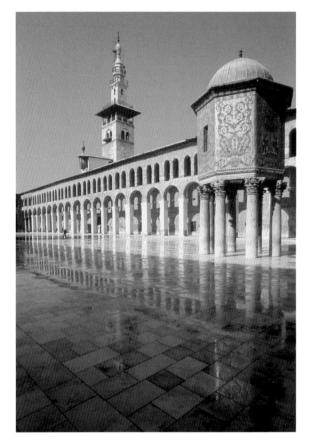

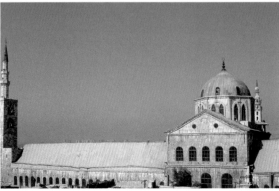

became the Church of St. John the Baptist (his shrine is still located in the mosque). The Muslims originally shared the mosque with the Christians, therefore, a part of it was used as a church and a part of it as a mosque. Al-Walid then purchased the whole site to build his mosque.

The mosque measures 100 x 157 m. and remains one of the largest in Islamic history. It shows an interesting combination of the Roman-Byzantine basilica plan, with its longitudinally oriented central nave and side aisles, and the hypostyle mosque, with its hall of columns and emphasis on the transverse axis to accommodate the rows of worshippers.

The mosque has three minarets, two at the corners of the southern (*qibla*) side, and one at the middle on the northern side. The third minaret may not belong to the time of al-Walid. The superstructure of the minarets were later additions, but the two southern ones rest on the foundations of Roman corner towers, and they are definitely among the earliest surviving minarets anywhere.

The mosque has also the earliest surviving concave *mihrab* in Islam. The *mihrab* is the niche in the *qibla* wall, and is usually located in its centre. Texts indicate that the earliest *mihrab* in Islam is the one that al-Walid ordered to be built at the Madina mosque, but that *mihrab* did not survive. Modern scholars have indicated the early *mihrab*s mark the place where the Prophet delivered the Friday sermon.

The most impressive are the wall mosaics that cover hundreds of square

*Umayyad Mosque,
detail of courtyard
mosaics, Damascus,
(Ettinghausen, 1977).*

*Umayyad Mosque,
detail of courtyard
mosaics, Damascus,
(Ettinghausen, 1977).*

metres and depict landscapes showing rivers, trees and buildings. They are closer to Roman Pompeian wall paintings of the second style than to the later highly stylised Byzantine mosaics. As with the mosaics of the Dome of the Rock, all portrayals of humans or animals are absent. Their exceptional quality has prompted considerable debate as to whether they were executed by local craftsmen or artists brought from Constantinople and interpretations of their subject matter vary a great deal. Some suggest they depict scenes of Damascus and other Syrian cities, others see them as scenes symbolising peace, security and prosperity under the Umayyads. A third interpretation explains the scenes as evocations of paradise itself. Probably, all three interpretations bear some truth. The marble grills covering the windows of the mosque have interlaced geometric designs and herald what was to become the dominant pattern of Islamic decoration.

Secular buildings (Khirbat al-Mafjar)

Almost none of the secular buildings constructed in the towns during the Umayyad period survived. Nothing remains of their palace in Damascus. Vestiges of *Dar al-Imara*, or governor's house, in Kufa and the commonly called Umayyad palaces in Jerusalem have been excavated partially, but their foundations and scanty remains provide only limited information. One of the better preserved ruins is the Umayyad

*Khirbat al-Mafjar,
around 126/744,
Jericho (Grabar, 1973).*

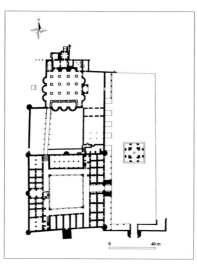

Palace of the Amman Citadel, which will be discussed below.

In contrast, a good number of estates that the Umayyads built outside urban centres, in the countryside and the *badiya* of Syria, have survived. As many of these buildings are in Jordan, they make up a large portion of Jordan's Islamic architectural heritage and will be discussed in more detail below. Some comments may be made, however, about one of the more important and more curious surviving Umayyad estates, Khirbat al-Mafjar near Jericho in Palestine.

It is believed that the eccentric *caliph* al-Walid II built Khirbat al-Mafjar. Also, it is thought that he began construction before assuming the title of *caliph* and it was not completed when he died in 126/744. The complex consists of a mosque, a castle and elaborate baths reportedly reflecting what is kown

about al-Walid II's character. A small pool or plunge bath within the complex is thought to be that which is referred to in later historical texts. It has been written that al-Walid II had the pool filled with wine, would jump into it and drink enough of the wine to considerably lower its level!

Two of the most notable features of Khirbat al-Mafjar are the floor mosaics and stucco relief. The extensive mosaics are located in the bath complex and their 39 continuous panels form the single largest floor mosaics surviving from antiquity. The mosaics consist primarily of geometric patterns and are of a very high quality but the masterpiece among them is the panel in a secluded room off the bathing hall. Unlike the other mosaics, this exquisitely designed and executed panel shows a figurative scene with two gazelles nibbling the leaves of a tree, and a lion attacking a third gazelle on the other side. The representation of tassels around the border of the panel indicates that it is a motif from a woven textile. The panel has been interpreted as an allegory to Umayyad power: it contrasts the blissful state under Umayyad rule with the wrath of the Umayyad *caliph* against his enemies.

While the mosaics reflect Byzantine influence, the sculptured stucco of Khirbat al-Mafjar has been inspired by Sassanian models. Stucco, which is both cheap and quick to mould or carve, was widely used in Sassanian art. One of the many surviving sculptures from the complex is the statue of a prince standing on a pedestal with two lions,

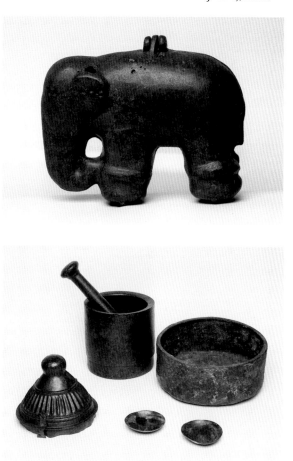

Iron mould of an elephant from al-Fudayn, Jordan Archaeological Museum, (Inv. Num. J 16514), Amman.

wearing traditional Sassanian garb and holding a dagger or a sword, attributed to his royal status. The quality of this work and of the other stucco sculptures, however, is not as fine as that of the mosaics. This is not surprising considering that Syria, at that time, was still renowned as a centre of mosaic production, but not of stone sculpture, nor of stucco. Still, the presence of those sculptures shows the growing influence of Iraq and Iran during the last days of Umayyad rule.

Umayyad decorative arts, also known as the "minor arts," such as metalwork, textiles, ceramics and ivories, are more difficult to study than Umayyad architecture. As many items continued to be produced more or less in the same tradition as that of earlier periods, many objects cannot be dated or identified accurately if removed from their original context. Thus, at times it is almost impossible to know whether a certain work is Umayyad Byzantine, Sassanian, or Coptic.

In addition, mediums such as textiles, carpets, metalwork, glazed pottery and book painting, were all very important in later traditions of Islamic art, and were beginning to appear under the Umayyads. Decorative arts, in general, were given a secondary role to architecture and mosaics as well as to figurative sculpture which were an integral part of the architecture of the Umayyads. One important exception is Umayyad coinage as developed from the time of 'Abd al-Malik, which eventually rejected the use of figurative representations and determined much of the evolution of Muslim coins in later times (see Early Islamic Coinage).

The Umayyads created the first artistic tradition of Islam. From some of the examples of Umayyad art and architecture, the foundations for much of what was to follow in later periods are derived. This is most obvious in the case of mosque architecture. Many features that have become integral parts of most

Bronze kitchen utensils from Umm al-Walid, Madaba Archaeological Museum, (Inv. Nums. 672-674, 787, 795).

51

Incised decorated steatite vessel from al-Fudayn, Jordan Archaeological Museum, (Inv. Num. J 19308), Amman.

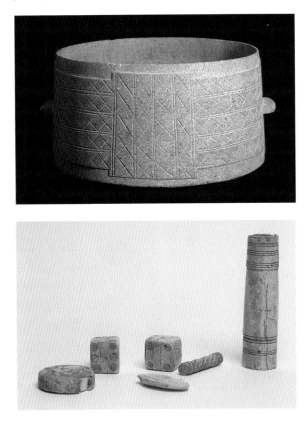

in Islamic art commenced in the Umayyad period. These are best seen in the marble filigrees at the Umayyad Mosque in Damascus and the mosaics of Khirbat al-Mafjar. The same applies to the use of writing in works of art and architecture, as is the case of the epigraphic bands along the interior arcades of the Dome of the Rock. On the other hand, certain art forms that were still favoured during the Umayyad period, such as mosaics and figurative sculptures, played a minor role and often did not feature in later traditions of Islamic art. The art historian Robert Hillenbrand summed up the characteristics of Umayyad art as being eclectic, experimental and propagandist. Umayyad art was eclectic in that it brought together in Syria the arts of the Western Hellenistic World and the Oriental art of Mesopotamia, Iran and Central Asia. It was experimental in that it created combinations of forms and themes in a manner that was uninhibited by previously established conventions. It was propagandistic in that many of its examples proclaimed the power and greatness of the Arab Muslim Umayyad State and its *caliphs*.

Ivory objects from al-Fudayn, Dept. of Antiquities office, (Inv. Num. 209), Mafraq.

mosques, such as the *mihrab* and minaret, find their origins in the Umayyad period. Also, the characteristic geometric designs

THE UMAYYADS: THE RISE OF ISLAMIC ART

Ghazi Bisheh

The five itineraries of Museum With No Frontiers were selected to give the visitor an overview of the cultures and arts, which flourished in Jordan during the Umayyad period (41/661-132/750). This period also constitutes the formative phase of Islamic Art. Cultural and social changes were not sudden, but transformations occurred gradually and may also have been directed by deliberate choice. As the Arab-Muslim conquest was accomplished without massive destruction or drastic demographic change, there was no major upheaval. In order to understand the process of change, it is necessary to give a brief account of the political, social and economic conditions prevalent during the decades preceding the conquest of Syria or *Bilad al-Sham* (the area which includes contemporary Jordan, Palestine and Syria).

In the year 610, Heraclius overthrew Phocas and assumed the role of emperor for the defence of the Byzantine Empire and Christian faith. One year later, the Sassanians of Persia overran northern Syria and by 614 conquered Palestine with Jerusalem from which the relics of the True Cross were removed to the Sassanian capital in Ctesiphon. In 628 Heraclius reconstituted his army and brought the war to the heart of the Sassanian Empire where he successfully persuaded the Persians to withdraw troops from the occupied Byzantine territory. In 630 Heraclius entered Jerusalem triumphantly carrying the retrieved relics of the True Cross. It was thus that Syria had experienced almost 15 years of Persian occupation and cultural influence prior to

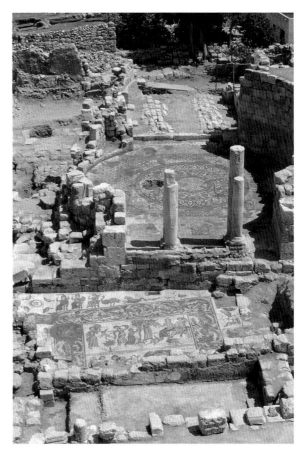

its liberation by Heraclius. From the time of his assumption to the imperial throne in 610, Heraclius had no respite and long wars and religious controversies, which had plagued Syria, created political instability. The main threat to Byzantine authority in Syria was the Sassanians from Mesopotamia. To counter this threat the Byzantines relied not only on the might of their legions, but also on a system of alliances with powerful Arab tribes such

Hippolytus Hall and the Church of the Virgin Mary, Madaba.

53

Umm al-Rasas, aerial view (Piccirillo, 1993).

the Banu Salih in the 5th and the Ghassanids in the 6th century. During the reign of Justinian (527-565), Byzantium abandoned the legionary camps and fortifications, which secured the areas along Trajan's Highway, the *Via Nova Traiana* (see Traders and Pilgrims), withdrew its troops and entrusted the defence of the frontiers to its Arab allies, the Ghassanids. This period saw a steady rise in the number of small towns and villages as well as the proliferation of churches and farmsteads with agricultural installations like wine and olive presses. It is possible that the countryside flourished at the expense of major towns, which from the 6th century shrank in size and were hit by a series of natural disasters in the form of earthquakes and successive waves of an epidemic plague (see Jerash). It is also debatable whether the withdrawal of the

Byzantine regular army from the fortified frontier (*limes*), leaving the Ghassanid allies in control of this frontier led to the relaxation of imperial laws and reduction of taxes, which contributed to the building boom of churches in towns and villages such as Madaba, Umm al-Rasas (Mayfa'a), Rihab, Khirbat al-Samra and Umm al-Jimal. It is important to keep in mind that during the 6th century, the "arabisation" of many areas in Syria, including Jordan and Palestine took place. Those Arab tribes originally from Yemen, were largely Christians and many of them were allied to the Byzantine Empire. In the Umayyad period these tribes were recruited by the Syrian army and by becoming the mainstay of the ruling dynasty they acquired privileged positions and wealth. This may explain in part the emergence of palatial residences in the

Belqa district (see Umayyad Administrative system) at sites such as al-Muwaqqar, al-Qastal, Umm al-Walid and Khan al-Zabib (see Palatial Residences).

Less than a decade after the expulsion of the Persians, Syria was again overrun, this time by the Arab-Muslim armies in the wave of the Islamic conquest of Egypt, Iraq and Iran. In 41/661 Damascus became the capital of the first Islamic Empire, with the establishment of the seat of the newly founded Umayyad government (see Historical Artistic Introduction). Until recently, accepted opinion was that the Persian invasion and subsequent Arab-Muslim conquest during the 1st/7th century was a time of substantial change and transformation. Generally, this change is seen in altered urban space: the shrinking of towns, encroachment on streets by makeshift structures, the use of *spolia* (stones taken from earlier monuments) in

new buildings, especially churches, and manifested in the failure to maintain civic amenities such as drains, aqueducts and public baths. It is becoming increasingly clear, however, that this change and transformation came about gradually having begun early in the 6th century. Subsequent historical events accelerated the process and it is clear that the changes were not the result of simple casual adaptations of existing structures but the outcome of conscious decisions made in response to a new concept of "the city". As bishops replaced the city councils and assumed the position of leadership, they worked, as a prominent scholar put it, for an ideal which was not the "good life" of the classical town but to enhance the spiritual "well-being" of the community. The building boom, in the 6th and early 1st/7th centuries, of churches seen in the cities and towns of Jordan did not change only

Umm al-Jimal, general view.

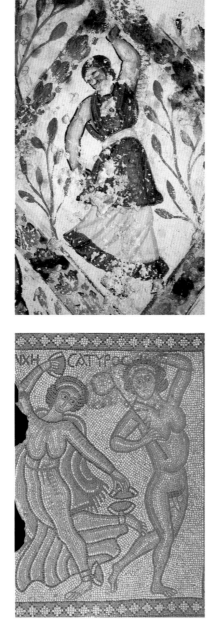

Qusayr 'Amra, dancing girl, al-Badiya, (J.L. Nou).

Bacchic procession, Madaba Archaeological Museum (Piccirillo, 1993).

the physical appearance of the towns but also contributed to the formulation of the city's Christian identity and in the Umayyad period this ecclesiastical "civic structure" remained largely intact. Not only did churches continue to serve as houses of worship, but new churches were built and paved, as before, with coloured mosaics, as seen at Madaba (Church of the Virgin), Ma'in, al-Quwaismeh and 'Ayn al-Kaniseh on Mount Nebo. What is remarkable in these churches is the continued use of Greek inscriptions with the indication of the Byzantine calendar year and the era of *Provincia Arabia* in the dedicatory panels. Such use strongly indicates continuity and little assimilation of the new Muslim rule by the local Christian communities. The phenomenon of building churches in the first Islamic period, which runs contrary to the legal opinion and formulation of Muslim jurisprudence, raises a terminological dilemma. Should these mosaics laid down in the Umayyad period for the use of the Christian communities be studied under the heading of Islamic Art? What is meant by Islamic Art in this case? Would it be more appropriate to label them "Christian-Islamic Art"? Perhaps it is safest to follow the suggestion of a leading scholar in Islamic Art and Architecture and use the word "Islamic" to refer to the culture of the civilisation in which the ruling class professed the faith of Islam and in whose milieu the diverse cultural assemblages were produced.

One of the changes brought about by the Arab-Muslim conquest was the migration of tribes of Arabian origin to new

settlements, which augmented the number of tribes already in Syria. The number of Arab immigrants were, however, no more than a small fraction of the total population of the region and the countryside remained largely Christian and agriculturally prosperous, except in the regions bordering on the Byzantine frontier in northeastern Syria. Artisans, craftsmen and farmers continued their normal life, albeit under new masters, and the affairs of cities and towns as before, were looked after by the bishops and their clergy. What is more important, however, is that the Arab-Muslim conquest removed the barriers between Iran and Mesopotamia on the one hand, and the Mediterranean World on the other, thereby producing an opportunity to mix the resources of two disparate civilisations and to bring about, for the first time since the conquests of Alexander the Great, the homogenisation of the Near East. The establishment of the Umayyad dynasty in Syria with Damascus as its capital, a province with a long history of artistic tradition, meant that the predominant artistic influences were classical or more precisely, orientalised classical elements. The commonly called Umayyad Desert Castles with their mosaics, frescoes and carved stucco show that the Umayyads had found a *modus vivendi* with the Syrian civilisation. The exuberant facade of Umayyad rule was shattered by the Abbasid revolutionaries who moved the seat of government to Iraq where the city of peace, Baghdad, (see Historical Artistic Introduction) was eventually founded as the capital of the new ruling dynasty.

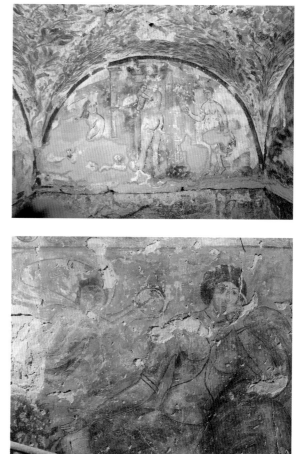

Qusayr 'Amra, bathing scene, al-Badiya (J.L. Nou).

Qusayr 'Amra, woman at a banquet receiving a wreath, al-Badiya (J.L. Nou).

57

الله لا إله إلا هو الحـ
ـي القيوم لا تأخذه سنة
ولا نوم لـه ما في
السموات وما في الأر
ض من ذا الذي يشفع
عنده إلا بإذنه يعلم
ما بين أيديهم وما خلـ
ـفهم ولا يحيطون بشيء من
علمه إلا بما شاء وسع كرسيه السموا
ت والأرض ولا يؤوده حفظهـما
وهو العلي العظيم

Amman, the Governor's Headquarters

Fawzi Zayadine, Ina Kehrberg, Ghazi Bisheh

Umayyad administrative system

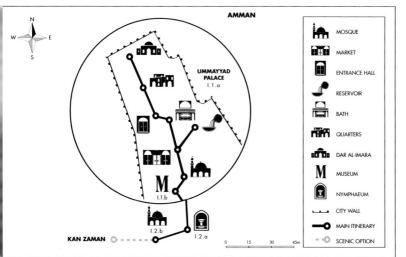

Stone engraved with Quranic verse from Amman, Jordan Archaeological Museum (Inv. Num. J 6383), Amman.

The site of Amman, ancient Rabbath Bani 'Ammon, was occupied as early as the Pre-Pottery Neolithic B (PPNB) period, around 8500-5500 BC. Excavations at 'Ayn Ghazal, at the northern entrance of Amman, unearthed a large settlement, more than 120 acres, containing houses with rubble foundations and provided with painted plaster floors. Thirty-two incomplete and fragmented statues were discovered together with busts and masks made of moulded plaster outlined with oxide paint. These unique works of local craftsmen find no contemporary parallels in the Near East except some plastered PPNB heads from Jericho and they demonstrate the early developed skills of the sculptors of this Neolithic Ammonite settlement.

Occupation of Amman in the subsequent periods was revealed mainly on the Citadel. This is a natural hill, 840 m. above sea level, protected by deep ravines, except on the north side where the Jabal al-Hussein's gentle slope constitutes a vulnerable approach. On this front, Middle Bronze II defensive walls were built in the 18th century BC. The Ammonite city extended to this rocky promontory where a huge water reservoir was carved and reached by a tunnel. Ammonite sculptures were found near this water reservoir. On the northern promontory, the Roman City walls are still standing. From there, the Citadel hill, which measures 400 m. x 250 m. extends from north to southeast in four terraces. Excavation on the lower third terrace revealed an occupation going back to the Neolithic period of around 5000 BC, suggesting that the 'Ayn Ghazal

people might have migrated to the Citadel. The southern slope of the third terrace is also protected by a Middle Bronze city wall, reinforced by a glacis, but perhaps best known is the fact that Rabbath Bani 'Ammon was settled properly first by Ammonite tribes who were probably of Amorite origin. A king of 'Ammon is mentioned in the time of the Judges of Israel (Judg. 11:12-33) and later references occur in the accounts of Saul and David. The first well-substantiated mention of the Ammonite kings, however, are recorded in the Assyrian Annals from the time of Shalmaneser III in 850 BC to the time of the Babylonian king Nebuchadnezzar II in 598 BC.

In the Achaemenid period, 5th century BC, Tobiyah was appointed governor of the Ammonite area. The family of the Tobiads reappears in the Hellenistic Ptolemaic period as tax collectors, in those days, a powerful position. In the 2nd century BC, a member of this family, Hyrcanus, built for himself a palace at 'Iraq al-Amir not far from Amman. At that time, Rabbath 'Ammon was renamed Philadelphia by Ptolemy Philadelphus in honour of his sister-wife Arsinoe Philadelphia. The Jewish revolt in the late Hellenistic period, led by the Hasmonaeans, brought destruction to the Hellenised cities east of the Jordan River, which Pompey later rebuilt. They became the nucleus of the *Decapolis,* an association of ten or more cities in Palestine, Jordan and Syria (see The *decapolis* in the Umayyad period).

After the annexation of the Nabataean kingdom by Trajan in 106 and the

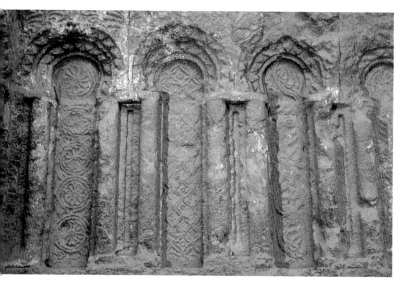

*Umayyad Palace,
carved blind niche in
monumental gate,
Amman.*

building of the *Via Nova Traiana*, Amman, then Philadelphia, prospered being situated along this Roman road between Damascus and the Red Sea. In the Antonine period, later in the 2nd century, Amman experienced a reorganisation as an urban centre based on a Graeco-Roman city plan, complete with an acropolis, temples and a lower city. Byzantine Amman flourished in the 4th and 5th centuries and several churches decorated with mosaics were built in the city. A renowned early historian, Malchus of Philadelphia, composed a history of Byzantium in about 500.

The decline of the city began in the late Byzantine period, around the mid- 6th-1st/ early 7th century, which aided the Arab Muslim troops, led by Yazid Ibn Abi Sufyan, to conquer Amman in 13/634, at the same time as the conquest of Damascus (see, for example, Early Islamic coinage and Umayyad Administrative System). The terms of capitulation were similar to those of Bostra in the Hawran, stipulating that the people, their wives, children and property would be safe, provided they pay the *jizya* or personal tax. It is not certain that this agreement was observed literally , since it was evident from the excavation of the upper citadel that the Byzantine quarter was replaced by Umayyad residences and a water reservoir.

The Citadel always had been the "symbol" of Amman and, therefore, the governors' headquarters. It appears obvious that the Umayyads retained this nucleus of the city for their own governor. As a capital of the Belqa, Amman became the residence of the governor in the Umayyad period (41/661-132/750).

It was reported that al-Walid II imprisoned his cousin, Sulayman Ibn Hisham, in

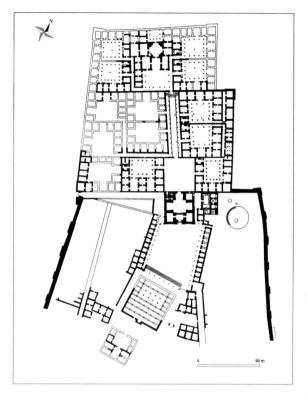

Citadel Umayyad Palace, Amman (Almagro, A. and Arce I., CHASM I, Suppl. SHAJ VII, f.c).

with it, suffered decline through the shift of the capital from Damascus first, then to Kufa and later to Baghdad.

F. Z

I.I AMMAN CITADEL

Lies to the north of the city centre (the point determined by al-Husseini Mosque). Open all day with free access to the site. The area can be reached from anywhere by taxi or service-taxi. Information: Jordan Archaeological Museum 06-4638795.

I.1.a Umayyad Palace

After they established their capital in Damascus, the Umayyads claimed the Citadel in Amman as the governor's headquarters. The upper terrace was reorganised and divided into three enclosed areas dominated at the centre by the Audience Hall, which was at the same time the Monumental Gateway. The spot held once, according to the excavators, the entrance or vestibule of a Roman building, reused in the early Byzantine period and built over by the Umayyads. The **monumental gateway**, which is almost square (24.40 x 26.10 m.), with a cruciform plan, is covered by a central dome and semi-domes on the arms of the cross. Two gates open from the south and north sides and two benches flanking the South Gate were probably intended for the guards. The interior is arranged around a central square (10.30 m. side length) from which extend the four arms of the cross. At each corner of the building are four

Amman, no doubt at the Citadel Headquarters. Being already well-placed as geographical centre and as the headquarters, the city was given an additionally important role in the Umayyad period because it became a main stopping point on a major road between Damascus and the holy cities of Islam, Mecca and Madina. This prosperous era (see Palatial Residences) was brought to an abrupt end through natural disasters: the epidemic of the plague and the catastrophic earthquake in 131/749. When the Abbasid revolt succeeded to topple the Umayyad dynasty in 132/750, the Belqa district and Amman

ooms: the southwestern room has a
tairway leading to the roof, while the
ortheastern room contains a flight of
teps to reach the northern side gate.
he passageway through this door leads
o the bath complex and the cistern.
he decoration carved into the stone
açade of the interior is remarkable and
overs several portions of the wall sections
aside the hall: the bottom of the walls, up
o 1,60 m. high, consists of two courses
f large ashlar blocks, probably reused
om a Roman building. A moulded cor-
ice separates the lower dado from a por-
on of blind niches, which are framed by
vo engaged small columns spanned by an
·ch that is decorated with indentations.
 cornice separates the lower segment
om a second row of larger blind niches,
ain flanked by miniature columns and
ecorated with medallions of palmettes or
osettes. A third section of smaller blind
ches repeats the design and terminates

the upper part of the wall. A frieze of
merlons crowns the façade. A covered
drain crosses the central space of the hall
from south to north. Another drain in the
southern enclosure opens into a circular
cistern. Water pipes fixed on the eastern
face of the wall collect rain water into the
circular water reservoir.

Early explorers of the last century identi-
fied the monument as "The Tomb of
Uriah" based on the biblical story in which
Uriah, the Hittite, found his death in front
of the walls of Rabbbath 'Ammon (see
Amman, the Governor's Headquarters).
Recent research, however, has recognised
it as the Monumental Gateway through
which one reaches the building complex in
the second enclosure. Although remains of
the buildings find their origin in the
Roman period, as is attested by the paved
courtyard and the enclosure wall decorat-
ed by niches, research of the monument
has shown that the remains were adapted

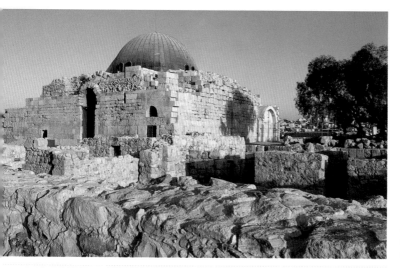

Umayyad Palace,
monumental gate,
Amman.

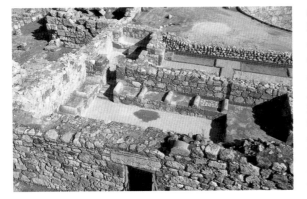

Umayyad Palace, bath, Amman.

Umayyad Palace, water reservoir and monumental gate, Amman.

are the gateway of the Umayyad palace c
Khirbat al-Minyeh on the Lake of Tiberia
(the Sea of Galilee) or the Audience Ha
of al-Mushatta, south of Amman. Th
Audience Hall of Khirbat al-Mafjar nea
Jericho is also comparable. The palace
popularly known as "Hisham Palace", i
attributed erroneously to Hisham Ibn 'Ab
al-Malik (105/724-125/743), who als
built a famous audience hall, similar to th
Amman vestibule at Rusafa in Syria. H
reign can be considered as the probabl
date for the building of the Amman palace
To the east of the Audience Hall, a **bat**
complex, recently excavated an
restored, consists of a disrobing roon
equipped with benches, a *tepidarium* wit
water basins and a *caldarium* heated by
furnace (see Qusayr 'Amra).
The **water reservoir** is a circular ci
tern, east of the Audience Hall and sout
of the Roman enclosure. It measures 1
m. across and is at least 5 m. deep. Th
retaining wall consists of 2 m. thick se
tions. The inner wall was built wit
masoned stone blocks and reinforced l
column drums. Two covered drai
empty into the water reservoir, fed l
pipes or gutters from the west roof of th
Audience Hall and from the north com
ing from the original Roman enclosur
The latter drain runs into a square shaf
which probably worked as a filtratic
sump. It is possible that the reservoir h
first Roman and then Byzanti
antecedents, and that these were lat
refurbished by the Umayyads. This su
gestion may be substantiated by the fa
that the building of the Umayyad rese
voir destroyed a Byzantine residenti

by the Umayyads for use as an Audience
Hall, comparable to the *Dar al-Imara* of
Abu Muslim al-Khurassani at Merv. An
earlier interpretation of the monument, as
a Byzantine church, was rejected due to
the character of its ornate decor of Persian
origin: the palmettes, rosettes and inden-
tations resemble the stucco decoration of
Sassanian buildings. Although the monu-
ment preserves clear Iranian-Sassanian
influence, the characteristic Sassanian style
may have come to Jordan through Iraqi
craftsmen after the Muslim Conquest. In
fact, close parallels within a short distance

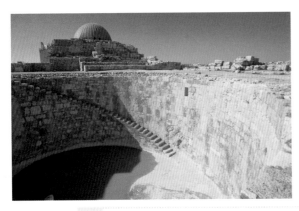

quarter which had been built around an olive-press system.

A long and systematic search for the location of the **mosque** belonging to the Umayyad governor's residence on the upper terrace was rewarded by its discovery in 1997. The monument was built on a raised artificial platform, southeast of the Audience Hall. It can be reached from the lower courtyard in front of the Audience Hall by a flight of monumental steps, leading to a portico of six columns. The northern façade of the mosque was decorated with buttresses and a frieze of small niches, some of them blind and others open. There was a doorway on the north wall and another on the south side; near the prayer niche, a third east doorway, reserved for the *imam,* is also possible.

The prayer hall is trapezoidal, 34.10 m. from east to west and 33.67 m. from north to south. It was paved with small, irregular stones and covered by a layer of lime plaster. The interior faces were plastered, probably, as can be seen from small fragments near the *mihrab*. This niche, in the long southern wall of the prayer hall, is 2.93 m. wide and has an inner diameter of 1.52 m. Two small pilasters once flanked the inner entrance of the niche. The prayer room has four aisles parallel to the *qibla* wall, with six columns in each aisle. In addition, there is a peristyle courtyard, which contains an underground cistern.

In front of the complex were 11 small rooms along each of the eastern and western sides of the courtyard, which were used as shops. A circular cistern in the centre of the courtyard was fed by chan-

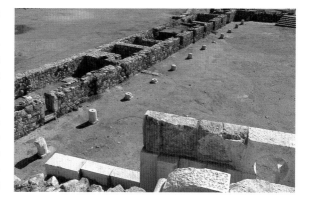

nels. One of them was linked with the mosque and collected the rain water for the cistern. Following the destruction by the massive earthquake of 131/749, the shops were converted into dwellings.

Opposite the northern entrance of the Monumental Gateway, a colonnaded street extends to the north and meets the gate of the enclosure. The cubic base of the columns and the first drums are monolithic. On one of those bases, a Byzantine cross was carved, a fact clearly demonstrating that the bases were reused from earlier buildings. The springer in the

Umayyad Palace, market, Amman.

Umayyad Palace, esplanade and colonnaded street of residential quarters, Amman.

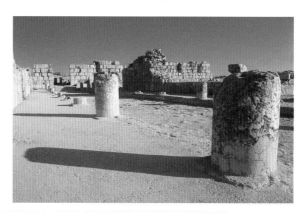

Umayyad Palace, residential complex, Amman.

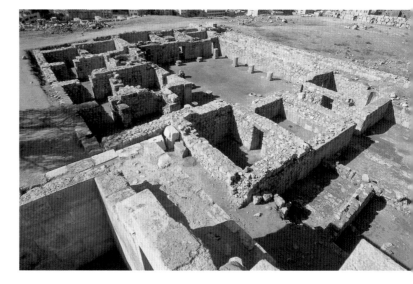

southern façade of the gateway indicates that the columns of the street were spanned by arches.

The eastern and western walkways of the Umayyad Street were once aligned with apartments. Three courtyards on the eastern side were enclosed by a portico with the same type of columns as the colonnaded street. Opening on to the courtyard are usually four rooms, some of them with a stairway leading to the terrace or to a second storey. In one of the courtyards to the west of the street, the skeleton of a camel was found, a victim of the earthquake of 131/749.

The northern gateway of the street leads to the **princely residence**. This official palace is entered through a vestibule, which was covered by a barrel vault. The floor of this vestibule is paved with cobbled stones, which was probably the bedding for a fine mosaic floor. The entrance of the vestibule was decorated with engaged columns, coated with stucco.

From the vestibule, the visitor proceeds to the "Throne Room", a cruciform chamber originally covered by a dome. The fragments of decorated blocks retrieved from the ruins indicate that this room was built by the same technique as the Monumental Gateway. The small rectangular unit to the south of the room was decorated with mosaics and was probably intended as a toilet. A doorway from the Throne Room leads to a portico toward the north, which overlooks the city toward modern Jabal al-Hussein. This side of the Citadel still has massive remains of the defensive walls from the Iron Age and Roman periods standing several metres high; below the Roman city wall and in the rock of the promontory, a water reservoir has been hollowed out.

The "Throne Room" is flanked by two sets of four rooms. To the east were probably the private apartments of the prince, originally coated with stucco. In one of the walls is a reused block with a Greek inscription dedicated to a Roman emperor, mentioning Philadelphia in Coele (Syria), which can be dated from the 2nd century and might have come from a temple.

To the west are another set of four rooms, which functioned as the storage and kitchen of the apartments. It is assumed that this building, which resembles the Dar al-Imara in Kufa, was the residence of the governor of Amman in the Umayyad period.

F. Z.

al-Walid, a forerunner of the Abbasid period. Its individual character lies mostly in the plastic applied decoration showing medallions of bearded stylised faces arranged on each side of a realistically rendered bust. The miniature relief shows a seated female figure reminiscent of the images of imperial couples on coins and other "Classical" representations on mosaics of the Byzantine period. The multiple handles arranged below the shoulder of the jar are also part of the decoration rather than functional. The vessel appears either to have had a ceremonial, rather than ordinary use, or was designed for a very particular household.

I.1.b Jordan Archaeological Museum

This national museum is located on the Amman Citadel and open from 8am-5pm on Saturday-Thursday and from 10am-4pm on Fridays and public holidays, during Ramadan from 9am-4pm. Excepting schools, there is an entrance fee. The exhibitions show archaeological artefacts from all periods and sites in Jordan, arranged in chronological order. Information: The Jordan Archaeological Museum 06-463795.

Storage vessel with applied decoration, Inv. Num. J 4982

The large jar is a singular piece, which fits a general typology by its form. The orange-beige ware and hand-painted red decoration, indicate that this vessel belongs to the late Umayyad period, not unlike the pottery found at Umm

Bronze and iron brazier from al-Fudayn (Mafraq), Inv. Num. J 15700, 15701, 15705

This 2nd/8th century bronze brazier is probably the most famous and complete

Storage vessel with applied decoration, Jordan Archaeological Museum (Inv. Num. J 4982), Amman.

of all Umayyad heating stands found in Jordan. Its perfection rests with the craftsmanship, the rendition of relief and figurines in the round. The combination of iron and bronze form a happy union as does the entire design. The arcaded sides remind one of the vaulted halls as at Qusayr 'Amra, and the erotic scenes depicted "within" recall the wall paintings of the baths. The eagles carrying the stand and the female nude figurines, standing 47 cm. high on their narrow pedestals, are part of the inherited Oriental iconography, which began in metal work as early as the Urartian bronzes of the 9th century BC.

Pottery jug from Dayr 'Ayn 'Abata (Cave of Lot), Inv. Num. J 16694

The pottery jug of cream ware is from the late Umayyad or early Abbasid period and has been found in the Church of St. Lot (Dayr 'Ayn 'Abata) which was still in use then as the repaving of the mosaic floor shows. The jug is of singular importance because it carries a band of Arabic inscription around its shoulder, making it one of the earliest pieces of epigraphy in Islam. The fact that the inscription was moulded reveals that this may be one of several pieces as it is doubtful that an inscribed mould or "roll-on stamp", the manufacture of which requires much skill and time for each application, was unique. The same may be said of the decorative broad band rouletted on the lower part (which is found also on fine Umayyad "white ware" pottery) of the body

Bronze and iron brazier from al-Fudayn, Jordan Archaeological Museum, (Inv. Num. J 15700, 15701, 15705), Amman.

Pottery jug from Dayr 'Ayn 'Abata, Jordan Archaeological Museum, (Inv. Num. J 16694), Amman.

68

*Steatite lamp from
al-Fudayn, Jordan
Archaeological
Museum, (Inv. Num.
J 19312), Amman.* *Stone incense burner
from Amman Citadel,
Jordan Archaeological
Museum, (Inv. Num.
J 1663), Amman.*

indicating the work off a potter of great skill and diversity.

Steatite lamp from al-Fudayn (Mafraq), Inv. Num. J 19312

The large mended fragment of an existing height of around 20 cm. belonged to an $2^{nd}/8^{th}$ century large lamp, which once stood on four feet. The soft steatite lends itself perfectly for carved decoration, which made the stone popular through all ages, including the Islamic period. Here the fragment shows an architectural decor in a style typical of the early Islamic buildings and reminiscent of the decoration on the contemporary bronze brazier also found at al-Mafraq. The finding of this lamp is also important because its decoration reveals the technique by which the incisions have been made and, therefore, some of the implements. It is evident that the maker used a form of compass to incise the multiple circles and the rosettes as well as the arches resting on the "walls".

Stone incense burner from Amman Citadel, Inv. Num. J 1663

This small replica of a domed audience hall or monumental gateway, the like of which can be seen on the Citadel itself belonging to the Governor's headquarters, is from the Umayyad period and shows all the architectural features attributed to an early Islamic structure. Basalt was used frequently for carving objects and sculptures from the 6th century

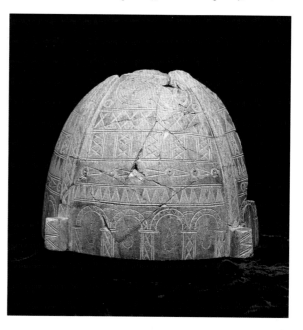

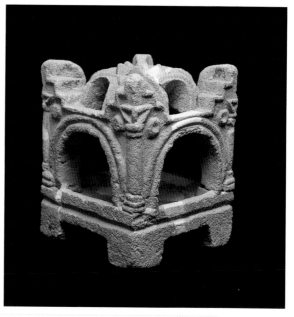

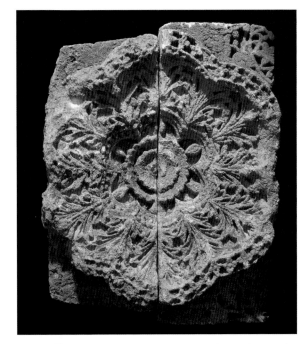

Fragment of frieze from Qasr al-Mushatta, Jordan Archaeological Museum, (Inv. Num. J 16585), Amman.

fretwork-like carving composed of acanthus leaves, which reveals the Classical heritage of architectural decoration seen in most Umayyad palatial residences. The skill of the stone masons, who carved the al-Mushatta monumental facades, is evident not only in the technical detail, but equally in the composition of motifs. Classical motifs going back to the Roman period (like the acanthus leaves) were not just copied but selected and arranged within a new syntax giving the Umayyad decor a particular two-dimensional quality, which was to become the hallmark of Islamic architectural ornamentation.

I. K.

I.2 CITY CENTRE (THE *SUQ* OR DOWNTOWN)

and increased in popularity during the $1^{st}/7^{th}$ and $2^{nd}/8^{th}$ centuries, not only in basaltic regions (Umm Qays, the Hawran). One may find carved basalt in Jerash and Amman where there is little natural outcrop of this type of rock, which may indicate that the pieces were brought there ready-made or the virgin stones were imported for local sculptors and masons.

Fragment of frieze from Qasr al-Mushatta, Inv. Num. J 16585

The sculpted façades of the earlier Umayyad *qasr*, most of which are exhibited in the Pergamon Museum in Berlin, are famous for their ornate quality of almost baroque dimensions. The rosette shows

Can be reached from the Citadel by taxi or service-taxi heading downtown.
Some of the restored Roman monumental structures of the Decapolis era were occupied by inhabitants during the Umayyad period.

I.2.a *Nymphaeum*

This Roman monument is close to the theatre by Quraysh Street in the Suq but less accessible being hidden by private houses and shops. It can be visited at any time during the day all week free of charge. Information: Dept. of Antiquities office at the site 06-4644921.

At the junction of the ancient north-south street (the Roman *cardo*, modern Hashimi

Street) and the east-west street (the Roman *Decumanus*, modern Quraysh Street) stands the *Nymphaeum* on the perennial stream of Amman (Seil). The monument is semi-octagonal and built over four vaults through which the water flowed at the southern end. The monument consisted originally of three stories with three semi-domed apses, each of them being flanked with a recess, which contains two tiers of scalloped niches. There is no evidence that water pipes led to the niches, nor of an outlet or spout as is the case at the Jerash *Nymphaeum*. The comparison between the two edifices is inappropriate and the identification of the Amman monument as a *Nymphaeum* highly questionable. A Greek dedicatory inscription found in the Amman theatre has been translated as: "To the nymphs and Muses, Capitolinus dedicated me". The nymphs and the muses are frequently associated in Greek mythology and Capitolinus, the dedicator, could have been the governor of the *Provincia Arabia*, in the mid-3rd century, but there is no evident relation with the *Nymphaeum*. Instead, the monument was part of the urbanisation plan of Amman (Philadelphia) in the Roman period of the 2nd century, together with the theatre and the forum, and was built either at the end of that century or the beginning of the 3rd. There are similar contemporary monuments in Syria (Shahba, Philipopolis), designated by the inscriptions as "*calibè*", and dedicated to the glory of the imperial family.

A frieze of human and animal busts originally set on the front colonnade was found reused in the later buildings in front of the monument. A church of the Byzantine period reused the central apse of the monument and a lintel decorated with a cross has been found among the reused blocks. There is also much reoccupation in the Umayyad and later Islamic periods, consisting of small rooms, probably shops, built on the southern side to which belongs a large enclosure and a cistern in the courtyard. Since the *Nymphaeum* is located in downtown Amman and with the stream running under it, there seems to be no doubt that it served in Islamic

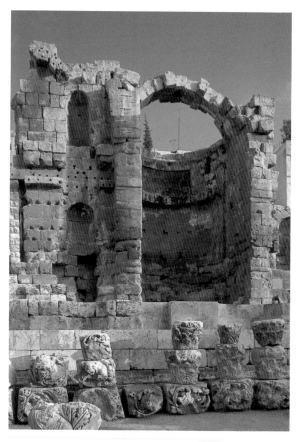

Nymphaeum, general view, Amman City Centre.

71

times as a station for wayfarers and pilgrims. The nearby congregational mosque (see al-Husseini Mosque) certainly attracted the inhabitants of the city as did the main market of Amman, which was, and still is, located in the same area.

F. Z.

I.2.b Umayyad Congregational Mosque (al-Husseini Mosque)

Lies in the heart of downtown Amman in the area, named for the mosque. The mosque is permanently open for prayer and visitors may enter any time during the day.

In his description of Amman, al-Muqaddasi (d. 375/985) writes, "(...) the city lies on the border of the steppe (...). There is, in the city, at the end of the marketplace a beautiful mosque (*zarif*), the nave of which is paved with mosaics". This monument, fortunately, was described and photographed by several explorers of the last century, the earliest of whom is Warren in 1867. The latest author to describe the monument was K.A.C. Creswell in 1920, before it was rebuilt as the modern al-Husseini mosque during the British mandate in 1923 by Amir Abdallah Ibn al-Hussein.

According to the early descriptions, the mosque measured 57.10 m. x 39.70 m., while the prayer hall was 39.70 m. x 14 m. The northern wall was built with finely dressed ashlar blocks and was 1.55 m. thick. Three entrances opened onto a portico, originally covered by beams, which were wedged in the upper course. Such a portico is also known from the al-Umari mosque at Bostra in the Hawran (modern Syria). Four windows, two of them pierced and two blind, interrupt the northern facade. A square minaret at the western corner of the outer wall was accessible by a spiral staircase, which reached a small room lit by four windows. This arrangement of the upper room resembles the tower of Umm al-Rasas (Mayfa'a), which shows a square tower of a stylite terminating in a small domed room (see Umm al-Rasas, Mayfa'a).

The nave of the prayer hall was terminated to the south by a niche (*mihrab*), set into a salient. There was another, smaller niche inside it, for this prayer niche was extremely wide (3.58 m. in diameter). This second

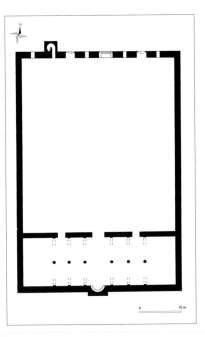

Al-Husseini Mosque, Amman (Northedge, 1992).

mihrab was added later and the problem of dating the different building phases has been discussed by various scholars. The original construction of the monument was Umayyad, since the round arches of the portals are similar to the construction technique of the Umayyad mosque in Damascus, at Bostra in Hawran and to the mosque of Qasr al-Hallabat in Jordan. A Kufic inscription found in the mosque mentions that it was built under the direction of the commander (*qa'id*), Hassan Ibn Ibrahim. This personage is not known historically, but it seems that the script is probably Abbasid. The commander might have been a general from the time of the Fatimid or Abbasid period. The minaret is thought to be a later addition, probably of the 4th/10th century or even later.

The mosque in the lower city was certainly intended for a large Muslim community, since it was close to the market place, while the mosque on the citadel was intended for the prince and his entourage in the residential area of the Citadel. The actual date for the Umayyad mosque of the lower city has been suggested to be between the reign of 'Abd al-Malik Ibn Marwan and Yazid Ibn 'Abd al-Malik (65/685-105/724).

F. Z.

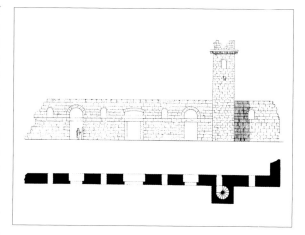

Al-Husseini Mosque, reconstruction plan, Amman (Northedge, 1992).

Khirbat Abu Jaber (Kan Zaman)

Is 40 km. to the south of Amman in the al-Yadoda area. The easiest way to reach it is by taxi or private car. A commercialised recreation of a Byzantine and Islamic village and caravanserai, *Kan Zaman constitute a popular recreational resort for the inhabitants and visitors of Amman. The reconstructed village, with its overtones of Islamic domestic architecture, can boast of a charming "ancient street" with shops, showing traditional crafts, and displays of 13th/19th century rural implements.*

Information: Kan Zaman 06-4128393.

Ghazi Bisheh

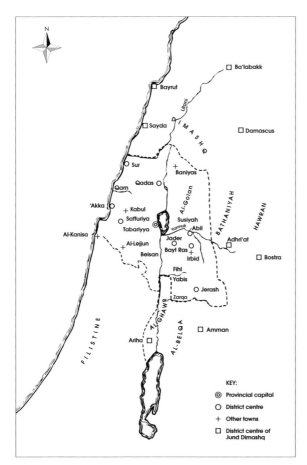

Map of the Ajnad (A. Walmsley, Aram 4/1&2, 1992).

In the course of the 4th century the territories of Palestine, the area south of Wadi al-Hisa in Jordan and the Negev desert were divided into three provinces: *Palestina Prima* with its capital Caesarea, *Palestina Secunda* with its seat at Scythopolis (Beisan) and *Palestina Tertia-Salutaris* with Petra. Later, towards the end of the 6th century Areopolis (Rabba) was the capital. The territories north of Wadi al-Hisa

remained within the Province of Arabia. The capital was Bostra in southern Syria. In the 6th century most of the frontier fortifications in Palestine III were abandoned and the duty of maintaining peace and order was assigned to allied Arab tribes under the hegemony of the Ghassanids (see Historical Artistic Introduction and The Umayyads: The Rise of Islamic Art). Unfortunately, we know almost nothing about the administrative arrangement during the Persian occupation (614-7/629). Likewise, it is difficult to understand precisely the structural transformations, which resulted from the Arab-Muslim take over. This is largely due to the limited source materials from the Arabic accounts written in the 3rd/9th century long after the fall of the Umayyad dynasty. Soon after the Arab-Muslim conquest, Syria was divided into four military provinces (*Ajnad*; sing. *Jund*). These, from north to south, are *Hims* (Emesa), *Dimashq* (Damascus), *al-Urdun* (Jordan) with its centre in *Tabariyya* (Tiberias) and *Filistine* (Palestine) with its capital in *Ludd* (Diospolis). During the reign of Yazid I (60/680-64/683) a fifth *Jund,* known as *Jund Qinnisrine* (Chalchis), was established. The geographical location of these military provinces, which ran east-west from the Syrian steppe to the Mediterranean coast, each with its coastline and ports, suggests a defensive arrangement against any counter attacks by the Byzantines. It has been argued recently that the *Ajnad* system reflects not the provincial division of the 6th century, but follows the reformed civil and military administration of Syria set up by Heraclius in the period

between 7/629-12/634. Others have claimed that the *Ajnad* system was a completely new Arab invention. The fact is that Jordan was divided between two *Ajnad*: Dimashq and *al-Urdun*. The hill country north of Wadi al-Zarqa, later known as Sawad al-Urdun, belonged to the military province of Jordan. Its boundaries corresponded to the civic province of Palestine II but included in addition to the coastal cities of *Sur* (Tyre) and *'Akka* (Acre) together with the western portion of the old *Provincia Arabia*, the *Decapolis* cities of Abila (*Quwailbeh*), Gadara (*Jader/Umm Qays*), Capitolias (*Bayt Ras*) and Pella (*Fihl*). To the west of the Jordan River, the main cities of this province were: Sepphoris (*Saffuriyah*), Qadas, Tiberias, the capital city, and Scythopolis (*Beisan*). The remainder of the territories extending from Adhri'at (Der'a) through Amman to Ayla (Aqaba) formed the Belqa district, which was part of Jund Dimashq with Amman as its main city. Often the southern boundary of Belqa is placed in Wadi al-Mujib or Wadi al-Hisa. It is reported, however, that when the last Umayyad *caliph* Marwan Ibn Muhammad heard of the subversive activities of the Abbasids in al-Humayma, he wrote to the governor of Damascus ordering him to collect Ibrahim Ibn Muhammad al-Imam from al-Humayma. The governor in turn ordered the *'Amil* (governor) of the Belqa, Sufyan Ibn Yazid al-Sa'di to arrest Ibn Muhammad al-Imam. The latter duly obeyed and proceeded to al-Humayma, arrested Ibrahim Ibn Muhammad al-Imam and sent him to Damascus; then hurriedly he was packed off to Marwan in the *Jazirah* where he was put to death. This report indicates that the area as far south as al-Humayma was part of the Belqa district, which formed a sub-governorate of *Jund Dimashq*. The Belqa in turn was subdivided into smaller administrative units (*Kuras*): Ma'ab, the hilly territory between al-Hisa and al-Mujib with its main city at *Rabba* (Areopolis); *Jibal* (Gabalitis), which included the mountains of Tafilah with Gharandal (Arandela) as its chief city; al-Sharat, which marked the southern limit of Belqa, east of the Jordan Rift Valley, with Udhruh (Augustopolis) and al-Humayma as its main cities; and *al-Ghawr* (the rift) with Zughar in al-Safi, south of the Dead Sea, as its centre.

The Belqa is located centrally to form a natural gateway connecting the Arabian Peninsula, the location of the two holy cities of Mecca and Madina, with Syria, Egypt, Palestine and Iraq. The overriding importance of this military district in the policy of the Umayyads, therefore, is reflected in its inclusion within the territories of *Jund Dimashq*.

The Umayyads and their Christian Subjects

Ghazi Bisheh, Ina Kehrberg, Lara Tohme, Fawzi Zayadine

Iconoclasm
Concept of Byzantine and Umayyad Iconography
Christian Pilgrimage Road from Jerusalem to Mount Nebo through the Baptismal Site

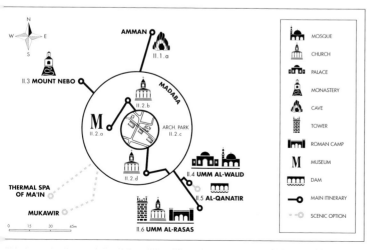

Church of St. Stephen, Kastron Mefaa, Umm al-Rasas (Piccirillo, 1993).

77

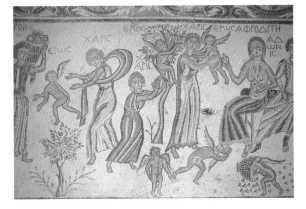

*Hippolytus Hall,
Aphrodite, Adonis and
Cupids, Madaba
Archaeological Park.*

*Church of St.
Stephen, interior view,
Umm al-Rasas.*

The 6th and early 1st/7th centuries were filled with a remarkable upsurge in the construction of churches in Jordan. Most of these churches survived remarkably well the military campaigns of the around 10/630's, which brought the Arab-Muslims into Syria (see The Umayyads: The Rise of Islamic Art). Archaeological research in the last 15 years has shown that no less than 56 churches in Jordan continue to be used well until the f. h. 2nd/mid-8th century and after, and no fewer than eight churches were built or repaved with coloured mosaics in the

Umayyad period (41/661-132/750). The countryside in particular remained populated and prosperous; the peasants and artisans continued their normal life albeit under new masters. One factor making for continuity was Christianity, which was the singular and important element in maintaining the cohesion and solidarity of the inhabitants of towns and villages. Each community preserved its own laws and customs as well as keeping its leaders. It seems that the ecclesiastical structure of some bishoprics, like the bishopric of Madaba, substantially remained intact until the end of the 2nd/8th century, and that the unity of the city and its territory was maintained by the authority of the bishop, which extended to both. It also appears that throughout the 1st century of Islam, the population of Jordan remained overwhelmingly Christian, while the number of Muslims, who formed a religious military elite, remained small. This is indicated by the large number of churches, which continued in use in the Umayyad period, and by the small number and size of the mosques (for example al-Qastal, Umm al-Walid, Khan al-Zabib) which were built in the same period. The Christians were not excluded from government posts. Good politicians counselled a broad tolerant policy for the majority of the population who were still Christians. The new regime's priority was to maintain order and social stability in order to preserve economic stability and growth. This could only be achieved through flexible and tolerant policies which, as a result, led to substantial contributions by Christians in the formation of Islamic art and culture. A brief mention should be made here of the

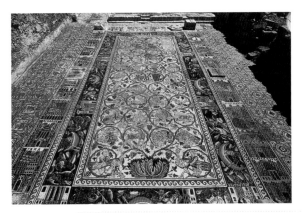

Cave of the Seven Sleepers, general view, Amman, (al-Rajib).

disfigurement of living beings portrayed in many mosaic pavements, which is sometimes attributed to an edict issued by the Umayyad caliph Yazid II in 102/721 (see conoclasm). The fact that the edict, however, is known exclusively through Christian writings produced in Egypt and considering its absence from the early Arabic sources, should make one view this report with scepticism. After all, the frescoes of Qusayr 'Amra, with their rich repertoire of figural representations, are close to Muwaqqar, the official residence of Yazid II. Yet, these representations show no trace of mutilation or deliberate damage.

G. B.

I.I AMMAN

I.1.a Cave of the Seven Sleepers

s situated in the village of Rajib about 7 km.

south of the centre of Amman and about 4 km. east of the intersection at the Jordan Television Centre along the Desert Highway.
The site is best reached by taxi or car taking about 15 minutes. A longer route is by service taxi departing from Wehdat bus station heading to the southern part of Amman.

The Cave of the Seven Sleepers is situated in the village of Rajib, southeast of Amman, dug on a hillside replete with late Roman and Byzantine tombs of the *arcosolia-loculi* type. The tale of the Seven Sleepers is known around the world and mentioned in Syriac, Latin, Greek and Arabic sources. It is a pious story of Christian youths persecuted by a pagan Roman emperor for their faith and saved from death by being put into a long sleep, which lasted for centuries (309 years, according to Muslim tradition). When they awoke, the world around them had become firmly Christian. Their miraculous appearance presented proof of God's ability to resurrect both the

Cave of the Seven Sleepers, arched recess with decorated sarcophagi, Amman, (al-Rajib).

In the early 6th century, a small church was built over the cave which was later converted into a mosque. The column bases in the nave of the church are still evident, although the mosque entrance was made in the east at the apse. Another mosque was built in the area in front of the cave entrance. This area was enclosed and a *mihrab* was incorporated into the south wall. This mosque underwent several reconstructions including one dated 277/890-891. The cave is entered through a narrow doorway and three steps carved out of the rock. Above the doorway are five medallions the central one showing a Greek cross. On each side of the entrance there are semi-engaged columns, a capital and a scalloped niche. Inside the cave are two arched recesses with three sarcophagi in each. The sarcophagi are decorated in high relief carved with motifs of intersecting squares, which form eight-pointed stars, as well as egg-and-dart and bead-and-reel patterns.

G. B.

II.2 MADABA

soul and the body. Islam came to share the same Christian parable of faith and devotion, for the same story forms the text of one of the chapters (Suras) of the Qur'an (Qur'an XVIII: Sura of the cave). It reads, "*Or dost thou think the Men of the Cave and al-Raqim were among our signs a wonder? When the youths took refuge in the cave saying, 'Our Lord, give us mercy from thee, and furnish us with rectitude in our affair'. Then we smote their ears many years in the Cave*".

Lies 30 km. southwest of Amman. Buses for Madaba and beyond depart from Wehdat, Raghadan and Abdaly bus stations. The route is along the Airport Highway. An alternative attractive road goes through Na'ur and Hesban. Information: Office of the Ministry of Tourism and Antiquities 05-543376, located in the Burnt Palace area and Dept. of Antiquitie. office at Madaba 05-544056 or 05-544189.

The city of Madaba originated in biblica

times, but this "City of Mosaics" is most famous for its seat of a Byzantine bishopric and for the centre of a mosaic school. During the Roman-Byzantine period, Madaba was part of the *Provincia Arabia*, which was drawn up by the Roman emperor Trajan after the Roman conquest of the region. After the Arab-Muslim conquest in the early $1^{st}/7^{th}$ century and during the Umayyad period, Madaba became part of the Belqa, which was under the jurisdiction of the military province of Damascus. Both archaeological and literary evidence points to the fact that the population and importance of Madaba declined after the $3^{rd}/9^{th}$ century. The reoccupation of the city by 90 Christian families from Karak, led by two Italian priests from the Latin Patriarchate of Jerusalem in 1297/1880, saw the start of archaeological research in the city.

L. T.

I.2.a Madaba Archaeological Museum

Is centred in the town of Madaba. It is open from 9am-5pm (summer); during winter, public holidays and Ramadan from 9am-4pm. Excepting schools, there is an entrance fee. Information: Madaba Archaeological Museum 05-544056 or 05-544189.

The museum is part of a group of tradiational houses and displays various aspects of Jordanian culture. The archaeological collections come from the Madaba region, in particular finds from Umm al-Rasas and Umm al-Walid of the Umayyad period.

Small kettle from Umm al-Walid, Inv. Num. 668

This intact kettle is almost 14 cm. tall and made of leaded bronze. Its charm rests with the zoomorphic shape reminiscent of a camel bearing a load or chair. The tripod held the kettle above the glowing charcoal in a brazier to heat its contents, which were poured through the mouth of the "camel", the spout. The bronze vessel belongs to the period of transition between the Umayyad and Abbasid dynasties, somewhere i.e. between the $2^{nd}/8^{th}$ and $3^{rd}/9^{th}$ centuries.

Pottery Jar from Umm al-Walid, Inv. Num. 793

The Umayyad jar is unique for its

Small kettle from Umm al-Walid, Madaba Archaeological Museum, (Inv. Num. 668).

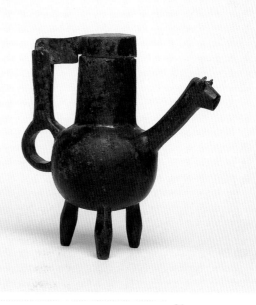

undamaged state and is extremely rare for its green thick glaze. The green began to appear then and the amphora could have been part of an exotic table ware or at least a show piece for "wining and dining", fitting the scenes painted on the walls of Qusayr 'Amra of the same period. The form is typical of the Classical period closely linked with its Greek antecedents. The vase was imported, perhaps from Iraq where Islamic glazed ware became highly prized possessions and began to appear on markets throughout the eastern Mediterranean.

Hand-Painted jars from Umm al-Walid, Inv. Nums. 659-661)

The three jars are made of orangey-beige ware with dark reddish brown geometric designs. This type of ware signifies the period at the very end of the Umayyad dynasty and it became the hallmark for the succeeding Abbasid potters ($2^{nd}/8^{th}$-$3^{rd}/9^{th}$ century). The hand-painted decoration is applied lavishly in broad sweeping lines and the sketchy work, where "speed" seems to be of the essence, is the true breakaway from earlier Classical tradition of making and decorating ceramics. At the same time, and parallel to this development, are introduced the finer glazed wares, which gain increasing importance as the painted ware decreases in quality of execution.

Lintel with hunting scene from Umm al-Walid

The shallow stucco relief of a panther chasing a gazelle once adorned the lintel

Pottery jar from Umm al-Walid, Madaba Archaeological Museum, (Inv. Num. 793).

Hand-painted jars from Umm al-Walid, Madaba Archaeological Museum, (Inv. Nums. 659-661).

for the gate of the Umayyad *qasr* at Umm al-Walid. This rare work of art is two-dimensional in aspect and impresses the viewer more like a painting than a relief. The contrast between smooth incised and "drawn" surfaces against a roughened background should be appreciated from the original position the "picture" once held, i. e. at a sufficient distance from the viewer to observe the stark contrasts of silhouetted lines. This deliberate play with shadow and light and the drawing of the animals themselves, recalls the puppets from shadow plays, which became immensely popular during the late Islamic period. The scene is also a reminder of the animals that were still extent in the wilderness during the Umayyad period and were subject to the hunts organised by the courts.

I. K.

II.2.b St. George, the Church of the Map

St. George, the Church of the Map, is in the city centre close to the Madaba Rest-house. Open 8am-6pm.

One of the major archaeological finds in Madaba is the 6th century Madaba Mosaic Map found during the construction in December of 1313/1896 of the Greek Orthodox Church of St. George on the site of an earlier church. The Church of St. George is located to the north-west of the partially excavated Roman Street (see Madaba, Archaeological Park). The map originally depicted an area extending from the Egyptian Delta in the south to the Levantine coast in the north, including the cities of Tyre and Sidon. Even though only a quarter of the original map has survived, the Madaba Mosaic Map represents one of the most important archaeological discoveries in the Middle East. The significance of the map lies in its details and in its geographical accuracy. Essentially a document of biblical geography based on the *Onomasticon* of Eusebius, written in the 4th century, the Map was probably intended as a guide for Christian pilgrims to the "Holy Land" or, as some scholars maintain, a representation of the "promised land" as reportedly seen by Moses. A total of 157 captions in Greek accompanied with illustrations

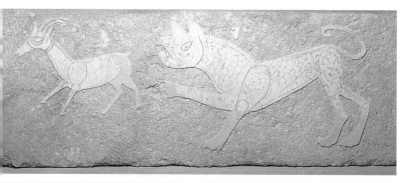

Lintel with hunting scene from Umm al-Walid, Madaba Archaeological Museum.

83

Church of St. George,
Mosaic Map,
representation of
Jerusalem, Madaba.

identify important religious sites. The Map covers the territory of the 12 biblical tribes of Israel and the surrounding regions, which in Byzantine times were believed to be the boundaries of the "promised land". The Map is oriented to the east, with the Jordan River and the Dead Sea forming the central axis. The highlight of the Map is the detailed bird's eye view of Jerusalem. The walls and gates of the city, its *cardo maximus* running north-south (left to right on the map) through the centre and its principal buildings are clearly discernible, including the Constantinian complex of the Holy Sepulchre halfway down the *cardo* and two large basilicas toward its southern end. The city of Jerusalem is represented as the centre of the Christian world. The detail elsewhere on the Map is as meticulous, for example, the fish swimming in the River Jordan, two boats on the Dead Sea, palm trees at the oasis of Jericho, tributary rivers, mountains, the sea.

L. T.

II.2.c **Archaeological Park**

Is located in centre of the town, 300 m. to the west of the Church of the Map and includes archaeological sites. Opening hours are from

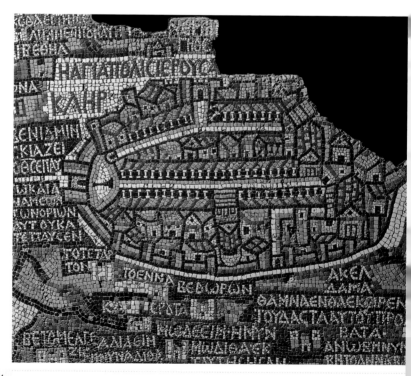

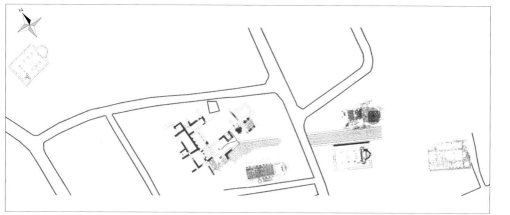

Madaba City
(Piccirillo, 1991).

8 am-6 pm (summer) and in winter from 8 am-5 pm; on public holidays from 10 am-4 pm. The entrance fee includes the visit to the Archaeological Park, the Museum and the Church of the Apostles. The park houses the "School of Mosaics", various churches and part of the Roman Road. Information: Madaba Archaeological Park 05-546681.

A large archaeological park dominates the centre of the city of Madaba. The Madaba Archaeological Park runs along the Roman road (decumanus) that crosses the city. The park includes several buildings (both secular and ecclesiastical) that date to the late Byzantine and Umayyad periods. These buildings include: the Church of the Virgin and the Hippolytus Hall, the Church of the Prophet Elias and the Crypt of St. Elianus, the Church of al-Khadir, the Burnt Palace and the Church of the Sunna Family. The park also houses an impressive selection of mosaics discovered in the Madaba region. These include a section from the oldest mosaic pavement found in Jordan, dating

from the 1st century BC found at the Herodian fortress at Machareus. Other mosaic panels, exhibited, include those from the upper mosaic of the Church of Masuh (6th century), panels depicting several cities of the region from the Umayyad-era from the Acropolis Church of Ma'in (2nd/8th century), and the Hall of the Seasons from Madaba (6th century).

The **Church of the Virgin** and the surviving parts of the Hippolytus Hall are housed within a large modern structure with walkways around the inside. The church was built in the late 6th century over a late 2nd-early 3rd century Roman temple to which a hall had been added in the early 6th century (the commonly called Hippolytus Hall). Covering the floor of the circular central nave of the Church of the Virgin, which corresponds with the podium of the Roman temple, is an intricate mosaic. The floral designs around the outer borders of the mosaic date from the late 6th-early 1st/7th century, while the central square enclosing a circular medallion was

85

Ma'in Acropolis Church, representation of Gadoron, Madaba Archaeological Park.

Church of the Virgin, central inscription, Madaba Archaeological Park.

personifications of the four seasons at each corner. Along the east wall, outside the border of the main mosaic, the cities of Rome, Gregoria, and Madaba are personified as three Tyches, each seated on a throne and holding a cross on a long staff. To one side of them is a small medallion with three sandals surrounded by four birds while on the other side are different creatures and birds. The central section of the mosaic consists of three panels. The bottom panel contains depictions of flowers and birds and the central panel shows characters from the Greek tragedy of Phaedra and Hippolytus (as recounted in Euripides' Hippolytus, hence the name attributed of the hall). A Greek inscription identifies each of the characters. Parts of the mosaic were destroyed when the hall was divided into two rooms at a later date. The top panel depicts a vignette involving the goddess Aphrodite and Adonis accompanied by several cupids and the Graces.

The Church of the Virgin and the Hippolytus Hall border the Roman *decumanus*, a section of which has been excavated revealing the large flagstones with which it was paved. Running roughly east-west this road would originally have linked two of the city gates and were once colonnaded. The street was covered with beaten earth during the Byzantine-Umayyad periods. Many columns were reused in later structures, both in antiquity and in more recent times.

On the other side of the *decumanus* is the **Church of the Prophet Elias**. This church was discovered in 1314/1897 and a fragment of mosaic flooring was uncovered near the steps leading to the

added later during the early Abbasid period by the bishop Theophane of Madaba. The date of the dedicatory inscription is incomplete, but is believed to be 138/756. The **Hippolytus Hall** contains a well-preserved mosaic, one part of which formed the floor of a private house, which was excavated in 1982. The borders consist of acanthus scrolls and hunting scenes, with

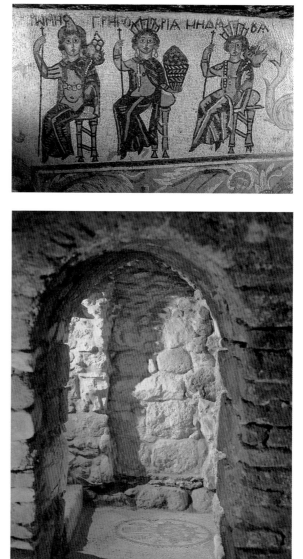

Hippolytus Hall, portrayals of Rome, Gregoria and Madaba, Madaba Archaeological Park.

presbytery, which included a dedication referring to the Prophet Elias and dating the church to 607-608. The church suffered damage during the early part of this century and today only the apse of the church is discernible along with traces of the mosaics, which covered the floor of the nave and side-aisles. Beneath the apse is the Crypt of St. Elianus with further traces of surviving mosaics and an inscription, dating the crypt from 595-596. The archaeological park also houses the **Church of al-Khadir**, the **Church of the Sunna Family**, and the **Burnt Palace**. The 6th century Basilica of al-Khadir (Martyrs' Church) suffered damage from iconoclasts in the 2nd/8th century but much of the intricate mosaic decoration, depicting hunting and pastoral scenes, still survives. The Church of the Sunna Family is a small church also dating from the 6th century. It has three aisles and a central apse. Only the mosaic floors of the southern aisle, portions of the nave, and a small portion of the northern aisle have survived. The commonly called Burnt Palace was a large residential complex, on the north side of the Roman Street opposite the Church of al-Khadir. This lavishly decorated palace dates from the late 6th to early 1st/7th century. Perhaps its destruction by fire was linked with the earthquake of 131/749. Also, within the archaeological park, though not open to the public, is the recently established Madaba Mosaic School, a joint Italian-Jordanian project aimed at training people in the art of making and restoring mosaics.

L. T.

Crypt of St. Elianus, south landing, Madaba Archaeological Park.

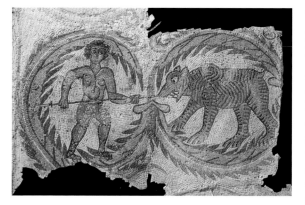

Burnt Palace, hunting scene, Madaba Archaeological Park.

Church of the Apostles, border foliate mask, Madaba.

II.2.d Church of the Apostles

A modern protective building encloses the Church of the Apostles, located on the southern edge of the city of Madaba. First discovered in 1319/1902, the text of an inscription in a room at the eastern end of the church (now lost) provides the construction date of 578 and reveals that the church was dedicated to the Apostles. A large mosaic of a border of acanthus leaves enclosing a geometric pattern of birds and plants covers the nave. In the centre is a medallion with a female personification of the sea represented by Thalassa, emerging from the waves and surrounded by fish and sea monsters. Both side-aisles of this church are decorated with geometric patterns. On the north side are two small chapels. The first contains a mosaic consisting of four trees oriented toward the centre and dividing the square into four triangles, each with a pair of animals, and at the top a dedication refers to the "Temple of the Holy Apostles". The other area consists of a smaller rectangle girdled with a floral mosaic with various trees, flora and a bird in the centre.

L. T.

II.3 MOUNT NEBO (SIYAGHA)

Is situated 10 km. to the west of Madaba and can be reached by taxi or private transport. Open 8am-5pm with an entrance fee.

The site of Mount Nebo lies northwest of Madaba, bounded on the southeast by Wadi Afrit and on the north by Wadi 'Ayoun Mousa. Mount Nebo's highest point reaches an altitude of 800 m. above sea level. Its other peaks are only slightly lower; of them, the two most historically important are the western peak of Siyagha and the southeastern peak of al-Mukhayyat. The view from

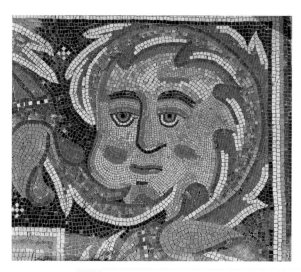

Mount Nebo is spectacular. To the south the panorama extends over the Dead Sea and the ancient Judaean Desert. Looking to the west, the view encompasses the Jordan Valley with the hills of biblical Judea and Samaria. The hills around Amman are plainly visible in the distance, as are the steep limits of the Hesban plateau and the mountain of Mushaqar. On clear days, one can pick out Bethlehem, and not far from there the singular cone that was once Herod the Great's fortress of Herodium, as well as the towers and buildings of Jerusalem from the Mount of Olives to Ramallah.

Habitation on the mountain goes back thousands of years, as the dolmens, menhirs (tall standing rocks), flints, tombs and fortresses from different epochs testify. The real fame of Mount Nebo, however, is derived from the final vision and death of Moses described in *Deuteronomy* 34. Until the 4th century, the name "Nebo" was also given to the fortified village that sits astride the peak of al-Mukhayyat. In the Old Testament the village is mentioned along with other cities of Moab. On the peak of Siyagha, the Christians of the region constructed a memorial church in honour of Moses as early as the 4th century, which became a popular pilgrimage site. The sanctuary became a main attraction for pilgrims from all over the Christian world. For example, the chronicles of the Roman pilgrim Egeria (travelling sometime between 381 and 384) and the writings of the bishop of Gaza, Peter the Iberian (second half of 5th century) relate in great

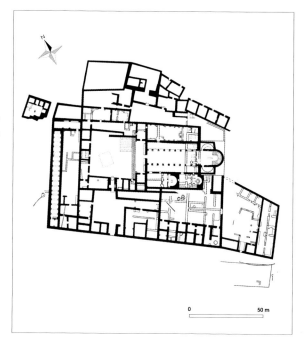

detail descriptions of the **Memorial Church of Moses** on Mount Nebo and the nearby "Springs of Moses".

Archaeological excavations, which started in 1933 and continue to this day, have exposed the 4th century church. This church was square-shaped with three apses of large limestone blocks with a vestibule in front of it, with tombs covered by the mosaic floor and two funeral chapels on each side. Fragments of the 4th century mosaic are still visible near the altar, notably a cross that decorated the spot where the memorial place of the death of Moses was commemorated. An open court in front of the church was bordered on the north by a passageway leading to a lavishly decorated baptistery

*Memorial of Moses,
Mount Nebo
(Piccirillo, 1986).*

89

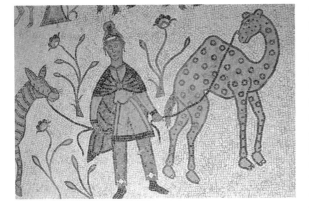

Ma'in Acropolis Church, iconoclasm in mosaic pavement, Madaba Archaeological Park.

Bronze serpent lifted by Moses by Giovanni Fantoni, 1984, Mount Nebo.

visited became the presbytery of the new church. The first stage of the work was completed in 597, as stated in the mosaic inscriptions in the new baptistery chapel. The basilica was decorated with wall and floor mosaics, and was surrounded by chapels. A long chapel at the north covered the old baptistery, and two chapels on the south are known today as the new baptistery chapel and the **Church of the Theotokos** (of the Mother of God, the Virgin Mary). In front of the altar, in the area of the presbytery, a rectangular panel can be still seen of mosaic flowers, gazelles, and two bulls standing before an altar with a *ciborium* on it. The mosaicist intended to depict the altar in the Temple of Jerusalem. Most of the mosaics, which once decorated the floor of the basilica have been lifted for preservation and are displayed on the walls of the modern building, which surround the 6th century basilica. The memorial of Moses survives as a raised structure near the pulpit at the eastern end of the south aisle.

While the sanctuary was undergoing its various stages of architectural development, the adjacent monastery also expanded. The monastery of Siyagha reached its greatest size during the 6th century, with the cells of the monastery grouped around different courtyards surrounding the Memorial Church of Moses. The monastery would have been able to accommodate several hundred monks and pilgrims. This monastery was abandoned in the 3rd/9th century.

A small modern monastery southwest of

chapel, which included a cruciform baptistery basin.

In the second half of the 6th century a three-nave basilica was built, in the time of Bishop Sergius of Madaba (the second half of 6th century). The earlier church that Egeria and Peter the Iberian

the Byzantine monastery lodges the Franciscan community and the archaeologists working on the site today. The iron snake on the beam outside the church, created by Giovanni Fantoni of Florence (Italy) symbolises the bronze serpent lifted by Moses in the desert, and Jesus on the cross, according to the words of the Gospel of John (3:14-15): *"The Son of Man must be lifted up as the serpent was lifted by Moses in the wilderness, so that everyone who has faith in him may in him possess eternal life".*

<div align="right">L. T.</div>

II.4 UMM AL-WALID

The ruins are 15 km. southeast of Madaba and can be reached by taxi or bus departing from the Madaba bus station. Information: Dept. of Antiquities office at Madaba 05-544056 or 05-544189.

The ruins of Umm al-Walid cover the length of a small hill (about 40 m.). The site features a mosque, an eastern *qasr*, a central *qasr*, two Roman temples and a western *qasr*. Even though the site has been occupied since the Bronze Age, archaeological explorations have focussed on the Umayyad period, and specifically on the eastern *qasr* and the mosque. Both the eastern *qasr* and the mosque probably date to the end 1st/first decade 8th century.

The **eastern qasr** consists of around 71 m. in length enclosure, with three half-towers on each side and a three-quarter round tower at each corner. The eastern façade has a fourth tower in the

middle, which served as the only entrance to the *qasr*. The interior of the *qasr* is made up of five *bayts*, or self-contained units, arranged around a courtyard. Each *bayt* is made up of four to five rooms. Several latrines and drainage pipes were also uncovered in the *qasr*. Some of the rooms of the *bayts* were plastered (probably painted) and decorated with carved stucco. The only surviving panel of stucco decoration from the *qasr* is a lintel from the northwestern *bayt*, depicting a panther hunting a gazelle (see Madaba Archaeological Museum). Excavations have also uncovered many ceramics and bronze vessels of the Umayyad period from the *qasr*, as

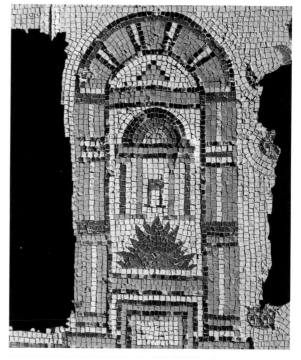

Church of the Theotokos, depiction of the temple of Jerusalem, Mount Nebo.

Umm al-Walid

Eastern Qasr, early
2ⁿᵈ/8ᵗʰ century, Umm
al-Walid (Bujard,
ADAJ 41, 1997).

Eastern Qasr,
volumetrical restitution,
early 2ⁿᵈ/8ᵗʰ century,
Umm al-Walid
(Courtesy of J. Bujard).

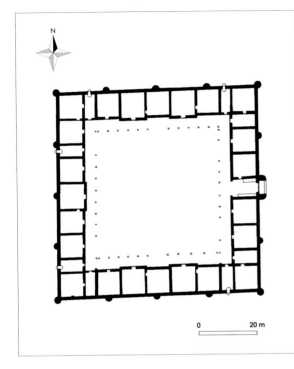

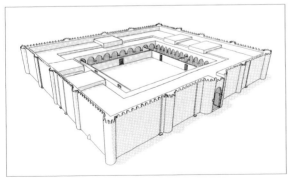

has found that there was an earlier smaller mosque on the site. It is interesting to note that the first mosque predates the *qasr*, which indicates that there was already a Muslim community in the village of Umm al-Walid. The second mosque is an enlargement of the first. The mosque has two entrances, one on the northern side and the other on the eastern side, and a semicircular *mihrab* (a niche which indicates the direction towards Mecca). The mosque was probably built at the same time as the eastern *qasr*. Both structures share the same building materials and the same architectural motifs. The interior of the mosque is divided into three nearly equal parts by two arcades of three arches.

The gradual decline and final abandonment of Umm al-Walid by the end of the 4ᵗʰ/10ᵗʰ century, was due largely to the switch of the capital by the Abbasids from Damascus to Baghdad, bypassing the area of Umm al-Walid, which had profited earlier from being at the crossroads of major trade and communication routes.

L. T.

*Bronze lid of incense
burner from Umm
al-Walid, Madaba
Archaeological
Museum, (Inv.
Num. 667).*

well as several cooking utensils and a millstone made of basalt.

The **Umayyad mosque** at Umm al-Walid is located about 60 m. to the east of the *qasr*. Archaeological exploration

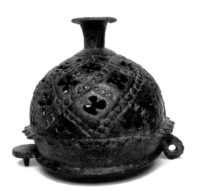

*Umayyad Mosque,
early 2ⁿᵈ / 8ᵗʰ century,
Umm al-Walid
(Bujard, 1992).*

II.5 **AL-QANATIR** (option)

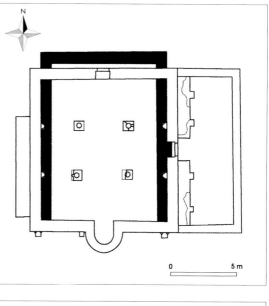

*Umayyad Mosque,
early 2^{nd} / 8^{th} century,
Umm al-Walid
(Bujard, 1992).*

The site is near Umm al-Walid at 2 km. cross-country walking distance. To reach the site by car one must return from Umm al-Walid to the Main Street and drive in the direction of al-Jiza. Information: Dept. of Antiquities office at Madaba 05-544056 or 05-544189.

Al-Qanatir refers to two massive stone dams located south of al-Qastal and the town of Zizya. The word *al-qanatir* is derived from the Arabic word *qanat*, referring to water systems in the form of chains of wells or dams that were used to irrigate agricultural estates. These dams were used to collect and store rain water for the dry summer months. Even though the exact date of these two dams cannot be ascertained, it is more or less certain that they date back to the Umayyad period.

The **northwestern dam** is the longer of the two and was built in a *wadi* (riverbed). It is 187 m. long and 7 m. high, and its width varies from 3.10-5.10 m. The middle of the dam was the thickest part of the wall, now destroyed, but two sluices controlling the flow of water have survived. **The southeastern dam** is about 1 km. to the southeast of the first dam. It is 135 m. long and 9 m. high with a width varying between 7.25 m. and 8.20 m., and is buttressed in the middle. The herring-bone pattern marking the fine mortar undercoat, over which a smooth layer of plaster was laid, has survived to this day on parts of the dam wall (the same can still be seen on

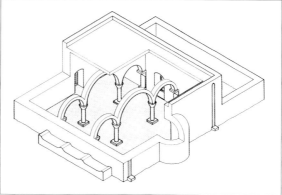

inner walls of other Umayyad structures, such as at Qasr al-Hallabat). At a short distance from this dam are the remains of a small building (10.20 x 13.50 m.) which was probably used as a sort of a guardhouse for the dam. Both dams have spillways, which control the overflow of

Umayyad Mosque, volumetrical restitution, early 2^{nd} / 8^{th} century, Umm al-Walid (Courtesy of J. Bujard).

water in the dams. The construction of both dams is similar. Both have stone walls filled with rubble and faced with mortar for the insulating plaster layer. The stone blocks used in both dams were probably reused from nearby earlier structures.

L. T.

II.6 UMM AL-RASAS

The large site with the famous mosaics in the Church of St. Stephens lies about 30 km. south of Madaba and can be visited any time during the day free of charge. The ruins can be reached from Umm al-Walid by car and from Madaba by bus going from the Madaba bus station south via Dhiban. Information: Dept. of Antiquities office at Madaba 05-544056 or 05-544189.

Umm al-Rasas is located halfway between Dhiban on the King's Highway and the Desert Road. The ruins consist of a walled area forming a fortified enclosure (158 x 139 m.), which served at one point as a Roman legionary camp or *castrum*, and an open quarter of roughly the same size to the north. About 1300 m. further north stands a 15 m. high tower near a small church and a cistern. This tall stairless tower might have been used as the abode of a stylite, an ascetic monk who spent years on top of a pillar or tower in prayer or meditation.

The impressive fortified walls of the *castrum* probably gave the ruins their modern name of *Umm al-Rasas* (meaning literally in Arabic "mother of lead"). The word *rasas* is probably a derivation of the Arabic word *rass* or *mourassas,* which connotes well-constructed walls. To date, archaeologists have concentrated on the ecclesiastical nature of the site and have identified four churches within the *castrum* walls and 12 churches outside the walls of the *castrum*.

The first known western explorer of Jordan to have recorded the name of Umm al-Rasas was the German Ulrich Seetzen, who in 1807, was told by his Bedouin guide of the existence of "(...) the most exciting [ruins] (...) the ruins of Umm al-Rasas". Seetzen, however,

Umm al-Rasas (Piccirillo, 1993).

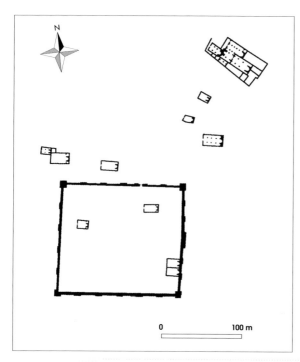

N

0 100 m

was never to visit these ruins, but the site was visited, thereafter, by a number of travellers: J. S. Buckingham in 1816; C. I. Irby and J. Mangles in 1818; E. H. Palmer in 1870; and H. B. Tristam in 1872. Tristam was followed by S. Vailhé who proposed that the large enclosure with the thick walls might have been a Roman legionary camp. On that basis, J. Germer-Durand proposed to identify the ruins with the biblical Mephaath (Joshua 13:18, 21:37; I Chronicles 6:79; Jeremiah 48:21), which according to the 4th century Roman historian Eusebius of Caesarea was also a Roman military station, Kastron Mefaa. Eusebius mentions that a unit of the Roman army was stationed on the edge of the desert at Mephaath, a place that the historian identified with one of the Levitical cities of refuge in the territory of the tribe of Reuben in Moab. Another text, also from the 4th century, a Roman imperial document, records that auxiliary cavalry troops of the Roman army were stationed in the camp of Mefaa under the command of the *Dux Arabiae*. Kastron Mefaa also appears in Arabic historical accounts from the 4th/10th and 5th/11th centuries as al-Mayfa'a. The proposal that the site of Umm al-Rasas was Kastron Mefaa was confirmed during excavations in 1986, when three inscriptions with the name Kastron Mefaa were found on the mosaic pavements of two churches. The *castrum* of Umm al-Rasas was probably demilitarized and transformed into a densely populated town sometime in the 5th century.

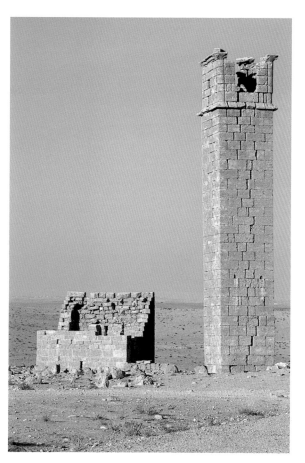

To date, archaeologists have identified four ecclesiastical buildings inside the walls of the *castrum*. Two joined churches are near the east wall, a third in front of the north gate, and a fourth located in the western sector. To date only the two joined churches have been excavated. The construction of both churches post date the *castrum* wall. Of the two churches, the north church, known as the **Church of the Rivers**, has been dated from 578-

Small church and stylite tower north of the Castrum, Umm al-Rasas.

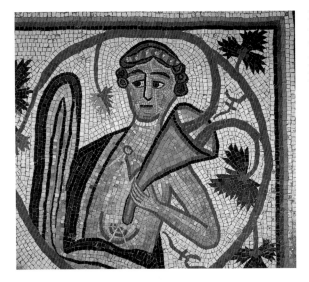

Church of the Bishop Sergius, the seasons, Umm al-Rasas, (Courtesy of M. Piccirillo).

higher level in the southwest sector of the complex.

The **Church of the Bishop Sergius** has an apsidal presbytery, two steps higher than the nave and a single sacristy to the north. The main entrance is through a paved courtyard. Two doors on the western side lead to a baptistery chapel, paved with a chessboard mosaic, and to a funerary chapel, which has a plain mosaic floor of white tesserae. In the presbytery of the church itself, the mosaic floor of the apse is a geometric grid with diamonds. In front of the altar a rectangular panel with an inscribed medallion dates the church from 587-588. The numerous images of people and animals in the carpet mosaic of the nave suffered deliberate damage by the iconoclasts (see Iconoclasm). The names of the benefactors of the church are also known and indicate the Semitic origins of the donors.

579 or 593-594. The south church, known as the **Church of the Palm**, is later than the northern one. Both churches are paved with mosaics, which are now badly damaged.

Excavations outside the walls of the *castrum* have exposed a large interconnected liturgical complex with four churches and courtyards enclosed by a continuous wall known as the **St. Stephen Complex** after its largest church. Two of these churches are paved with mosaics and have been considered by archaeologists as the two main buildings of this complex. The two are the **Church of the Bishop Sergius** and its attached baptistery on the north end of the complex, and the **Church of St. Stephen** on the east. A courtyard separates these two buildings. The courtyard, later, was converted into a church by the addition of an apse. A fourth church occupies a

The **Church of St. Stephen** lies southeast and 1 m. higher than the Church of the Bishop Sergius. Its wealth in inscriptions and mosaics make it one of the most important archaeological remains in Jordan. The plan of the church is similar to that of the Church of the Bishop Sergius. There is a sacristy on the south side of the apsidal presbytery and an apsidal chapel on the north side. Dedicatory inscriptions on either side of the altar of the presbytery indicate that the church was paved with mosaics in 138/756 by the mosaicists, Stauranchius and Euremius. This inscription is significant because it indicates that there was an active Christian community present at Umm al-Rasas

six years after the end of the Umayyad period and more than a century of Islamic rule of the region. A second dedication inscription, which runs along the step of the presbytery, records that additional mosaic work was undertaken during the time of Bishop Sergius II (from early mid-2^{nd}/8th century). The letters, which once dated this inscription, were repaired sometime in antiquity and it is, therefore, difficult to assign a specific date for the church in the 2^{nd}/8^{th} century (scholars have suggested the dates of 99/718 or 170/787). Either date would be significant since both possibilities post date the Muslim take over of the region. Unfortunately the portraits of the benefactors and scenes of hunting, agriculture and pastoral life, which once animated the nave mosaic have been disfigured by iconoclasts and are often unintelligible. The frame of the central mosaic floor, which depicted a river with fish, birds, water lilies, boats and boys fishing, is also disfigured. This frame, however, also contains the preserved and well-

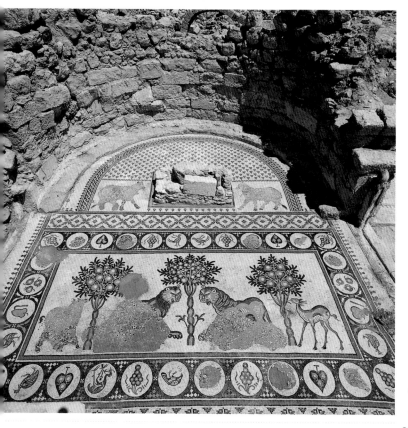

Church of the Lions, presbytery, Umm al-Rasas (Courtesy of M. Piccirillo).

97

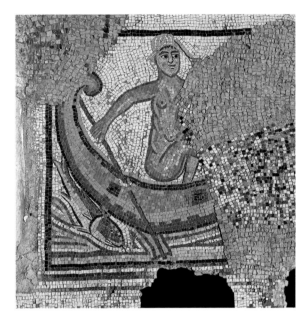

Church of the Priest Wa'il, Fisherman, Umm al-Rasas, (Courtesy of M. Piccirillo).

aisle, associated with portraits of benefactors and inscriptions. Another toponym without an illustration mentions Mount Nebo-Phisga.

Archaeological excavations in the urban sector between the St. Stephen Complex on the northern ridge of the ruins and the walls of the *castrum* to the south have brought to light two more ecclesiastical complexes. The southern one, which rotates around a tri-apsidal church with exquisite mosaics, is known as the **Church of the Lions**. This church has four entrances, two in the north and two in the west. The raised presbytery contains one of the best-preserved Byzantine pulpits in Jordan. An inscribed medallion in the nave of the church dates it to 575 or 589. Unfortunately, the church mosaics were not spared by the iconoclasts.

known pictures of a series of 10 cities in the Nile Delta, identified by the inscriptions: Alexandria, Kasin, Thenesos, Tamiathis, Panau, Pilousin, Antinau, Evaklion, Kynopolis and Pseudostomon. Other cities, also accompanied by a toponym in Greek, are shown on either side of the nave. There are eight cities from the west of the Jordan River in the north row: Jerusalem, Neapolis (Nablus), Sebastis (Sebastia), Caesarea on the Sea, Diospolis (Lydda), Eleutheropolis (Beit Gibrin), Askalon and Gaza; seven cities from the east of the Jordan in the south row: Kastron Mefaa (Umm al-Rasas), Philadelphia (Amman), Madaba, Esbunta (Hesban), Belemunta (Ma'in), Areopolis (Rabbath) and Charach Muba (Karak). Two additional villages, Limbon and Diblaton are depicted at the head of each

Another ecclesiastical complex, made up of at least two churches dating from the late 6th century was also uncovered. The main church in this complex is the recently excavated **Church of St. Paul** (578 or 593).

Another late 6th century church, known as the **Church of the Priest Wa'il** (575 or 589) was also uncovered outside the *castrum* walls. Like all of the churches uncovered to date at Umm al-Rasas, this church is also adorned with beautiful mosaics mutilated by iconoclasts.

Occupation as a whole at Umm al-Rasas seems to have declined seriously (or ended) by the early Abbasid period in the 3rd/9th century, by which time the excavated churches seem to have gone out of use.

L. T.

Thermal Spa of Ma'in

(Hammamat Ma'in)

The thermal spas of Ma'in lies 30 km. to the south of Madaba and from there can best be reached by taxi or private car. The spa is open daily with an entrance fee. Accommodation is available.

The site is unusual because of its natural hot springs and it bath complex. The large and small spring-fed waterfalls are an attractive feature and enjoyed by a multitude of visitors. The hot springs have been known for their healing powers from ancient times and are no less popular now. Being in an area densely populated from the Iron Age archaeological sites are within calling distance and provide an added attraction to a visit.

Mukawir (Qal'at al-Mishnaqa)

Lies about 40 km. southwest of Madaba. It can be reached by car from Madaba driving south toward Libb, from there turn right and continue straight on the road to the site.

The ruins of the ancient Fortress of Machaerus (1st century BC) are walls speaking of its past. The site is famous for its beautiful views overlooking the Jordan Valley and beyond and is perhaps best remembered for the story of Salomé and St John the Baptist: It was here that Salomé took her gruesome revenge and demanded the beheading of St. John.

Thermal Spa, Roman-Byzantine Baths of Baaru, Ma'in, (Zohrab).

ICONOCLASM

Ghazi Bisheh

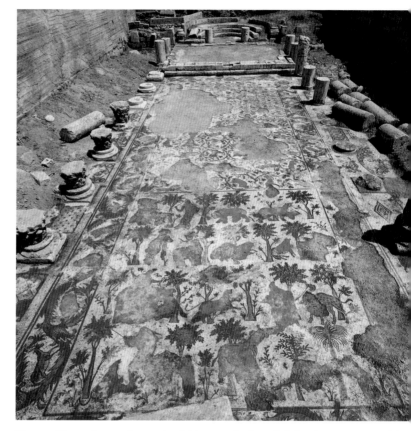

Church of al-Khadir, mosaic pavement, Madaba Archaeological Park, (Courtesy of M. Piccirillo).

The word Iconoclasm refers to the deliberate destruction of images of living beings. In a sizeable number of Byzantine churches in Jordan, human and animal images were deliberately destroyed. This was not because the images were objects of veneration as was the case in the iconoclastic movement in the Byzantine Empire, the first phase which lasted from 111/730-170/787, but rather because of the objection to any depiction of living beings. What accounts for this damage? Who was responsible for carrying it out

and when did the damage occur? The answer to these questions has been the subject of debate among scholars. Robert Schick, who studied mosaic floors with disfigured images, noticed that these mutilations, far from being acts of random vandalism, were carried out carefully and with considerable effort. In several examples the same tesserae were plucked out, scrambled and then carefully reinserted. This careful treatment of the damaged images indicates that it was the local Christian communities that were

responsible for these acts of disfigurement and scrambled reassemblage. This suggestion is supported by the placement of a cross in the damaged section of the mosaic floor in the Church of Masuh near Madaba. As to the date of this phenomenon, archaeologists increasingly point to a date after 132/750. This date is indicated by the inscriptions in the apse of the Church of St. Stephen at Umm al-Rasas and the Church of 'Ayn al-Kaniseh on Mount Nebo, dated 138/756 and 144/762, respectively. This hypothesis implies that all churches with traces of iconoclasm continued to be used throughout the Umayyad period (41/661-132/750) and slightly later. Concerning the motive for the defacement of living beings in these churches, it has been suggested that it was due to a deep-rooted dislike by Semitic peoples for human representations in sculpture and paintings, and that the hostility toward images of animate beings was present even in Semitic literary tradition. It is difficult to determine the meaning of the word "Semitic" in such a context especially in view of the fact that the ancient Semitic art of Syria and Mesopotamia has always shown both human and animal forms. Moreover, recent archaeological investigations have revealed that even Southern and Northern Arabia have used figural representation in their art. It should also not be forgotten that the decoration, restoration and rearranging of images in these churches was done by local Christians who were Semites. Others have attributed this iconoclasm to an edict issued by the Umayyad *caliph* Yazid II (101/720-

105/724). The edict, however, as recorded in the various Christian sources, contains inherent weaknesses, which question its authenticity. Curiously, mention is absent from early Arabic sources and in the Christian accounts it appears as an anti-Muslim and anti-Jewish document of doubtful historical validity. Perhaps the explanation for the defacement of living beings in the Byzantine churches in Jordan should be sought in the socio-religious environment in which the Christians found themselves. It is likely that the continued polemics and persistent criticism by Muslims, Jews and Monophysites of Melchite Christians for venerating images could have provided the motive. Accusations of idolatrous practices probably played a cataclysmic role in prompting some Christians to re-evaluate their attitude toward figurative images and to turn away from them, adopting, therefore, an attitude closer to the Muslim faith.

Diaconicon-Baptistry, hunting scene, 530-31, Mount Nebo.

CONCEPT OF BYZANTINE AND UMAYYAD ICONOGRAPHY

Fawzi Zayadine

After the triumph of Christianity and the foundation of Constantinople in 324, the Byzantines in Syria and Palestine became the direct inheritors of the Graeco-Roman civilisation, well rooted in the East since the conquest of Alexander the Great in 331 BC and perpetuated in the foundation of the cities of the Decapolis. It is not surprising, therefore, to witness in Byzantine art the survival of classical traditions. Those artistic elements are interpreted as being "rhetorical" in nature, i.e., cultural adoption of forms lacking religious significance. The classical allusions should not be seen as resistance to Christianity, but as an expression of the "paidia" or erudition of the aristocracy. In several cases, for example, Heracles fighting the lion, a myth, poorly interpreted as shown in a mosaic floor at Madaba. In the mosaic of Aphrodite and Adonis (see Madaba Archaeological Park), the mythological representation is only decorative. It should be borne in mind that Christianity originated in Palestine and "Classical" Byzantine art absorbed artistic features from the Oriental culture. These elements have their roots in the ancient oriental tradition beyond the Hellenistic period, which was already influenced by the Near East. In the Apostles Church (Madaba), the representation of Thalassa is inspired by the image of the sea goddess Thetis, but the mosaicist converted the subject to suit a Christian allegory by adding an inscription from Psalm 101 "Oh God who created the earth and sky give life to your servants".

Similarly, the Arab Islamic conquest of Syria established Damascus as the capital of the Umayyad Dynasty in 41/661. This city was the heart of a long heritage of civilisations going back, beyond the Hellenistic period, to the Aramaean kingdoms. Jordan played a major role in the new Islamic Empire, since it was a vital bridge between Syria and the holy cities of Mecca and Madina. At the governor's headquarter of Amman, for instance, the Audience Hall was at the same time the monumental entrance to the residential quarters and most of the excavated Umayyad palatial residences in Jordan include a "Classical" basilica-like audience hall and a bath complex of the Graeco-Roman type. This demonstrates that the Arab rulers and the new aristocracy sought to emulate the cultural standards of the conquered lands and adopt previously known traditions into their style of life.

This is a reminder that the new masters of Syria and Palestine were not cameleers and pastoralists of nomadic origin. They were city dwellers of Mecca, Madina, Tayma', Taif and Adumatu (al-Jawf). The Nabataean tombs of Hegra (Meda'in Saleh) were carved by local sculptors. Hellenistic tribal manors, such as Qasr Marid in Adumatu, thought to date back to the 3rd century BC, have some bearing on the development of Islamic Umayyad art. The Arab conquest of Mesopotamia and Iran removed the barriers between the Sassanids and the Byzantines. In other words, the Middle East experienced, for the first time since the conquest of Alexander the Great, a certain unity. The exchange between the techniques of Iran and Hellenised Syria generated new

trends and ideas in illustrative arts. The following demonstrates the persistence of classical influence in both Byzantine and Umayyad iconography. This can best be seen in mosaic floors and wall paintings, which bring forth the underlying principles of decorative art forms for each period.

The hunting scene is one of the favourite themes of mosaics and paintings. The hunt of wild animals is a royal sport that decorated the bas-reliefs of Ashurnasirpal at Kalkh-Nimrud (9th century BC) or those of Ashurbanipal (7th century BC) at Niniveh. The royal hunt is rendered with the vitality and realism of the late classical style seen on the commonly called "Alexander Sarcophagus" of Sidon, dated to the 4th century BC. Such typical hunting scenes decorate the mosaic floor at Mount Nebo, dated to 531. In the north aisle of the basilica, in front of the older baptistery, the scenes are arranged in four registers. In the upper one, two hunters on foot are fighting a lion and a leopard. The lower register is animated by two horsemen, attacking a hyena and a boar. Although the hunt is reminiscent of the relief on the Sarcophagus of Alexander at Sidon, there is no relation between the other two sections, which depict conventional scenes. The lower portion shows a shepherd, seated under a tree and watching his herd grazing in peace, and a peasant in the fourth part drives a camel and an Arabian ass while a Nubian is holding the bridle of an ostrich. The artificial arrangement of the four sections carries an allegorical message: the wild animals represent the evil spirits, ready to attack

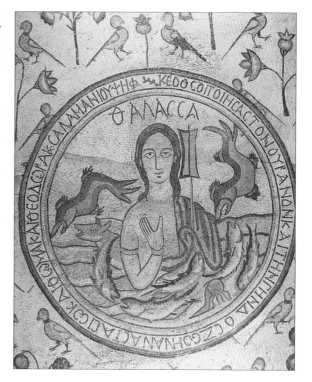

Church of the Apostles, medallion with Thalassa, Madaba.

the believers as forewarned in the epistle of St. Peter (1 Pt. 5,8): "Be sober, be watchful! For your adversary the devil, as a roaring lion, goes about seeking someone to devour".

The Umayyad wall painting of a hunt at Qusayr 'Amra (see Qusayr 'Amra), showing the capture of onagers on the west wall, is executed in rich and realistic detail. The hunt is taking place in a "real" landscape, the desert, suggested by a tent at the northeastern corner of the scene, and in the night, as the servants are holding torches around the net. The animals are driven by beaters, on horseback, to be captured alive in the net. On the eastern

103

wall, the hunt of wild oxen by seluqi hounds add to the naturalistic impression of the painting. On the same east wall, the panels representing the workers involved in the construction of the monument add to the realism of the scenes. Stone cutters load the blocks on a camel and deliver them to the builders and to the mason, while a blacksmith is preparing a tool. The entire mural resembles a film-clip.

The well-known mosaic floor in the Madaba Museum shows a different thematic concept. It depicts a garden planted with four symmetrical trees in the corners of the panel with couples of opposing animals in between. Represented are two lambs, two guinea hens and two antelopes, while a lion and a bull are eating at a plant. The interpretation of this scene can be deduced easily from the biblical and Christian teachings. The second coming of Christ, at the end of time, will bring about everlasting peace to fulfil the prophecy of Isaiah 11: 7; "The lion eats straw like the ox". This biblical

interpretation is confirmed by a Greek inscription in a similar pavement at Ma'in, near Madaba. The idealistic and the antithetic position of the animals is artificial, since the whole scene is allegoric.

A difference of technique and intention can be noticed in the Umayyad mosaics of the Dome of the Rock in Jerusalem and the "Hisham Palace" (Khirbat al-Mafjar) at Jericho. The walls of the Dome of the Rock are covered with a mosaic of 1200 square metres made of glass and gold tessarae, mother of pearl, representing vegetal motifs. It shows palm, almond and olive trees with tufts of reeds, and vine branches laden with heavy bunches of grapes interlocking in harmonious scrolls. This vegetation is depicted with realism and accuracy. It is not necessary to interpret the vegetation as the image of paradise but the fruitful trees refer to the earth and to an era of material prosperity. The holy *Qur'an* refers to olive and fig trees and God appeals to the believers: "O ye who believe! Eat of the good things that we have provided for you and be grateful to Allah" (*Surat al-Baqara,* 172).

In the audience hall of Khirbat al-Mafjar, a well-preserved mosaic represents a realistic design of a quince tree in the uneven growth of the main branches or the twisting of one of these branches around its straighter and sturdier neighbour. Realism is also expressed in the rendering of the two gazelles. The mosaicist succeeded in reproducing the slenderness of the body by contrasting shades and in suggesting the movement of the heads while grasping the leaves. To the right of the tree, the artist shows a

Qusayr 'Amra, panel with blacksmith, al-Badiya (J. L. Nou).

fierce lion attacking a gazelle. The portrayal is so real that one can almost feel the desperate attempt of the weak animal trying to escape the sharp claws and fangs of the beast. The whole panel is evidently influenced by ancient Oriental hunting scenes of the Neo-Assyrian or Persian periods. Yet, it is in sharp contrast with the allegoric scene of the heavenly paradise in the mosaic of the Madaba Archaeological Museum.

Bull and lion eating a shrub, Madaba Archaeological Museum.

Theological ideology dominates the Madaba Mosaic Map in the Church of St. George at Madaba. This famous geographical document of the Near East stretching from Sidon in Phoenicia (Lebanon) to Alexandria in Egypt is dated mid-6th century (see Monastery of St. Lot, and Zoar). The map has several interpretations, ranging from the controversial hypothesis of "the vision of Moses" to the more generally accepted theory of a representation of Christian history. After the wandering in the desert, the Israelites crossed the Jordan River at Beth "Arabah" and ancient Jerusalem, where they witnessed the death and resurrection of Jesus Christ, which became the heart of the New Testament Land.

There is a good comparative reference to the Madaba Mosaic Map on the west wall of the portico in the Umayyad mosque of Damascus, built by al-Walid I. The glass mosaic depicts cities and villages with magnificent palaces and villas by the side of a flowing river and among splendid gardens. Some classical monuments, such as the representation of a theatre, are not common to Arab Islamic tradition. A reasonable interpretation was given by al-Muqaddasi in the 4th/10th century who stated that "(…) there is hardly a tree or notable town that has not been pictured on those walls". Ettinghausen, a renowned historian of Islamic art, adds a plausible explanation of the mosaic: "The mosaic of Damascus seems to imply that the whole world, under the aegis of the caliphs, has entered the house of Islam". The various examples of mosaics and paintings presented here are examples of the difference between Byzantine and Umayyad iconographic concepts. While the Byzantine artist served the interests of symbolising Christian teachings, the Umayyads were more inclined to express human aspects depicting daily life with evident realism. Although both the Byzantine and Umayyad artists drew their iconographic inspiration from Graeco-Roman art, the Umayyads were in closer contact with the realism of classical representations, because they were free from allegoric and theological constraints imposed on the artists by the Byzantine Church.

CHRISTIAN ROAD TO PILGRIMAGE FROM JERUSALEM
TO MOUNT NEBO THROUGH THE BAPTISMAL SITE

Fawzi Zayadine

Palestine was the birthplace of Christianity and from there the new faith spread not only to the East, but also westward throughout the Roman Empire. Jordan was bound closely with Palestine, since John the Baptist baptised on the east bank of the River Jordan where Jesus Christ was baptised. This fact was brought about by several reasons. At the site was a boat crossing the River Jordan where people gathered and Jordan was controlled by the Nabataeans who were more receptive to the message of John the Baptist than the Jews of Palestine. In one instance, the Jews wanted to arrest Jesus "(…) but he eluded them. He went back again to the other side of the River Jordan to stay in the districts where John had once been baptising" (John, 10: 39-40).

This place is shown on the Madaba Mosaic Map (mid-6th century) under the legend of "Aenon, where now is Shpsaphas". The name is derived from an Aramaic name, most probably 'Aynun, meaning "spring". It is located in Wadi al-Kharrar, about 2 km. east of the River Jordan. A spring gushes in this valley, which is densely covered by wild vegetation. It is said that monks lived in two caves and that the Baptist lived in a similar cave, according to a vision, which appeared to a monk around 500 who arrived in this area from a monastery near Jerusalem. He was travelling to the Sinai but during the vision he was ordered to stay in this cave where Jesus had visited John the Baptist. According to 1 Kings, 17:2-6, the prophet Elijah, who was originally from Tishbe (Khirbat Tilsit, in the Ajloun mountain), was commanded by Yahweh to go east and hide in the Wadi Cherith (Kharrar). Two ravens were sent, one to carry bread in the morning, the other meat for the evening. Elijah's ordained

Church of St. George, Mosaic Map, Jordan river and the site of baptism, Madaba.

journey took place in the 9th century BC, and a survey of the area did identify an Iron Age I-II site on this spot. When he came from Jericho with his servant Elisha', "(…) Elijah took his cloak, rolled it up and struck the water; and the water divided to the left and right, and the two of them crossed over dry-shod" (2 Kings, 2:8). As they walked, a chariot of fire appeared with horses of fire and "Elijah went up to heaven in the whirlwind" (2 Kings 2:11). The hill from which Elijah was taken to heaven is located at the mount of Wadi al-Kharrar where a church, paved with a fine mosaic floor, was built by the Abbot Rhetorius in the 6th century.

According to a Christian doctor who settled in Caesarea of Palestine, the site of the baptism has its origin in the 3rd century. In this *onomastikon,* a list of biblical sites in Palestine and Jordan written around 330, Eusebius of Caesarea confirms the location of the baptism place at Bethabara, the crossing ford. The Greek term of *deiknutai* used by him means that guided tours for pilgrims were organised already in his time.

The pilgrims coming from Europe began their tour from the Holy City of Jerusalem and went on to Jericho. They descended to the River Jordan and crossed at Bethabara to the baptismal site where recent excavations have brought to light a square basilica built by the emperor Anastasius (491-518) on an arched support to protect it from the floods. From there, the pilgrims arrived at the plain of Livias (Tell al-Rameh) and followed the Roman Road to Esbus (Hesban). At the sixth milestone from Esbus, at the fortress of a Mehatta, a detour brings the pilgrims to 'Ayoun Mousa, or the spring of Moses. From there the road ascends to Mount Nebo, the Memorial of Moses.

Memorial of Moses, interior view, Mount Nebo.

Palatial Residences

Mohammad al-Asad, Ghazi Bisheh

First day

III.1 AL-BADIYA
III.1.a Al-Qastal
III.1.b Qasr al-Mushatta

Al-Mushatta Façade at Berlin

III.1.c Al-Muwaqqar Water Reservoir
III.1.d Qasr al-Kharrana
III.1.e Qusayr 'Amra

Opulent Lifestyles and Caliphs' Entertainment

SCENIC OPTIONS
Al-Azraq Nature Reserve
Al-Shawmari Reserve
Al-Azraq Wetland Reserve

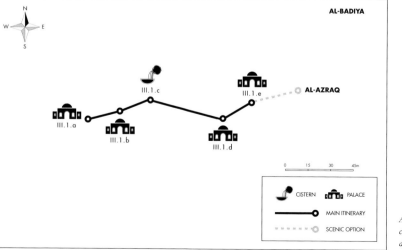

Al-Qastal, detail of carved stone, al-Badiya.

Qusayr ʿAmra, general view, al-Badiya.

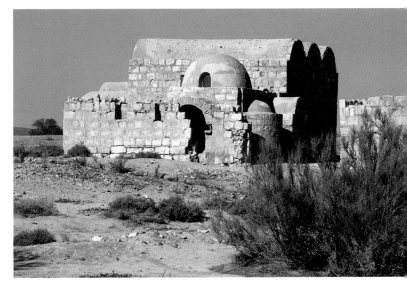

Jordan has the largest concentration of Umayyad complexes usually referred to as "desert palaces" or "desert castles". Some scholars have rejected these terms indicating that the areas in which these complexes are located were not deserts during the Umayyad period. In fact, the irrigation systems that have been excavated in a number of them provide a clear indication of the agricultural activities they harboured. These complexes are too extensive to be referred simply to as "castles" or "palaces". A number of them can more accurately be described as estates or small settlements that contained residential quarters, a mosque, a bath complex and the infrastructure necessary for agricultural activities. Some also functioned as caravan stations and trading posts.

Our knowledge of these estates is far from complete, and many questions concerning their dates, patrons and function remain to be answered. This is partly due to the lack of contemporary Umayyad literary sources and to the scarcity of inscriptions having survived *in situ*. Even without such supportive evidence, however, these Umayyad monuments remain of great historical importance. Although the construction of such estates outside urban centres was a short-lived phenomenon in the Islamic world, they are among the earliest known examples of Islamic architecture, and also the earliest examples of secular, and more specifically palatial architecture from the Islamic world. They provide one of the few examples in ancient and medieval architecture where a significant number (more than 20) historical buildings of the same period, the same geographic area and the same building type are still

110

extant. In addition to being important material evidence of princely life in the early Islamic period, they also provide continuity with the Roman country villa that survived into late antiquity, and, therefore, can shed some light on this building type.

Numerous explanations have been given for these rather mysterious structures since scholars have studied them from the early part of the 20th century. They have been explained as "pleasure palaces" where Umayyad princes engaged in a variety of pleasurable activities including hunting and feasting. Another widespread opinion was to see in them an example of an early, romantic Muslim taste for life in the *badiya* (the edges of the desert) where the air is fresher and cleaner, and the Arabic language is purer than in the city. Although the modern term of *badiya* means the edges of the desert, during Umayyad times it referred to "estates in the countryside" and in this context the original Umayyad meaning of *badiya* has been retained. They have also been explained in socio-economic terms as centres of agricultural land that the Muslims inherited from members of the Christian Byzantine aristocracy who fled Syria after the Muslim conquests. It has also been suggested that they served as administrative and political centres where Umayyad princes met and strengthened ties with local tribal leaders on whose support the Umayyads greatly depended. More recently, the idea has been put forward that the complexes served as stations along trade and pilgrimage routes connecting *Bilad al-Sham* and *al-Hijaz*.

Probably, there is an element of truth in each of these explanations.

In many instances, these complexes include living quarters, a bath and a mosque. It is not unusual for the baths to predate the living quarters since the latter do not need to consist of permanent structures, but the baths do. The art historian, Oleg Grabar, has pointed out, that many of these complexes were intended for intermittent rather than permanent use, that they had high levels of amenities but few public functions, and that many

Detail of carved stone from Qasr Tuba, Jordan Archaeological Museum (Inv. Num. J 1950), Amman.

Al-Qastal, detail of carved stone, al-Badiya.

111

*Al-Qastal, before
126/744, al-Badiya
(P. Cartier, 1984).*

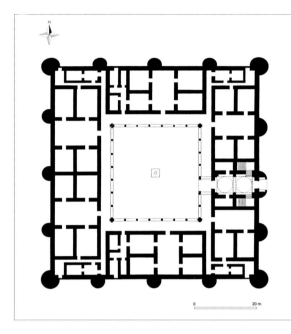

of them tended to express and serve pleasure more than power.

Almost all of these complexes belonged to the Marwanid branch of the Umayyad dynasty, which consisted of the descendents of Marwan Ibn al-Hakam (64/684-65/685). It has also been suggested that Marwan's son, 'Abd al-Malik (65/685-86/705), assigned the areas of *Bilad al-Sham* to his sons in order to exert better control over the region, and that this system survived until the fall of the Umayyad dynasty two generations later. Based on this opinion, it is thought that the pattern of Umayyad patronage of these complexes corresponded to this division of the land. Complexes built in a specific area, therefore, were usually the work of the prince or princes (most of these princes later became *caliph*s) to whom that area had been assigned.

M. A.

III.I AL-BADIYA

The only way to reach al-Badiya sites is by car or with locally organised tours. There is no entrance fee and the sites can be visited daily.

III.1.a Al-Qastal

Is on the Desert Highway about 25 km. to the south of Amman. From Hammamat Ma'in the site can be reached by taxi or private transport in the direction of the Desert Highway; from Amman it is best to drive along the Airport Highway where the site is marked.

*Al-Qastal, corner
tower of palace,
al-Badiya.*

Al-Qastal is a large complex with a residential palace, a mosque, a bathhouse, a cemetery, domestic quarters and water harvesting systems.

The palace is about 68 x 68 m. It has four three-quarter round corner towers and in all 11 semicircular towers in between. Each of the façades contains three of the semicircular towers except for the east one, which has four towers, two of them flanking the entrance gate.

Originally, the palace is believed to have consisted of two stories, although the upper storey has not survived. The ground floor is composed of six *bayts* (self-contained units) arranged around a central courtyard, with each *bayt* consisting of four rooms and a court.

The mosque is located to the north of the palace and has a rectangular hall measuring 16 x 5 m. entered through a rectangular court measuring 17 x 10 m. It is built of the same stone cut in the same size and shape as the palace. A minaret with a spiral staircase of 6 m. in diameter is still standing with a height of 6 m. and connected to the northwestern corner of the mosque. It may well be the oldest surviving minaret in Islam.

It is believed that the inner sanctuary of the mosque was covered over initially in wood but was replaced later by a stone barrel vault. The originally thin walls consequently were enlarged to support the weight and lateral thrust of the new roof. The cemetery, which is the earliest Muslim cemetery in Jordan, is located to the southwest of the palace. A number of inscribed tombstones belonging to the Umayyad and Abbasid periods have survived and are now

displayed in the Madaba Archaeological Museum. It could be of interest to note that earlier tombs of the cemetery may be oriented toward Jerusalem.

The water-collecting systems include a dam located about 1 km. to the east of the palace. The dam was made of a 400 m. long wall 4.30 m. thick. A cistern, which measures 30 x 22 x 6 m., is located about 1 km. to the northwest of the palace, and

Al-Qastal, view of corridor in palace, al-Badiya .

Qasr al-Mushatta, general view, al-Badiya.

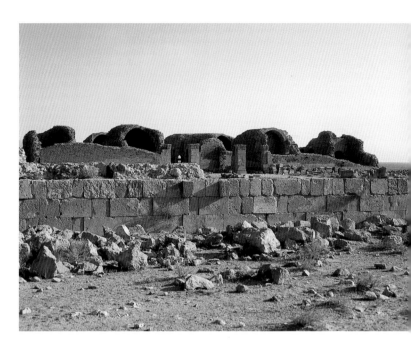

Qasr al-Mushatta, al-Badiya (Grabar, 1973).

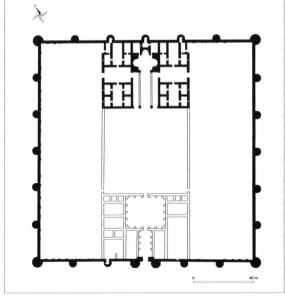

about 70 small cisterns are dispersed around the area of the palace.

Although it is agreed that most of the complex is Umayyad, considerable debate exists concerning its exact date. A reference in a later historical account supports the suggestion that it was completed before 126/744, but the actual time of construction is difficult to determine. It was also reused as residential quarters between the 6th/12th and 10th/16th century, during the Ayyubid and Mamluk eras, and a few minor additions to the Qastal complex date from that period.

M. A

III.1.b Qasr al-Mushatta

The monument is very close to the Queen Alia

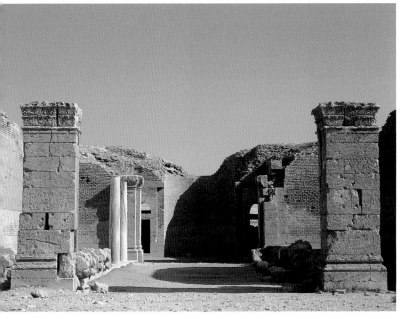

Qasr al-Mushatta, view of basilica-like hall facing the throne room, al-Badiya.

International Airport and about 35 km. to the south of Amman. Coming from al-Qastal by car proceed along the airport route, turn right at the airport hotel.

Qasr al-Mushatta measures about 144 m. in length and is the largest in size of the Umayyad palaces in Jordan. The complex contains an audience hall, a throne room, a small mosque and living quarters. It was never completed, and parts were ravaged by natural forces such as earthquakes. Its 1.7 m. thick outer walls are still standing at the height of 3-5.50 m. and a significant section of the southern façade with its beautiful and intricate relief carvings, was brought to Berlin early in the 20th century (see Al-Mushatta Façade at Berlin). Fortunately, enough has remained in place

Qasr al-Mushatta, view of the brick wall at the entrance, al-Badiya.

115

to verify the original splendour of this ambitious monument.

While the lower courses of the walls are made of stone, the upper parts, the interior walls and the vaulted roof were built of fired brick. The exterior walls are distinctive for 21 semicircular towers and four corner towers that are almost circular. The corner towers have an impressive diameter of 7 m., and the semicircular ones are slightly smaller (5.25 m. in diameter). Although the towers give the appearance of a fortified palace, they were not designed for defence since four of the towers served as latrines and the remaining ones were solid.

The complex is divided into three sections oriented along a north-south axis. Construction on the two sides never began, but the central section was partly completed. This middle part was further divided into three partitions with a central court and a southern and a northern section. Each of the northern and southern sections was divided further into three smaller units, and some of these subdivisions were divided again into three units. The southern part includes living quarters and a mosque, identified as such because it contains a niche facing Mecca. The northern section ends in an axially arranged throne room. The tri-apsidal room is preceded by a basilica-like hall with a triple-arched entrance.

The planning, construction methods and architectural details of the structure show a combination of Byzantine, Sassanian and Persian influences. The use of stone in the outer walls was prevalent in Byzantine architecture and the use of brick for the interior walls and vaults was a Sassanian feature. This mixture of influences is also obvious in the decoration of the south façade (see Al-Mushatta Façade at Berlin). The massive size of this palace sets it apart from the much smaller palaces built by the Umayyads. It is believed that the palace was intended to accommodate large number of people, perhaps the whole Umayyad court. It was also designed for ceremonial grandiose performances as is evident in the incorporation of the throne room and basilica-like hall.

A number of scholars have posited the Umayyad *caliph* al-Walid II as the builder of al-Mushatta and although there is no evidence to support the claim, al-Walid II, in his brief rule of less than a year between 125/743-126/744, had already become known as a prolific builder.

M. A

AL-MUSHATTA FAÇADE AT BERLIN

Mohammad al-Asad

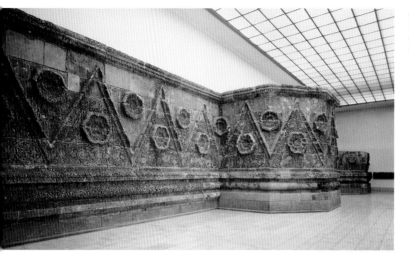

A significant part of the southern façade of al-Mushatta including the main entrance, was moved to the "Staatliche Museen zu Berlin" (The Pergamon Museum). During the rule of the Ottoman Sultan 'Abd al-Hamid (1293/1876-1327/1909), Jordan was part of the Ottoman Empire and was given the façade as a present to the German Kaiser Wilhelm II (1888-1918). The façade, standing to a height of 3.80 m., was brought to Berlin by German archaeologists who dismantled it for shipment. It is possible that the *Hijaz Railway* line that the Ottomans were building with German technical assistance, already passed near the site of al-Mushatta. This might have simplified the transport in bringing the prized façade by train to the Mediterranean port of Haifa from where it was shipped to Germany to be reassembled and displayed in Berlin. The façade is divided into triangular sections that measure about 2.85 m. in height and 2.50 m. in width at the base. A large rosette highlights the centre of each of the triangles. The façade is sumptuously decorated with friezes of animals and vegetal motifs. The decoration of the triangles to the right of the main gate differs greatly in style and execution from that of the left triangles and it has been suggested that this is the result of work by different teams of craftsmen. The façade in front of the mosque is decorated with vegetal motifs and does not include animals, thus adhering to the already established Muslim tradition against human and animal representations in mosques. The decor of the façade was carved after its construction and the ornamentation of the blocks was never completed.

Some of the vegetal motifs reveal Coptic stylistic influences, while Persian iconography can be recognised in the use of mythical animals taken from Sassanian art. It is not unlikely that some of the craftsmen were recruited from Egypt and Iran.

Capital with Kufic inscriptions from al-Muwaqqar water reservoir, Jordan Archaeological Museum (Inv. Num. J 5085), Amman.

travellers and orientalists such as Aloi Musil. When the architectural historian K.A.C. Creswell visited the site during the early 1960's, much of what the early visitors had seen had been destroyed except for a few subterranean vaulted structures that have survived until today. The most important remains of the Umayyad complex is a vast reservoir that is still in use. It probably served caravans passing through the area, as well as the local inhabitants.

A few ornate capitals that once crowned the columns and carried an entablature have been salvaged from the site and moved to a number of museums. One of these capitals, today in the Archaeological Museum on the Amman Citadel, is of considerable importance. This capital belongs to a column, part of which has survived that was once used to measure the water in the reservoir. The capital bears an Arabic inscription revealing that the reservoir was built by order of the caliph Yazid I from 103/722-104/723.

M. A

III.1.c **Al-Muwaqqar Water Reservoir**

The reservoir lies about 20 km. east of Amman. From al-Mushatta, turn back through the eastern route to Amman and follow the route of Sahab Azraq proceeding directly to the site of the reservoir.

The buildings of al-Muwaqqar have been destroyed almost completely. A few remains still existed at the turn of the century when the site was visited by early

III.1.d **Qasr al-Kharrana**

Lies 55 km. east of Amman on the north side of the road to Azraq. From al-Muwaqqar, continue the route of the Sahab Azraq highway. Typical Jordanian hospitality awaits the visitor in a Bedouin tent near the site.

Qasr al-Kharrana is a relatively well-preserved square building that measures about 36.50 x 35.50 m. It has two storeys of rooms decorated with stucco and

arranged around a courtyard with a cistern underneath it. Small rooms are annexed to two rectangular halls (around 13 x 8 m.) on the southern, or frontal, side which are "divided" by the entrance passageway. Two inner stairways are directly opposite the eastern and western sides and lead to the upper storey.

The *qasr* is built of stone rubble and was once covered with a coat of mortar. The four corners are distinguished by three-quarter round towers and a semicircular tower marking the middle of the eastern, western and northern façade. Two quarter-circle towers flank the entry gate in the centre of the southern façade.

The façades of the structure are further articulated through the use of a herringbone design, diagonally placed bricks that run as a frieze around the upper quarter of the building.

In spite of Qasr al-Kharrana's fortress-like appearance, the building was not used for military purposes. The towers and the numerous arrow slits marking the outer façades are ornamental since the former are solid and the arrow slits too high above the floor to serve archers.

The *qasr* shows Persian influence in the building methods (rubble covered in mortar) and its decoration (of stucco finish). This has led K.A.C. Creswell, the renowned historian of Islamic architecture, to conclude that it was not an Umayyad but a Sassanian or Persian building going back to the Sassanian occupation of the area from 614 to 6/628. The Persians were not known to have carried out any building programmes, however, during their occupation. To the contrary, the idea

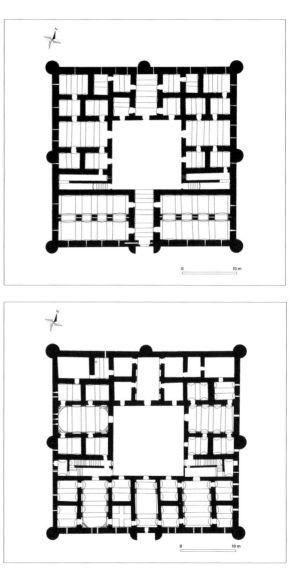

Qasr al-Kharrana, ground floor plan, before 91/710, al-Badiya (Utice, 1987).

Qasr al-Kharrana, upper floor plan, before 91/710, al-Badiya (Utice, 1987).

*Qasr al-Kharrana,
general view,
al-Badiya.*

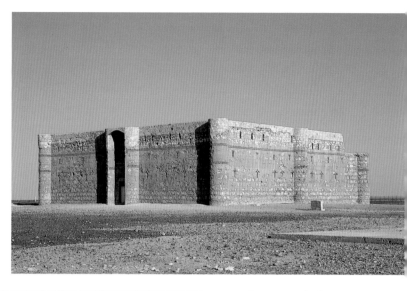

*Qasr al-Kharrana,
view of interior hall,
al-Badiya.*

of simulating a fortified appearance, and the fact that the related structures were non-functional, is characteristic of other Umayyad palaces such as al-Mushatta.

A graffito found in the *qasr* gives the precise date of 27th *Muharram* 92/24th November 710, which is evidence that the construction was either before or around that date. There has been considerable debate about the exact date and while some have attributed it to the reign of al-Walid I (86/705-96/715), there are other suggestions dating it before 65/685. The latter year favours the argument that the palace is the only pre-Marwanid Umayyad palace known. As for the main function of Qasr al-Kharrana, it has been posited that it was used as a meeting place where Umayyad princes met with local tribal leaders.

M. A.

III.1.e **Qusayr 'Amra**

Is 80 km. east of Amman and 16 km. east of Kharrana. To reach the site from al-Kharrana, continue on the same route along the Sahab Azraq highway. A Bedouin tent provides a

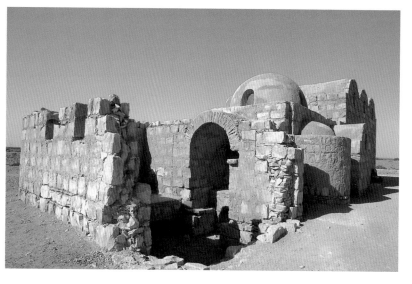

Qusayr 'Amra, furnace room behind the hot room, or caldarium, al-Badiya.

shady spot near the site where one can experience Jordanian hospitality.

The term *qusayr* is the diminutive form of *qasr*, which (as the English "Castle") is derived from the Latin *Castrum*. This relatively small and well-preserved palace contains an audience hall and a bath complex. A hydraulic complex with a water wheel worked by animal power, a 40 m. deep stone circular well and a cistern provide ample water (see Water and Irrigation). Recent excavations have brought to light additional buildings about 300 m. northwest of the main residence which, together with its hydraulic installation, were part of a large estate.

The discovered remains consist of another small castle with rooms arranged around a courtyard, a watchtower and a second watering system similar to the first installation. With it were found retaining walls

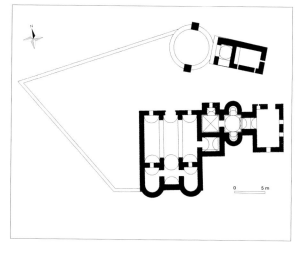

to prevent erosion of arable land in an agricultural plot.

The exterior of Qusayr 'Amra corresponds exactly to the spatial arrangement of the interior. The relatively small rectangular

Qusayr 'Amra, after 92/711, al-Badiya, (Grabar, 1973).

121

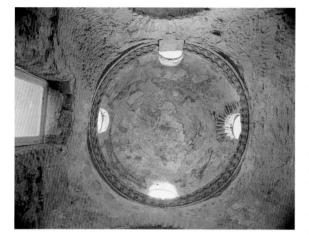

*Qusayr 'Amra,
painting of the Zodiac
over the caldarium,
al-Badiya (J. L. Nou).*

*Qusayr 'Amra,
painting of the Six
Kings, al-Badiya
(J. L. Nou).*

audience hall measures about 8.50 x 7.50 m. and is bordered on the south by a set of three small rooms. The hall contains three barrel-vaulted aisles separated from each other by two slightly pointed transverse arches, one of the earliest examples of its type in Islamic architecture.

The baths on the east side of the audience hall, consist of three small rooms. The

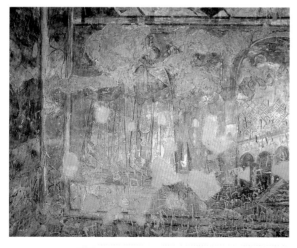

first of these is a barrel-vaulted "changing or disrobing room" (*apodyterium*) which leads to a "warm room" (*tepidarium*) covered by a cross vault and has a raised floor to allow for the circulation of warm air. The warm room in turn leads to the "hot room" (*caldarium*), which carries a dome on pendentives with four windows. A passageway that had a water tank on top of it leads from the hot room to an enclosure that contained the furnace. Ceramic pipes connected the water tanks to the baths, and drainpipes carried the used water from the baths to a nearby cesspool.

Mosaic pavements have been found in two of the small rooms annexed to the audience hall. Other rooms were paved with marble, and marble was also used to panel the walls up to a height of 80 cm. The frescoes are, however, the most famous feature of the palace. The paintings, which cover much of the walls and ceilings, are the most extensive frescoes to survive from any secular building before the Romanesque period. The paintings deal with a wide range of subjects. In the reception hall are hunting scenes, nude or scantily dressed women and exercising athletes. There are also scenes of craftsmen at work like blacksmiths, carpenters, masons and stone cutters. A ruler, probably the owner of the palace, is shown surrounded by birds and flanked by two attendants and personifications of poetry, history and philosophy.

A famous painting of the bath complex represents the constellations of the Northern Hemisphere accompanied by

the signs of the Zodiac with the Great Bear (*Ursa Major*) and Little Bear (*Ursa Minor*), which adorn the dome of the hot room.

The best-known painting, however, is the "Painting of the Six Kings" at the southern end of the west wall. This painting depicts the Umayyad ruler surrounded by six sovereigns who have been identified as the Byzantine emperor, the emperors of Persia and China, the Visigoth king of Spain, the king of Abyssinia and a Hindu or Turkish king. It is seen as a symbolic representation of the family of kings to whom the Umayyad dynasty belonged. Underlying this theme is an allegory "showing" the exalted position of the Umayyad *caliph* accepted the homage paid to him by the most important rulers of the world .

Ancient Greek influence in many of these paintings can be recognised in their subject matter, and in the fact that some bear Greek inscriptions. The historian Glen Bowersock has remarked that in Qusayr 'Amra "(...) there is little sign, apart from the architecture of the buildings themselves, that the region was then firmly in the hands of an Islamic administration". He adds that what we see is an "indigenous Hellenism that is local, not alien". Some of the hunting scenes could fit this interpretation. They seem to have been inspired by local nomadic cultural traditions going back far beyond any Greek influence.

Qusayr 'Amra has been attributed to al-Walid I (86/705-96/715), under whose

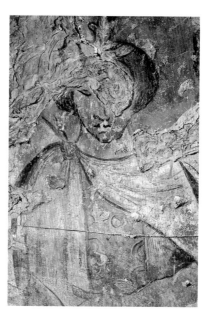

Qusayr 'Amra, detail of the painting of the Six Kings, al-Badiya (J. L. Nou).

rule Umayyad power reached its zenith. This attribution is based primarily on the study of the painting of the Six Kings. It has been argued that most of the figures represent rulers (or their descendants, as in the case of the Persian king) that had been defeated by al-Walid. The brief rule and life of the Visigoth king of Spain, Rodorik, from 91/710 to 92/711 came to an abrupt end during al-Walid's reign when Rodorik was defeated by the advancing Muslim troops. If the interpretation of the painting is correct, the demise of Rodorik provides a date for the construction of Qusayr 'Amra in that the palace could not have been built before 92/711.

M. A.

Mohammad al-Asad

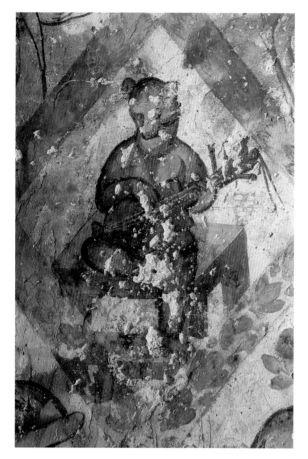

Qusayr 'Amra, painting in the bath complex of a bear playing the lute, al-Badiya.

Much of what we know about the lifestyles of the Umayyads, however, comes from literary sources, the earliest of which date from about a century and a half after the fall of the Umayyad dynasty. Two sources stand out in particular. The first is *Kitab al-Aghani*, "The Book of Songs" by Abu al-Faraj al-Isfahani (284/897-356/967). This work of 24 volumes consists primarily of an anthology of songs and poems popular in 4ᵗʰ/10ᵗʰ century Baghdad, but it also provides information about manners and customs in the Umayyad and Abbasid courts. The second source is *al-'Iqd al-Farid*, "The Unique Necklace" by Ibn 'Abd al-Rabbihi (246/860-328/940). This work is a collection of writings designed to provide specific knowledge for a well-educated man of the time, and in addition, includes useful information about life at the Umayyad court. Exceptional for the period, both authors appear favourable to the memory of the Umayyads. The fact that al-Isfahani, although a *Shi'i* Muslim, was a descendant of the Umayyad family, and Ibn 'Abd al-Rabbihi was attached to the Spanish Umayyad court in Cordoba, may have influenced their opinion contrary to the otherwise negative attitude held by many of their contemporaries. The time that separates them from the Umayyads of Syria, nevertheless, leaves some doubt as to the accuracy of their accounts.

Kitab al-Aghani and *al-'Iqd al-Farid* reminds one that listening to songs (and sometimes participating in the singing) was a major courtly pastime of Umayyad princes. One is told that Yazid I, the second Umayyad *caliph,* was a composer and

The palaces that have survived from the Umayyad period provide proof of the opulent lifestyles that Umayyad princes sought through their patronage of art and architecture. Reflections of such opulence can be found in the mosaic floors and stucco sculptures of Khirbat al-Mafjar, in the wall paintings of Qusayr 'Amra, and in the imposing basilica-like hall culminating in the tri-apsidal throne-room of Qasr al-Mushatta.

124

introduced singing and musical instruments to the Umayyad court. Some of the troubadours who performed at Umayyad palaces became famous. One of them, the Medinese singer Ma'bad Ibn Wahab (d. 125/743-744) became a favourite at the courts of al-Walid I, Yazid II and al-Walid II. Yazid II especially was fond of two female singers, Habbaba and Sallama, both of whom were pupils of Ma'bad. Al-Walid II, on the other hand, not only enjoyed listening to singers, but also composed songs himself and played the lute. The "Golden Age" of Arabic songs, however, came after the fall of the Umayyad dynasty. The greatest Arab singer probably was Ziryab (d. around 236/850). Ziryab was a freedman who first sang at the Abbasid court in Baghdad. His exceptional talent made his competitors jealous and intrigues instigated against him at court forced him to flee Baghdad. He finally settled in Cordoba, the capital of al-Andalus (Muslim Spain), where he found a patron in the Spanish Umayyad ruler 'Abd al-Rahman II (206/822-238/852). Ziryab is credited with introducing the sophisticated musical traditions from Baghdad to Cordoba, and initiating a musical Andalusian style. It was he who established the first conservatory of music in Spain and being an educated and refined person, he became a favourite and had his own followers in the Spanish Umayyad court. Information reveals that his contributions to courtly life ranged from introducing hairstyles to creating new culinary dishes and refining etiquette.

Al-Azraq Nature Reserves
The reserves and the ancient site are 110 km. east of Amman and 28 km. from 'Amra. They can be visited at any time during the day. Information: The Royal Society for the Conservation of Nature 06-5334610 or the Visitors Centre in al-Azraq 05-3835225.
Al-Shawmari Reserve lies a further 10 km. south of Azraq and the opening hours are from 7:30 am to 6:00 pm. The protected area encompasses 22 square kilometres and is one of the first of its kind in the region. The wildlife reserve also serves as an ideal place to reintroduce extinct indigenous fauna.
Al-Azraq Wetland Reserve is an oasis but it is best to check before visiting as it can be dry due to lack of rainfall. It protects the very fragile ecology of the marshland, which is a resting-place and feeding ground for migratory birds gathering here on their route to Africa. The marshland is, however, under constant threat of extinction due to the long draughts and depleted fossil water. The lack of surface water diminished the marshes and many flocks have had to bypass the reserve for want of food. Both the al-Shawmari and the Wetland Reserves are rare protected areas where visitors may still appreciate indigenous wildlife providing a glimpse of the rich and varied tapestry of flora and fauna that once existed in this region.

125

Palatial Residences

Mohammad al-Asad, Ghazi Bisheh

Water and Irrigation

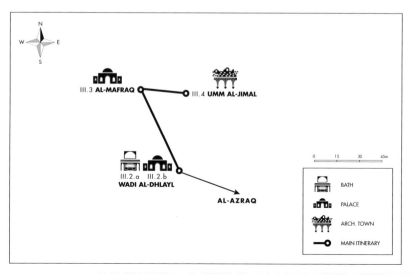

III.2 WADI AL-DHLAYL

III.2.a Hammam al-Sarah

*Is situated about 55 km. northeast of Amman
and 2 km. to the southeast of Qasr al-Hallabat.
To reach Hammam al-Sarah from Azraq take
the main road between Azraq and Zarqa head
north.*

The plan of the building is strikingly sim-
ilar to Qusayr 'Amra, though its mason-
ry is better finished and its courses are
more tightly joined. It consists, like
'Amra, of three principal elements:
 Audience hall
 Baths complex
 Hydraulic structures
To these elements might be added a
roofless mosque which is of recent
construction.
The bath is entered through a door in
the centre of the south wall; the entrance
is spanned by a single monolithic lintel
carved with a tabula ansata and two
knotted wreaths. The audience hall is
roofed by three tunnel vaults resting on the
sidewalls and two intermediate transverse
arches which sprang from two engaged
pillars. The northeastern corner of the
audience hall has a fountain pool, which
received its water from the water tank
situated to the east. At the back of the
central aisle of the hall is an alcove; two
doorways on the right and left sides of the
alcove open into lateral rooms, which were
paved with coloured mosaics. At the back
of the side rooms, in the outer corners, are

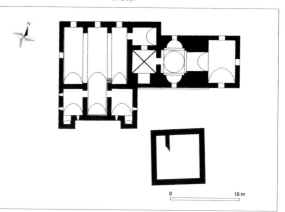

Hammam al-Sarah,
$2^{nd}/8^{th}$ century, Wadi
al-Dhlayl (Creswell,
1958).

Hammam al-Sarah,
view of interior, Wadi
al-Dhlayl.

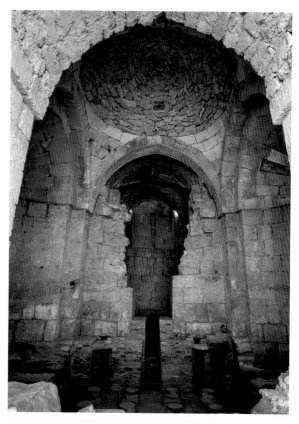

127

Hammam al-Sarah, hypocaust, Wadi al-Dhlayl.

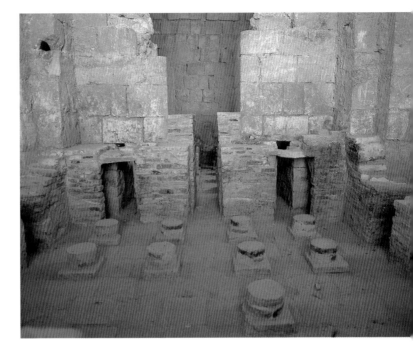

two small rectangular recesses, forming salients on the east wall. It is clear that the two recesses were latrines.

A door in the northwestern corner of the audience hall leads into the tunnel-vaulted disrobing room *(apodyterium)*. In the centre of the east wall is a door, which leads into the cross-vaulted warm room *(tepidarium)*. On the far side of the room, opposite the entrance, is a nearly square recess covered by a tunnel vault. In the upper part of south wall there are three vertical grooves, which extend through the roof to the outside. These grooves were intended for pottery pipes, which served as chimney-flues. The floor of this room was sustained by 25 supports built of circular bricks. A door in

the centre of the north wall leads into the hot-room *(caldarium)*. To the left and right are two semi-circular recesses topped by semi-domes; the walls of the recesses, which served as a tub in which bathers could splash themselves with water, are pitted with small holes for the original marble cladding. The hot room was originally covered by a spherical dome built with 19 projecting ribs composed of wedge-shaped pieces of shale. The *hypocaust* consists of 16 supports arranged in four rows. On the north side is a tunnel-vaulted passage and at its far end is the stokehole. The vaulted passage opens onto an open-air walled enclosure which was the service and storage area for fuel.

To the east of the bath proper are the hydraulic structures, which consist of three main features:

a) A raised square water tank, which allowed the gravitational flow of water.

b) A well 5 m. in diameter constructed of coursed masonry.

c) A round structure built largely of roughly shaped stones and rubble. It served as the space where the beast of burden walked round to drive the water pumping mechanism (*saqiya*) and to lift water from the well into the tank. Finally, it should be pointed out that Hammam al-Sarah should be understood not as an isolated monument, but in relation to Qasr al-Hallabat, which was rebuilt in the Umayyad period (see Qasr al-Hallabat).

G. B.

III.2.b Qasr al-Hallabat

Is about 65 km. east of Amman, 30 km. east of Zarqa and about 18 km from the nearest point (to the northwest) of the Via Nova Traiana. The site can be reached from Hammam al-Sarah on the same road between Azraq and Zarqa going north. Both sites are open during the day. There is no entrance fee.

The site of Qasr al-Hallabat comprises a conglomerate of separate and widely spaced units. These include: a *qasr* (castle), a mosque, a huge reservoir and eight cisterns dug into the western slope. In the plain next to the reservoir is an irregularly shaped agricultural enclosure with an elaborate system of sluices and a cluster of poorly built houses, which extends to the northwest of the reservoir. To these

units should be added the baths complex of Hammam al-Sarah (see Hammam al-Sarah) situated 2 km. to the east of the castle.

The plan of the castle measures 44 m. in length with square corner towers, which project from the face of the enclosure wall. The entrance to the building is through a single doorway in the middle of the east wall. It opens into a passageway, leading to an open courtyard paved with flagstones. Originally a portico surrounded the courtyard because the walls facing this courtyard were plastered, which in some places preserved faint traces of paintings in dark brown. A series of oblong and nearly square rooms surrounds three sides of the central courtyard. The northwestern quadrant is occupied by an inner structure, which also consists

Qasr al-Hallabat, Wadi al-Dhlayl (Piccirillo, 1986).

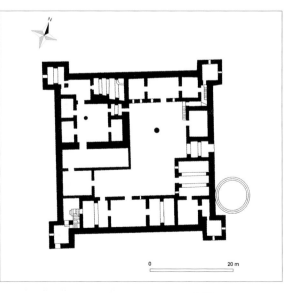

0 20 m

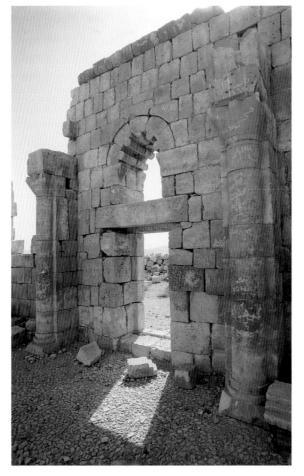

Qasr al-Hallabat, detail of the mosque facade, Wadi al-Dhlayl.

servants' quarters. In each of the two courtyards there is a cistern.

There were two inscriptions thought to be related to the architectural phases of the castle: one is in Latin, dated 212, and refers to the construction of a *Novum Castellum*; the other is in Greek and dated 529. Excavations and clearance work within the castle uncovered a total of another 142 Greek inscriptions, in addition to two Nabataean, one Safaitic and one modern Armenian inscription. The vast majority of the Greek inscriptions, engraved on regularly dressed basaltic stone, belong to an edict issued by the Byzantine emperor Anastasius (491-518) for the administrative and economic reorganisation of *Provincia Arabia*. It is likely that all the inscribed stones were brought from a nearby settlement, possibly Umm al-Jimal, and reused as building material during the Umayyad reconstruction of the castle. In the course of this reconstruction, the castle was provided with elaborate decorations in carved stucco, frescoes and coloured mosaics, and thus transformed from a fortified building into a palatial residence. This change was accompanied by a remarkable development of the site, which can be seen in the appearance of new monuments such as the extra-mural mosque, the agricultural enclosure with an elaborate irrigation system, and the bath complex of Hammam al-Sarah.

G. B.

of a central courtyard surrounded on all sides, except the south, by a number of rooms. This quadrant, is set apart from the rest of the building. It contained a small winepress and may have served as

130

WATER AND IRRIGATION

Ghazi Bisheh

Jordan reached its highest degree of economic development in the Byzantine period, which included the ruralisation of the country. Archaeological surveys show that the number of rural settlements in the Byzantine period was higher than in any period preceding it. It is likely that the countryside flourished in the Byzantine period at the expense of cities, which shrank in size and population. The last decades of Byzantine rule, however, marked by continuous strife with the Sasanians (see The Umayyads: the Rise of Islamic Art) were a period of regression, though churches continued to be built. Unfortunately, Arabic sources on agricultural activities in Jordan during the early Islamic period are patchy and not sufficient to form a clear picture of the overall trend of agricultural development. This deficiency, however, is compensated by archaeological and epigraphical evidence, showing that the Umayyad *caliph*s and

members of the ruling family had sponsored water-harvesting projects as part of a wider policy of land reclamation. The perceptive French scholar, Jean Sauvaget, noted that the commonly called Umayyad desert castles (al-Qastal, al-Muwaqqar, al-Mushatta, Qusayr 'Amra, etc.) were always equipped with hydraulic structures such as cisterns, reservoirs, dams and aqueducts, and proposed that these buildings were centres for agricultural exploitation. These structures did not serve to supply the palace with water merely, but also to water fields and gardens. Innumerable cisterns dug out of the limestone rock dot the landscape in the immediate vicinity of al-Qastal, al-Muwaqqar, al-Mushatta and al-Hallabat. Substantial dams can be seen at al-Qastal and al-Qanatir (see al-Qanatir) situated halfway between al-Qastal and Umm al-Walid. An Arabic inscription tells us that Yazid I ordered the construction

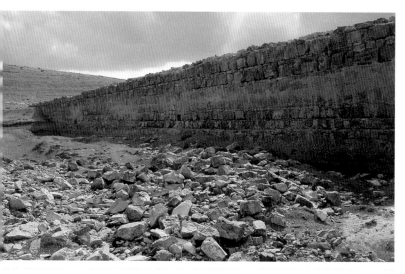

South-East Dam, al-Qanatir.

131

of the reservoir at al-Muwaqqar. At al-Hallabat, the pre-Islamic fortress was transformed into a luxurious residence and fitted out with extensive decorations in mosaics, carved stucco and frescoes. This transformation was accompanied by the introduction of new structures: a bath (*Hammam* al-Sarah), an extra-mural mosque, a huge reservoir and numerous underground cisterns. Approximately 400 m. to the west of the *qasr*, an agricultural enclosure (270 x 220 m.), with an elaborate system of sluices for the distribution of water to the rectangular plots within the enclosure, was set up. A grandson of the *caliph* 'Uthman Ibn 'Affan owned al-Fudayn (see al-Fudayn) and large tracts of land around it. Unlike Iraq, where investment in irrigation was made in conjunction with the founding of new cities (*amsar,* sg. *misr*), for example Basra, al-Kufa and Wasit, in Syria, the wealthy Arab investors preferred unoccupied terrain and the development of new land, perhaps to avoid the claims of landlords and peasants, and to benefit from tax differentials. Since for new, undeveloped land one paid the tithe (*'Ushr*) instead of the higher land tax (*kharaj*), the tax differential offered a more lucrative return for private developers. Members of the ruling family, tribal chiefs and high government officials, therefore, began to seek generating revenue from the reclamation of wasteland (*Mawat*). This led to the expansion of the agricultural regime to marginal areas. An Arabic source describing the dominant traits of each Umayyad *caliph* related that the dominant trait of al-Walid I (86/705-96/715) was his love of building, the construction of the irrigation works and the acquisition of estates. During his reign, people avidly amassed estates and properties, confirming the Arab proverb, "people follow the religion-trait of their leaders".

North-West Dam,
al-Qanatir.

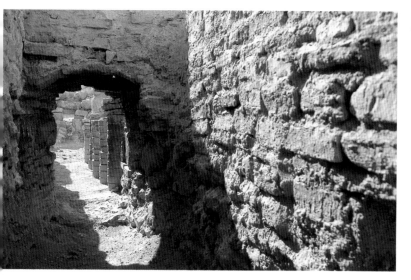

*Bath complex,
al-Fudayn (Mafraq).*

III.3 AL-FUDAYN (MAFRAQ)

*The site, located in present-day Mafraq where
the road branches north to Syria and east to
Iraq. It is about 70 km. to the northeast of
Amman and most easily reached by car from
Qasr al-Hallabat toward Zarqa heading north
to Mafraq. Information: Dept. of Antiquities
office at Mafraq 02-6231885.*

The word *al-Fudayn*, diminutive of *Fadan*,
is of Aramaic origin meaning high wall or
tall and elevated building. The site was
first occupied in the Neolithic and Bronze
Ages. In the Iron Age, possibly in the 9th
century BC, a fortified structure
measuring 70 x 50 m. was built to defend
the area against nomadic attacks. This
structure was destroyed apparently in the
8th century BC, perhaps by the military
campaign of the Assyrian king Tiglath-
Pileser in 732 BC. In the Byzantine
period the site accommodated a monastic
complex (*al-Samra*), which was
transformed into a palatial residence in
the Umayyad period.

The ruins, which take the form of a rec-
tangle (180 x 60 m.), consist of three
main architectural units:

— A rectangular structure (70 x 47 m.)
surrounded by substantial walls built of

*Al-Fudayn (Cortesy
of A. Husan).*

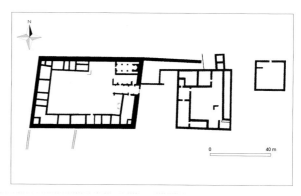

gigantic blocks, some of which weigh up to five tons. On the inside, the plan consists of a central courtyard with a series of rooms built within the enclosed walls. The northeastern corner is occupied by a chapel with a mosaic pavement. To the south of the chapel, there is a passageway, apparently an addition from the Umayyad period. It was in this passageway that a cache of iron animal moulds was found, which included an elephant and a ram; the hiding place also contained a bronze "brazier", an incense burner and numerous steatite vessels.

A structure measuring 40 square metres with a central courtyard was flanked by rooms of various sizes. This unit was the residence of the owner of al-Fudayn. It was provided with a bath complex on the north side complete with a furnace, *hypocaust,* cold, warm and hot rooms as well as a hall for disrobing and relaxation.

To the south was a mosque with a complex history reflected in the modifications introduced into the original plan. The south (*qibla*) wall was coated with stucco panels, which may have dated from the early Abbasid period.

A small square structure measuring 20 x 20 m. of fairly late date.

Information on the history and owners of al-Fudayn has been obtained from the Arabic sources. The agricultural estate of *al-Fudayn* was bought by Khalid Ibn Yazid Ibn Mu'awiya, in exchange for *al-Khadra'* the palace with a "green" dome in Damascus. Later, it was transferred to Sa'id Ibn Khalid Ibn 'Amr Ibn 'Uthman, a great grandson of the third Orthodox *caliph.* The new owner was extremely wealthy and in addition to *al-Fudayn,* he owned extensive estates and tenement apartments in Damascus. One of Sa'id's daughters married the *Caliph* Hisham Ibn 'Abd

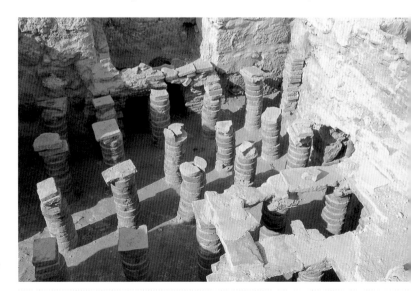

Bath complex, hypocaust, al-Fudayn (Mafraq).

al-Malik, and another by the name of Sa'da was the wife of al-Walid II until her death before his accession to the caliphate. Upon her death al-Walid II married Sa'da's sister, "Salma" who was to die before the murder of her husband. The ownership of *al-Fudayn* apparently remained in the hands of the descendants of Sa'id until the end of the $2^{nd}/8^{th}$-first 3^{rd}/first quarter of the 9^{th} century. During the reign of the Abbasid *Caliph* al-Ma'mun (197/813-218/833) Sa'id al-Fudayni led a revolt and claimed the caliphate. The revolt was, however, short-lived and ended with the escape of al-Fudayni and the destruction of *al-Fudayn* at the hands of Yahya Ibn Salih, commander of the army sent against the rebel. *Al-Fudayn* belonged to what might be called privately reclaimed land, and it was referred to in the Arabic chronicles as an agricultural estate (*Day'a*). Among the remarkable artifacts uncovered at *al-Fudayn* is a bronze brazier supported on four griffins with outspread wings. On the upper corners stand nude women with one hand stretched forward and another holding a bird or a torch. The sides are decorated with arcad patterns, six of which contain panels representing erotic scenes.

G. B.

III.4 **UMM AL-JIMAL**

The ruins are 20 km. east of Mafraq. The site can be reached by car from Mafraq going east to Umm al-Jimal. Information: Tourist Information Office 02-6267040.

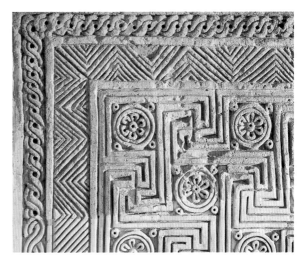

Umayyad Mosque, carved relief, al-Fudayn (Mafraq).

The settlement of Umm al-Jimal consists of two parts. The first has survived in relatively good condition and archaeologists refer to it as the "town" of Umm al-Jimal. It was inhabited during the Roman, Byzantine and Umayyad periods from the 2^{nd} to the mid-$2^{nd}/8^{th}$ century. The second part is about half the size of the town and has been called the "village" of Umm al-Jimal. Unlike the town, the village, situated 200 m. east of the town, is totally in ruins. The village was inhabited during the Nabataean and Roman periods between the 1^{st} and 4^{th} centuries. The village of Umm al-Jimal was primarily a civilian settlement. It had no enclosure wall, which attests to the security that prevailed during the *pax romana* when the region became a Roman province in the early 2^{nd} century. Remains show that the village was linked closely to nearby Bostra (in modern Syria), the capital of the Roman province of Arabia. In fact,

135

Umm al-Jimal
(de Vries, 1998).
1 North Church
2 North East Church
3 West Church
4 Cathedral
5 Main Reservoir
6 "Praetorium"
7 Numerianos Church
8-9 Housing
Complexes
10 South West Church
11 Barracks Chapel
12 Later Castellum
13-14 Housing
Complexes

historical sources mention that residents of Umm al-Jimal even served on the Bostra city council during the 2nd and 3rd centuries.

The town of Umm al-Jimal, founded in the 2nd century, was a Roman military and administrative centre. The main occupants were Roman soldiers and administrators, while civilians continued to live in the nearby village. Parts of the *praetorium* (administrative seat) and the *castellum* (barracks) are still standing. In addition, one can see the remains of one of the earliest dated structures in the town, the northwest gate, which carries an inscription dated from the reign of the emperor Commodus (161-192). The gate

was one of eight belonging to the defensive town wall.

During the Roman period, Umm al-Jimal was not very important as a civic community and held a secondary position to the major *Decapolis* towns of the area such as Bostra, Philadelphia (Amman) and Gerasa (Jerash). In fact, it lacked the formal layout and the monumental public spaces and buildings characteristic of such *poleis* (pl. of *polis*, ancient Greek city-state).

The town achieved considerable prosperity during the Byzantine period, especially during the 6th century. It was a period when imperial control weakened in the area, and a town Umm al-Jimal was probably responsible for its own defence. The town probably served as a stop for caravan routes passing through the region, and, more importantly, was a trading centre for agricultural products grown in the area. In contrast to the Roman period, noted for the growth of urban centres, the Byzantine period was characterised by increasing towns and villages in the countryside due to flourishing production and trade of agricultural goods. Umm al-Jimal is a typical example of these new and prosperous country towns and it is posited that the population of Umm al-Jimal, during that period, increased to about 3000.

It was during this period, that the town changed from a military and administrative centre to a domestic settlement, and became noted, as other areas during the Byzantine period in general, for extensive church building. The remains of no less

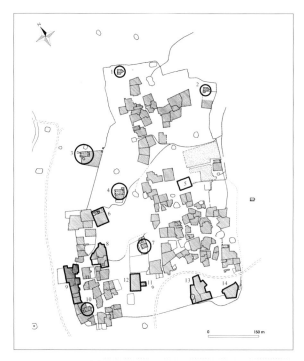

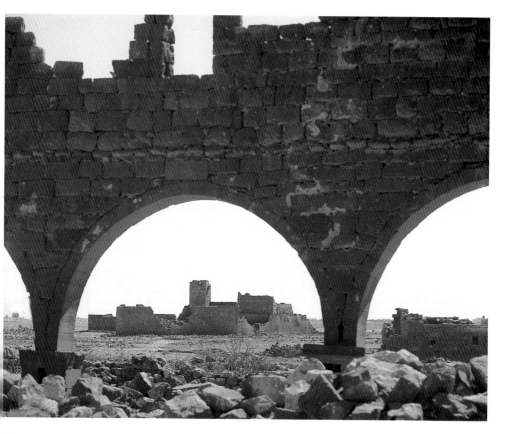

Barracks, Umm al-Jimal.

than 15 churches have been found. The largest is the Church of Julianus and while traditionally dated 345, latest research has shown that the church was not built until the late 5th or 6th century.

Presumably local Arab tribes inhabited both the village and the town, and inscriptions from the site indicate that the inhabitants were bilingual in Greek and in Nabataean, one of the earliest recorded local Semitic languages.

The town of Umm al-Jimal continued to be inhabited during the Umayyad period, but on a smaller scale than in the Byzantine period. Umayyad building activity was limited to adapting existing structures mostly, including the *praetorium*. Most of the rooms of the *praetorium* were replastered and a mosaic floor was installed in the "cruciform room". Inhabitation of the town does not seem to have lasted beyond the Umayyad period, and abandonment was probably due to the devastating earthquake of 131/749, which left most towns of the region in ruins.

137

The town was deserted until the early 20th century when members of the Druze religious sect moved there from nearby Jabal Druze, located to the north in modern-day Syria. They settled there for about three decades and reconstructed a number of the historical buildings in the town for their own use. At first glance, it is difficult to differentiate between the original and the reconstructed parts since the work done by the Druze closely resembles the original constructions. The French and British armies also used the town as military camps before the modern border between Jordan and Syria was drawn up in the 1920's. Following that, local Bedouin families inhabited the town until 1975, when the Jordanian government fenced it in to protect the archaeological site.

It is interesting to note that there is no reference to the name of *Umm al-Jimal* (Arabic for "Mother of Camels" which also meant the "Place of Camels") before the 13th/19th century. It is this name, however, which has led to the claim that the town served as a stopping place for caravans. The ancient name of the town remains unknown and none of the numerous inscriptions give any information about its first appellation prior to the 13th/19th century name.

The area in which Umm al-Jimal is located receives relatively scarce rainfall of about 100 mm. every year between the months of November and March. As

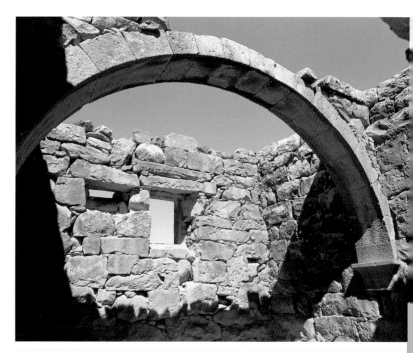

Praetorium, view of interior, Umm al-Jimal.

there are no wells or springs in the town and its environs, water had to be collected during the rainy season and stored in cisterns. Each of the houses had at least one cistern and a number of large public cisterns were distributed throughout the town.

One of the most striking features of Umm al-Jimal is the black basalt stone from which the buildings were constructed. The dark stone, which gives the town and even the ruins today a somewhat daunting sense, is volcanic rock that is abundant in the area. The stone was not only used for walls but also for the roof construction made of stone beams resting on corbels or on narrowly spaced arches. Even the doors were made of stone slabs rather than wood. This extensive use of stone is largely responsible for the survival of a considerable number of the buildings at the site.

M. A.

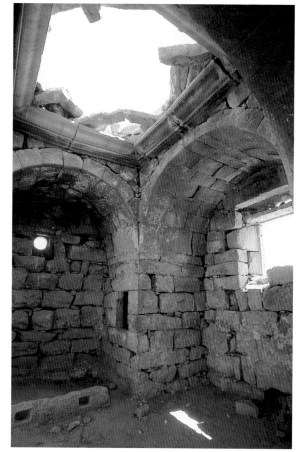

Praetorium, view of interior, Umm al-Jimal.

The *Decapolis* in the Umayyad Period

Fawzi Zayadine, Ina Kehrberg, Lara Tohme, Ghazi Bisheh

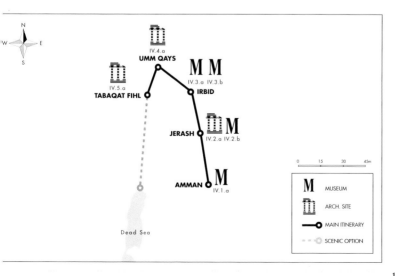

*Octagonal Church,
Umm Qays.*

Umm Qays (Gadara), aerial view, (Courtesy of J. Taylor).

Initiated by Pompey when he occupied Damascus in 64 BC, the *Decapolis* was a union of cities in Syria, Palestine and Jordan, and as the name indicates, originally 10 in number. The member cities must have varied, however, as there are ancient lists, which name any number from 11 to 18 cities. The collapse of the Seleucid Empire was followed by an incursion of the Hasmonaean Jews who captured and destroyed the Hellenised cities, such as Pella and Gadara. At that time, the Nabataeans were at the zenith of their power and had expanded their commercial kingdom to the Hawran and even occupied Damascus from 83 to 72 BC. Pompey freed the *Decapolis* cities from Hasmonaean domination and began to rebuild them. To control Nabataean expansion, he created the union of the *Decapolis* cities, six of which are in the Jordan. They became an administrative entity

and were ruled by a Roman governo[r]. They adopted Greek as an administrativ[e] and religious language and borrowed th[e] urban planning system of Athens a[nd] Rome. In the 2nd century, after the Rom[an] annexation of the Nabataean kingdom [in] 106, the *Decapolis* cities enjoyed gre[at] prosperity based on the *pax romana* and th[e] creation of a network of roads, whi[ch] opened the way to free and safer tra[de] between the reorganised provinces of th[e] East from Lebanon to Syria-Palestine a[nd] the Jordanian plateau. The *Via Nova Tra[j]ana*, paved and fitted with statio[ns] between 107-114 by the order of Traja[n] contributed greatly to the unity of th[e] province of Arabia. The now Roman citi[es] of Philadelphia (Amman), Gerasa (Jerash[,] Gadara (Umm Qays), Capitolias (Ba[it] Ras) and Abila (Quwailbeh) were emb[el]lished with colonnaded streets, temple[s] theatres and baths. At the beginning of th[e]

4th century, after the revolt of Queen Zenobia in Palmyra (Syria), Emperor Diocletian regrouped the provinces of Syria and Arabia into three districts, called *Palestina prima, Palestina secunda* and *Palestina tertia*.

In the Byzantine period, the *Decapolis* cities continued to function more or less in the same vein, accepting Christianity as the religion of the Roman empire after the victory of Constantine the Great in 324 and the creation of Constantinople as the capital of the Christian East. A new trend in art and architecture was inaugurated re-using Roman monumental plans and decoration. The first church built by Constantine the Great was in 313, St. Giovanni's in Laterano, based on the plan of the Roman basilica (market) and decorated with mosaics on the floors and walls. This became the basic model for future church buildings.

After the Arab-Islamic conquest in 15/636, the passing of power into Muslim hands was peaceful and the Christians continued to practise their religion and pave their churches with mosaics (see Historical Artistic Introduction and The Umayyads: The Rise of Islamic Art). When the Umayyad *caliphs* established their capital in Damascus, the *Decapolis* of Gerasa, now Jerash, continued to be an important station on the way to Philadelphia, now Amman, and the holy cities of the *Hijaz* in Arabia.

At the south *decumanus* (east-west street) in Jerash, a large Umayyad quarter was built on the very spot of a Roman and Byzantine domestic complex. Apparently, a small "mosque", along the *cardo maximus* (north-south street) was built on the foundations of an abandoned Roman house (see Jerash / Gerasa). The cities of the ancient *Decapolis* continued

Jerash (Gerasa), general view.

143

Obverse of Umayyad gold coin, 'Abd al-Malik Ibn Marwan, Numismatics Museum, CBJ, Amman.

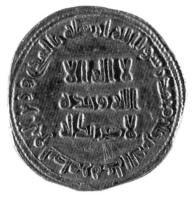

Reverse of Umayyad gold coin, 'Abd al-Malik Ibn Marwan, Numismatics Museum, CBJ, Amman.

of Umm Qays continued to be used in the Umayyad period. Bayt-Ras, ancient Capitolias, famous for its wine, became the summer resort of *Caliph* Yazid I (101/720-105/724). He resided there with the famous singer, the slave Habbaba, who met her premature death by swallowing a pomegranate seed. When building their palaces and caravan stations to suit their taste, the Umayyads selected from the rich architectural and artistic repertoire of *Decapolis* cities certain building types, construction techniques and decorative styles. Qusayr 'Amra (see Qusayr 'Amra and Palatial Residences) is one of the best-preserved examples illustrating this brief renaissance of the Graeco-Roman arts in the mid-2nd/8th century.

F. Z

IV.I **AMMAN**

IV.1.a **The Numismatics Museum**

The Numismatics Museum is housed in the Central Bank of Jordan, Amman. Open from 9 am-3 pm weekdays. No entrance fee. The museum has a collection of over 2000 coins from different periods from the Hellenistic to the Islamic eras, including 20th century Jordanian coins. Information: Numismatics museum 06-463 0301.

Coinage gradually became less frequent in the Umayyad and succeeding Islamic periods. At first, the Umayyads used

to prosper through commerce and issued coins struck with inscriptions in Arabic and representations in imitation of Byzantine money. The northern *Decapolis* cities continued to prosper, although modestly: a new quarter was rebuilt at Pella (Tabaqat Fihl) in the Jordan valley and at Gadara, the Roman thermal baths of Hammat Gader were renovated under Mu'awiya Ibn Abi Sufyan (41/661-60/680). The Basilica of the Miracle of Christ at the west gate

144

*Reverse of gold-coin
hoard, al-Walid I,
Numismatics Museum,
CBJ, Amman.*

*Reverse of silver-coin
hoard, al-Walid I,
Numismatics Museum,
CBJ, Amman.*

ate Byzantine coinage as their own cur-
rency, but also re-minted them, i.e.,
super-imposed their own emblems on
op of the Byzantine images. Early
Umayyad society continued at first to
mint their coins in the manner of Per-
sian money with Sassanian inscriptions
and images. Gradually, Arabic texts
were added and the name of the *caliphs.*
n 77/696-697, the *caliph* 'Abd al-Malik
issued a reform for minting Umayyad
coins and brought about standardisation
of Islamic coinage where all images
were removed and their space filled
instead by the written word (see Early
slamic Coinage).

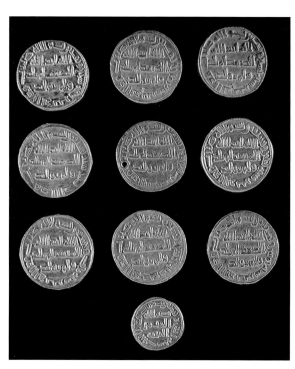

Umayyad gold coin

The coin minted during the reign of 'Abd
al-Malik Ibn Marwan in 78/697-698.

Umayyad gold-coin hoard

The complete collection of money was
minted during the reign of al-Walid I
86/705-96/715); the small coin is worth
one-third of a dinar and was minted in
91/709.

Umayyad silver-coin hoard

This complete set of coins was minted
during al-Walid I (86/705-96/715) in the
town of Waset in Iraq.

I. K.

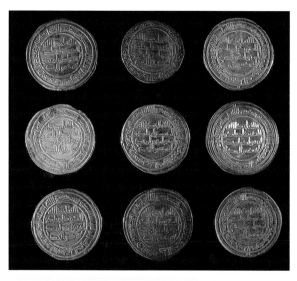

IV.2 JERASH (GERASA)

The town is 42 km. north of Amman. The archaeological site is open daily from 8 am until sunset with an entrance fee, which includes a visit to the museum on site. Jerash can be reached by taxi or car as well as by bus, departing from Abdali bus station in downtown Amman. Tickets are available by the Hadrianic Gate at the Tourist Centre on the parking lot. Information: Dept. of Antiquities office at Jerash 02-6351014 or the Visitors Centre 02-6351272.

IV.2.a Archaeological Site of Jerash

Rich in soil, with water supplied by perennial springs and a mild Mediterranean climate, the valley of Jerash attracted human settlement early in pre-recorded history. The earliest evidence of settled life was found east of the Hippodrome and the Hadrianic Arch where ploughing brought forth masses of fine Neolithic flint tools dating from about the 7th millennium BC. Dolmens and an Early Bronze Age village (around 2500 BC) in the northeast of the valley, are indications of a continuous settlement in the Jerash Basin and the town of Jerash in particular. The *tell* of the early town, now occupied by the local museum, east of the Oval Piazza, dating in unbroken sequence from the Early Bronze Ages or 3rd millennium BC, through the Bronze and Iron Ages and continuing the sequence from the

Hellenistic to Byzantine and Early Islami(c) times. This faint echo of the settlement i(s) evident in the ruins of the town, in th(e) area that grew around the nucleus of th(e) *Tell* named "Camp Hill".

Jerash was first mentioned in the Hel lenistic period by Ptolemy II or Philadel phus of Egypt (283-246 BC) who rule(d) this part of Jordan in the 3rd century B(C) and gave the name of Philadelphia t(o) Amman. The change of the name to "Anti och on the Chrysorhoas" was done b(y) Antiochus IV, who ruled over this area i(n) the early 2nd century BC. At the end of th(e) 1st century Flavius Josephus related in hi(s) account the story of the "Tyrant" Theo dosus of Philadelphia who lived at the en(d) of the 2nd century BC. Apparently, after having been chased from Gadara (Umm Qays), he fled to Gerasa where, it wa(s) claimed, he hid his treasures in the Tem ple of Zeus and asked for asylum as no one could violate a person who sought sanctu ary at that temple. This "law" was know(n) from early ancient Greek times where some temples became inviolable places o(f) refuge. Another story (confirmed b(y) inscriptions) reported that the Jewish Hig(h) Priest and ruler of Gerasa, a certain prince Alexander Jannaeus who governed the town from 102-76 BC. Upon the arriva(l) of Pompey the Great in 63 BC he declare(d) Gerasa as part of the Province of Syria. This step brought Jerash into the Roma(n) World, but it was not until about 200 year(s) later that Gerasa was proclaimed a colony, a cherished annexation with the larg(e) Roman Empire, elevating its politica(l) standing, which carried with it profitabl(e) privileges for the Gerasites.

Oval Piazza and Cardo, Jerash.

Jerash, aerial view (Aerial Archaeology in Jordan Project, photo B. Bewley).

During these three millennia, Jerash grew from a small village (the *Tell*) into a vibrant provincial centre during the *Decapolis* era, which began flourishing under Trajan at the turn of the 1^{st}-2^{nd} centuries. Gerasa, as it was renamed again under Roman rule, peaked in the second half of the 2^{nd} century and gradually lapsed again into small town existence during the 3^{rd} century. The latter change was brought about slowly by political events that took place at Rome and because of Rome. Even though Gerasa lost its main place at what was once the crossroads between north and south, the town continued to prosper moderately through its agriculture and above all the pottery manufacture and their trade from the late 2^{nd} century onwards. In fact, it was the ceramic industry, which helped Gerasa sustain decent living standards and even some wealth right through to the Late Roman and

Byzantine periods, to diminish only sometime after the Islamic conquest. Archaeological evidence shows only a gradual decline probably caused by the fall of the Roman Empire and not by any violent cultural break between the Byzantine and Islamic worlds and new trading routes when the early Islamic capital was moved from Damascus to Baghdad.

Examples of cultural continuation in spite of political changes are expressed in the re-use of civic buildings, for example, the North Theatre and the *Artemision*. During the 1st/7th and 2nd/8th centuries, parts of the buildings and complexes became a smaller version of potters quarters as observed earlier from the 3rd to 6th-early 1st/7th centuries at the Hippodrome, which was the largest industrial complex. It is possible that many of the potters from the hippodrome moved inside the city walls toward the north of the city and occupied space in the theatre, which was architecturally similar to the Hippodrome, and the nearby shops along the north *cardo*. This probably was not due to uncertain times of the Islamic conquest (15/636-40/661), which at Jerash shows no evidence of destruction, but rather because of the plague or "Black Death" which struck Jerash in the middle of the 1st/7th century for the second time in 100 years. The mid-1st/7th century mass burials in the *cavea* chambers of the Hippodrome suggest strongly that the area as a whole had already been abandoned and the building was chosen because of its isolation outside the city wall (and perhaps also because the grounds were once part of the Roman

necropolis). The North Theatre complex continued to be occupied sporadically in a squatter-like manner like other ruins of Gerasa until the 9th/15th to 10th/16th century during which time the Mamluks were the sole and uncontested rulers of the Orient.

The **Umayyad Mosque** (1st/7th-2nd/8th centuries) is one of the many stone edifices that reveal the re-use of stones, whether the recycling of tumbled blocks or the use of remains still *in situ*, from early Roman days to the 13th/19th century Circassian occupation of the town. Excavators have discovered that the edifice of the mosque was constructed by making use of building materials from the Umayyd period containing Roman remains and architectural features of the Roman villa that stood once in its place along the eastern side of the *cardo* not far from the *propylaea* of the *Artemision*. Only the ground-level pavement, bits of the first course of the "peristyled" inner courtyard, a niche still standing 1.50 m. high and column drums survived the earthquake of 131/749. Both the west wall and southeast corner had an entrance, the reused south niche has been interpreted as a *mihrab*, the raised platforms in opposite corners are assumed to have been used for preaching and for the call to prayer. Nearby an almost 2.5 m. long room contains remains of water pipes with an outlet to the *cardo*, and another room with a mosaic floor further east is thought to have been the *Imam's* It is still easy to recognise the layout of the Roman villa, through the "veil" of Islamic transformations, an adaptation

*Umayyad House,
volumetrical
restitution, Jerash
(A. A. Ostrasz).*

with the minimum of alteration of what was left of the Roman villa, which may have been destroyed during one of the earthquakes in the 4th, 5th or even 6th centuries as attested by architectural destruction in much of Gerasa's public district.

The **Umayyad House** (1st/7th-2nd/8th centuries), is one of the very few existing early Islamic domestic complexes and probably the most complete known thus far in Jordan. The large complex, centred around an inner paved courtyard, was founded directly on late Byzantine ruins later 6th to the early 7th century, according to archaeological evidence) of a similar residence. In fact, the *decumani* (pl. of *decumanus*), along one of which the Umayyad house is found, are essentially the thoroughfares of residential quarters with houses and shops lining the colonnaded and paved pedestrian walkways. As may be expected, even the Byzantine quarters, now largely lost due to the later occupations on the site, represent the continuation of domestic quarters, which began in the early Roman period of the 1st and 2nd centuries (and probably even before that, already during late Hellenistic times). The cisterns and caves under the South *Decumanus*", where the "Umayyad House" is located, were installed before the *Decapolis* era. Like the hypogean tombs for the Hippodrome on which it was built, the deposits in these cisterns provide building date of the *decumanus* wich can be placed in this case around 170 by the latest coins found in the underground reservoirs.

The date for the main phase of the Umayyad residence has been given as

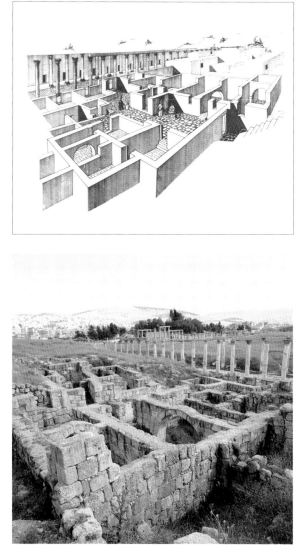

*Umayyad House,
general view from west,
Jerash (Zohrab).*

39/660 by the excavators. The date may relate to archaeological evidence of an earthquake in 38/659 (or 37/658) inmediately prior to the building of the

Umayyad House, general view from the north, Jerash.

Umayyad House, main reception room, Jerash.

complex. It is obvious that the structure, with its multiple units, was built mainly of Roman building blocks and Byzantine "recycled" building material. The construction continues the Byzantine method, which at an early date adapted the tumbled Roman remains to their requirements by using a patchwork method. Bits of blocks and mostly small stones and mortar filled the irregular gaps left between blocks of varying size and state of preservation not bothering about the same size of stones to allow for a speedy construction. The walls were lined with fine mortar and then plastered to receive a coat of whitewash and/or paint. It seems that this patchwork manner became more carelessly applied with time, which might be due simply to a dimishing supply of good building materials available for re-use. Even the irregular shape of the complex, the courtyard almost meandering amongst the closely-knit units, reveals the re-use of underlying structures, an economizing aspect not of expense but of effort, which is not easily discernible in the splendid Umayyad palaces. It has been suggested that the "Umayyad House" consisted of two stories the second storey possibly being accessible through a landing of the narrow "back stairs", which lead into the inner courtyard. The main entrance was, of course, from the *decumanus* and a passage led pass the first units of kitchen and stor-age rooms on each side into open space around which the residential units were grouped on floor space of 200 square metres with the entire house measuring 13 m. NS x 21m. EW. The roofing was composed of traditional wooden beams probably plastered with daub, a construction still evident in the late 13th/19th century Ottoman houses at Jerash and elsewhere. Sometime in the 2nd/8th century it is evident that the residence was subdivided into smaller units by regrouping other rooms, closing some passages and opening new ones in other walls.

The dwellings consisted of "sunken" rooms reached through a doorway from the courtyard by descending stairs. Some of the larger rooms were divided into two units by a central broad arch, an Islamic feature surviving until today and especially evident in modest houses of some 13th/19th century villages. The kitchen, also below the level of the courtyard entrance, was small but efficiently equipped with a well and benches. In the vicinity an underground sewage drainage system was found linking up with that of the municipal outer one, obviously still in use from the Roman days! After the earthquake in 131/749 and a period of partial abandonment, the domestic units were covered almost completely by Abbasid kilns and other quarters in the 3rd/9th and 4th/10th centuries, built over the ruined Umayyad living quarters. It was the last extensive occupation of this complex.

Parallel to and contemporary with the Umayyad House, a large residence of a well-to-do family, the **Umayyad Kilns at the Artemis Sanctuary** are a good example of the early Islamic construction methods, employing, even exploiting, whenever possible, large Roman architectural blocks for their own building purposes. Three small kilns were grouped around one large kiln and all fitted into a network of workrooms pertaining to this large pottery site. Apart from courtyard and anterooms for the kilns themselves, each firing box and stocking chamber was surrounded with a strong circular wall. There were water channels covered with stone slabs to pro-

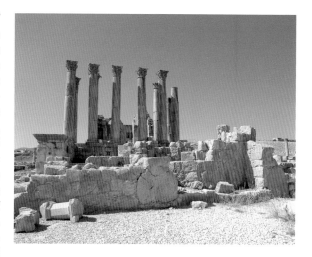

Artemis Temple, Umayyad potters complex, general view, Jerash.

vide water for the workshops, open space for preparations, drying areas and probably domestic "annexes" for the workers as well as storage space for finished products. It must have been a well-run, lucrative establishment because excavations showed that there were at least two phases of production with kilns added, rooms altered and the complex expanded. What may have begun as a modest workshop by the end of the late Byzantine period (early 1st/7th century) soon stretched from the altar base to the space once occupied by the temple steps, which by that time had disappeared out for recycling in building activities or lime production.

The **Pottery Kilns in the North Theatre** were identical in the construction of oval chambers and in some remains of misfired pottery vessels were found; together with the typical "Jerash Lamp" with its zoomorphic -type handle and oval- slipper shape, already known from

151

Pottery lantern or incense burner from Jerash, Jerash Archaeological Museum, (Inv. Num. G 1236).

the Byzantine kilns of the 6th century at the Hippodrome and elsewhere at Jerash. The history of Umayyad pottery production in Jerash, as illustrated by the Artemis kiln complex, is interesting from various points of view. It highlights the continuation of Jerash as a major centre of ceramic manufacture, Wares from here have been found over much of northern Jordan, in heavy competition with centres in other *Decapolis* cities especially during the late Byzantine period (see Umm Qays/Gadara and Tabaqat Fihl/Pella to name other known pottery markets on the east side of the Jordan while at Beisan/Scythopolis massive Umayyad kiln deposits have been excavated).

It is only the Artemis Kiln Complex, which has been preserved as a representative of a lively trade, which did not lose its impetus until after the Abbasid period in the 4th/10th century. Then Jerash experienced a general decline in commercial activities and probably also in population both being interrelated. Much of this permanent recession had to do with the shifting of the main trading routes between greater Syria and Iraq. Being bypassed Jerash continued an existence of modest means due to reduction of trade and relied on smallholdings in agriculture and manufacturer catering to local needs.

A few accounts show evidence of deliberate destruction. Also mentioned in records is that this occurred, it seems, during the Crusades when the long abandoned ruins of the Artemis and the Zeus Temples provided shelter for the Ayyubids and lastly, in the post-Crusader period, by the Mamluks. This state of an almost forgotten slumbering country town remained intact until the Ottoman rulers installed the Circassian population there in the 13th/19th century and Jerash, thought of even then as a town of ancient ruins, became once more a thriving place, as it is today.

Still, a final word needs be said. The historical picture gleaned to date from the excavations (from the late 1920's to the present) is distorted or at least unbalanced because the excavations have concentrated on monumental remains and public spaces rather than on ordinary dwellings and a general town plan.

I. K.

IV.2.b **Jerash Archaeological Museum**

Is located on the Tell *inside the ancient site. Open daily from 8 am-6 pm (summer) and*

from 8 am-5 pm (winter); Fridays and public holidays from 9 am-4 pm; Ramadan from 8 am-4:30 pm. The museum visit is included in the entrance fee for the site. Exhibitions show archaeological artefacts from Jerash in chronological order; the garden of the museum is an open-air lapidarium. Information: Jerash Archaeological Museum 02-6352267.

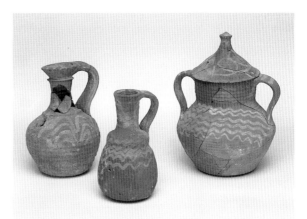

Pottery lantern or incense burner, Inv. Num. G 1236

This type of pottery lantern or incense burner was introduced toward the end of the late Byzantine period (late 6th-early 1st/7th century). It became popular in the Umayyad period embellished with more ornate decoration of both incised and mostly white painted motifs. The lantern shape derives from a jug the body of which was pierced and fenestrated to put either a pottery lamp or incense inside. It was hung from the ceiling (the ring attached to the pinched spout is missing). The lantern was made in red-and-grey ware each usually with white painted and/or incised decor.

Painted jars and jugs, Inv. Num. G 234, 236, 1241, 1242

This red-ware pottery with hand-painted, white decoration is typical of the earlier Umayyad period still very close in style and ware to the late Byzantine pottery from which it developed. Multiple wavy lines, swirling circles and accentu-

ated angles for the profile became very popular during this period, the ware itself being fine and often ribbed. The jugs and jars belong to the common tableware.

Pottery oil lamp, Inv. Num. G 683

The grey-ware moulded oil lamp is an example of the early Umayyad trend of potters to sign their pieces and use

Painted jars and jugs Jerash, Archaeological Museum, (Inv. Nums. G 234, 236, 1241, 1242).

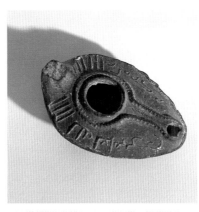

Pottery oil lamp, Jerash Archaeological Museum, (Inv. Num. G 683).

153

Large storage jar from the Umayyad house, Jerash Archaeological Museum, (Inv. Num. G 1391).

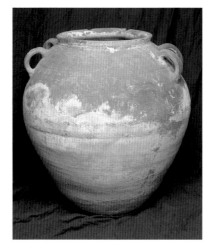

larger pottery like storage jars, amphora and basins. The four handles were primarily for tipping this heavy beaker from side to side and for manoeuvrability rather than for lifting it. The pot is a perfect example of ceramic production linking the Byzantine and early Islamic period and it is the only find from excavation, which can link the vessel to one period or another. The combed incised decoration on the shoulder, the body of the receptable and profile can be found throughout the 6^{th} and $1^{st}/7^{th}$ centuries bridging the two cultures of Christianity and Islam. The vessel was stored on the ground and probably partially buried to keep the contents cool and to prevent it from overturning.

writing as a form of decoration, which is reminiscent of the early epigraphical decorative bands displayed as wall decoration in the first mosques (see the Dome of the Rock). The radiating body decor of the late Byzantine mould, which has been used for this lamp is discernible still where the writing has not obliterated the impressed lines. The average size of these lamps ranges between ca 10-13 cm. in length with a tendency to elongate the basic slipper shape with the approach of the Abbasid period ($3^{rd}/9^{th}$ century).

Pottery storage jar, Inv. Num. G 1391

The large red storage jar was found in the courtyard of the Umayyad House, where it once stood, probably to serve as a vessel for drinking water. The ware shows the typical beige-red colour common to

Pottery Funnel, Inv. Num. G 1345

The funnel, a kitchen object, is made of red ware and was turned on the potter's wheel like a casserole. Instead of forming a rounded base, however, the potter added a "neck" without a spout. The handle was added for easier management but the whirly white hand-painted decoration recalls tableware and the fact that the potter generally used very limited standard forms to fabricate a variety of functional objects. This "minimal" approach in manufacture demonstrates efficiency and professional craftsmanship where speed, quantity and uniformity of products are essential for successful trade.

I. K.

POTTERY WORKSHOPS AT JERASH

Ina Kehrberg

Jerash developed a local ceramics industry from the beginning of its existence as a Bronze Age settlement. It was not until the late Hellenistic period, however, when Jerash became a provincial town of some notice, that the pottery industry made headway producing imitations of imported tablewares for the local and less affluent markets in the area. The potters continued to improve their skills and developed distinctly indigenous wares during the Roman period, bringing their craft to perfection in the time of the *Decapolis*. Then Gerasa prospered from newly found riches due to an increase in all trades, which in turn fostered the local artisans. By the time of the Umayyads, Gerasa was known as one of the major centres of pottery making and their wares reached far beyond the smaller boundaries of the local district. One could find typical late Byzantine Jerash pottery types, the famous "Jerash Bowls" and "Jerash Lamps", from Petra in the south, to Bostra in the north (modern Syria) and in the Jordan valley at Pella as well as in Amman on the Citadel. These particular wares continued to be made at Jerash during the early Umayyad period ($1^{st}/7^{th}$-early $2^{nd}/8^{th}$ centuries), together with common table and kitchenware, which changed little in form and decoration until well into the $2^{nd}/8^{th}$ century. New distinctive forms, particularly the cup-like angular flat-based bowls with pendant and quasi-concentric semicircle painted designs, began to make their mark and it is in this period that glazed ware was introduced (see a rare, green-glazed vase in the Madaba Archaeological Museum).

The white-painted decoration on red background and incised styles on much of the grey-ware continued to be applied to standard forms following the late Byzantine tradition in general but were altered and motifs were added.

It is probably the tolerant succession of governments from the Byzantine to the Umayyad period that was responsible for the continuation of substantial ceramic productions in Jerash, which reflects regular trade outside the town. The uninterrupted flow of ceramic production

Painted jar, jug and bowls, tableware from the Odeun, Amman Citadel and Jerash, Jordan Archaeological Museum (Inv. Nums. J 14698, 12292, 14748, 14757, 5199, 5205), Amman.

Casseroles, Jordan Archaeological Museum (Inv. Nums. J 14805, 14806), Amman.

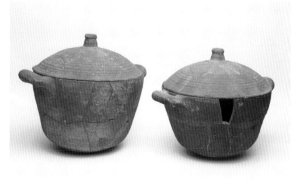

Base mould for pottery oil lamp and Jerash Lamp, Jerash Archaeological Museum, (Inv. Nums. G 685, 681)

from Byzantine to Umayyad workshops occurred in all *Decapolis* towns each with slight variations in wares and forms, none of which, however, equalled the special qualities of the Jerash potters.

Still today, one can see reminders of this profitable trade. These include restored remains of Umayyad pottery kilns and workrooms in front of the Temple of Artemis built on the huge 2nd century altar, which was once the centre of attention on the Roman *temenos*. Other kilns of the same period were found inside and around the outer walls of the *cavea* of the North Theatre nearby and in what were once Roman shops along the northern *cardo* annexed to the *propylaea* of the Artemision. The recycling aspect of Jerash constructions in the Islamic period is a repetition of what had happened during the Roman and Byzantine periods when the inhabitants occupied and fitted older buildings and installations to serve their needs. It is a part of any history, which is often forgotten, never quite fin-

ished and in many ways reflected even in the pattern of ceramic production, where "discarded" older style moulds for pottery lamps have been reused in later periods.

Similar finds of early Islamic kilns of the 1st/7th-2nd/8th centuries were reportedly made in the 1970's excavations on the lower terrace of the Temple of Zeus and in the *orchestra* of the South Theatre during the 1950's excavations, under the general direction of the renowned Gerald L. Harding. It is interesting to note that most of the pre-Islamic potteries were found in the south and the largest industrial complex was outside the city walls at the hippodrome, with smaller kilns at the Zeus Temple complex and the Macellum, spreading out thinly towards the north. In contrast, the largest early Islamic pieces found to date were in the northern half of the town. This may have occurred in connection with the plague, which effected the town during and before the Islamic conquest and seems to have left the southern external part ravaged and a desolate place fit only for burials of plague victims.

Much is left to be excavated between the civic centre and the north-west-south city wall and this wide space dotted here and there by churches holds much promise for the untold history of the site. There was a glimpse of the hidden wealth of information when, in the early 1990's, the Department of Antiquities exposed western parts of the city wall to almost the original level. With the exposure of the still standing courses, many

kiln dumps, burn marks and basins abutting the wall against the lower courses were revealed indicating that potteries were established inside; along or near the west wall from the late Roman to the end of the Byzantine period onward, i. e. from the 3rd to the late 6th-early 7th centuries.

The Umayyad kilns in the North Theatre were almost identical in plan to those at the end of the Byzantine period as was evidenced by remains of the late 6th-early 7th centuries excavated at the hippodrome. The proof for stylistic continuation of form and decor was discovered in the collapsed stacking chambers of the North Theatre early Umayyad kilns where remains of misfired pottery vessels ("wasters") were found. Among them was the typical Byzantine "Jerash Lamp" with its zoomorphic-headed handle closely associated with "Jerash Bowls".

The lamp type is of special interest as it provides one of the few indications that quasi-religious motifs, like the "Greek Cross" on the Jerash lamps, continued to be used in production to the early 2nd/8th century. It shows, as with other decorated objects, that either the potters made little distinction with regard to "meaning" of general iconography or it is an example of religious tolerance or indifference. The lamps were probably bought by Christians and Muslims primarily for their function and not for the symbolic motifs, which decorated the lamps. Other lamps found in kilns and elsewhere on the site have provided definite dates for the Umayyad kilns and associated pottery as some of the variants carried inscriptions with the name of the potter, place (Jerash) and Islamic date of production (see Jerash Archaeological Museum).

IV.3 **IRBID**

Is 88 km. north of Amman and can be reached easily from Jerash by car or bus, taxi or service-taxi, the station being near the Roman East-Baths complex. The road goes directly to Irbid through the town of al-Husn. Information: Dept. of Antiquities office at Irbid 02-7277066.

The second largest city of Jordan, Irbid lies northwest of Amman near the Syrian borders. It is close to *Tell* al-Rameith, ancient Ramoth Gilead, on the east and famous for its antiquities dating back to the early Iron Age. The ancient *Tell* of Irbid is to the north of the modern city, where tombs from the early Bronze, late Bronze II and early Iron Age were excavated. It rises to about 578 m. above sea level and measured originally about 500 x 400 m. There was a strong three-courses wide defence wall built with large basalt boulders, in about 2000 BC. The water system of the city, which included an underground channel, dates back to this period and was adapted to modern use. Irbid has been identified with Abila, a city of the *Decapolis* (see The *Decapolis* in the Umayyad Period), but the only historical reference to the site is in Eusebius' *Onomasticon* in which he mentions the town in the early 4th century (314-15). The Byzantine writer locates Abila in *Palestina Secunda*, at the borders of ancient Judaea and in the territory of Pella.

Irbid became famous in the Umayyad period under the name of Arbed, its Arabic name, together with Bayt Ras because it was where Yazid II lived and died in 105/724.

Bayt Ras, just north of Irbid, was linked with this ancient city. It was better known than Irbid, since it was identified first with Capitolias, another city of the *Decapolis*. The city is not as old as Irbid, but has better preserved ruins from the Graeco-Roman periods. One of the most impressive remains is the water conduit, which was cut out of the rock and empties into a large reservoir. The remains of a Byzantine church, dedicated to the Virgin Mary, were discovered when a modern mosque was built on that spot. The Umayyad *Caliph* Yazid II settled in Bayt Ras where recent excavations uncovered a vaulted *suq* (market) from the Islamic period near the modern mosque. A tomb of the late Roman period has well-preserved wall paintings depicting the Trojan War and the victory of Achilles over Hector. One panel represents the creation of man by Prometheus.

F. Z.

IV.3.a **Irbid Archaeological Museum**

Is in the centre of the town on "Tell Irbid" and open during office hours and workdays. There is no entrance fee. The museum collection comprises archaeological artefacts from the district and will be moved together with the Dept. of Antiquities office to the renovated traditional Ottoman building known as "Dar al-Saraia". Information: Irbid Archaeological Museum 02-7275817.

Mosaic from Qasr al-Hallabat, Irbid Archaeological Museum.

Mosaic from Qasr al-Hallabat

This mosaic fragment comes from Room 4 of the *Qasr* and shows the rich embroidery reminiscent of woven tapestry. The border decoration of intertwining circles with clusters of pomegranates in each centre is one of the best examples of its kind in early Islamic buildings and finds parallels in other castles, such as in al-Qastal. The iconography is in its geometrical composition typical of the Umayyads but single features like the pomegranates and the curled wavy band recall ancient Greek and Roman times.

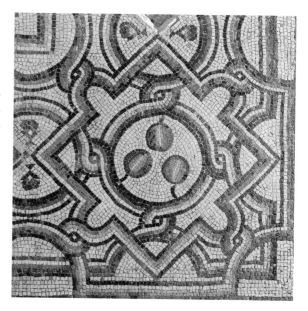

Mosaic from Qasr al-Hallabat

This second mosaic of Qasr al-Hallabat shows an oryx, the flowers indicate a field or garden (maybe even a "wild park" for hunts such as shown on the famous Neo-Assyrian reliefs of the 9th and 7th centuries BC). The quality of the mosaics at al-Hallabat leaves little doubt as to the mastery of the mosaicists. More than one master produced this work. Their hands can be traced from room to room, easily identifiable by their skills and preference of motifs. The guilloche pattern framing the individual animal pictures as seen in our example could be a "paved" walkway in a garden or zoo, reinforcing the idea of a wild park, already known in Jordan in the Hellenistic period, but also attributed to castles of the Umayyad princes.

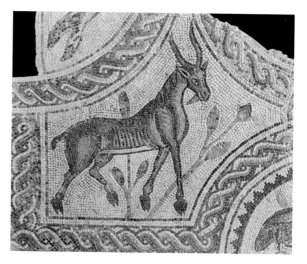

Mosaic from Qasr al-Hallabat, Irbid Archaeological Museum.

159

Umayyad potter became "commercially conscious". He stamped and dated his lamps, which became the main decorative feature and provided the historian with an accurate date of the style and context in which the lamp was found. The use of the potter's mark of identification as a known craftsman indicates the flourishing production of ceramics in the $1^{st}/7^{th}$ and earlier $2^{nd}/8^{th}$ centuries already established in the late Byzantine period. These lamps are made only in Jerash, as the signature shows, but have been found on other sites throughout Jordan.

Pottery oil lamps, Irbid Archaeological Museum (Inv. Nums. 1977, 2182).

Pottery oil lamps, Inv. Nums. 1977, 2182

The pottery oil lamps are derived from the mould-made late Byzantine "Jerash Lamp" with its typical zoomorphic handle. While the potters still employed the same moulds, they were adapted to suit the Islamic taste of the period. Apart from improving functional features (the channel between filling the hole and nozzle was added to capture spilt oil), the

Pottery oil lamp, Irbid Archaeological Museum (Inv. Num. 130).

Pottery oil lamp, Inv. Num. 130

The mould-made pottery oil lamp combines characteristic features of both the Byzantine and Islamic worlds. The red ware, overall shape and radiating pattern recall the Byzantine lamp: the slipper type in form and the Jerash tongue handle type in decor. The channel around and between filling the hole and nozzle are typically Umayyad (in fact the earliest examples of such channels go back as far as Greek black-glazed Hellenistic lamp and Roman lamps fabricated in Gaul), but the large cross is distinctly Byzantine or Christian and by itself a unique example. Although many "Jerash Lamps" with a cross below the handle were still mass-produced during the Umayyad period and obviously bought by both Christians and Muslims alike. However this example seems, due to its singular occurrence, to have been designed for a Christian home of the $2^{nd}/8^{th}$ century.

Glass juglet from Tabaqat Fihl (Pella), Inv. Num. 2131

This perfect little juglet would be difficult to define as either late Byzantine or early Umayyad if it were not for the context in which it was found. Umayyad glass has the same properties as late Byzantine glass giving it the same clear-blue to greenish blue colour. Like the pottery of the 1st/7th and 2nd/8th centuries, there is little, if any, distinction between the repertoire of types and manner of decoration. Perhaps the Umayyads preferred a more ornate decor as is already evident in ceramics. The material and the manufacturing process itself limited the range of vessels, which could be produced through blowing and moulding. Glass, remained expensive and not an item that could be mass-produced (in contrast to our own culture where moulded glass is common and blown glass the exception).

Glass lamp from Umm Qays (Gadara), Inv. Num. 1892

It is rare to find a glass vessel intact and more so a glass lamp. Glass lamps became enormously popular during the Byzantine period when churches needed lighting other than from pottery lamps. These glass lamps took a variety of forms based on the wine-goblet. Like the potters, the Byzantine and/or Umayyad glass blowers were practical and commercially-minded, using one basic form to suit several purposes with only minor adjustments to suit the use.

Glass juglet from Tabaqat Fihl, Irbid Archaeological Museum, (Inv. Num. 2131).

With four added handles, a goblet could be hung, usually on a cluster of bronze chains. The wick dipped in oil held by the goblet was looped over the rim. This example shows a beaker transformed into a lamp and there are lamps with an elongated heavy stem for balance, and without handles, which are placed in a bronze ring and, like a chandelier, are suspended from the ceiling. The glass lamps are probably mostly from churches and mosques. Few, apart from the ruling classes, could afford costly glass lamps

Glass lamp from Umm Qays, Irbid Archaeological Museum, (Inv. Num. 1892).

161

Basalt relief from Azraq, hunting dog, Museum of Jordanian Heritage, Yarmouk University, Irbid.

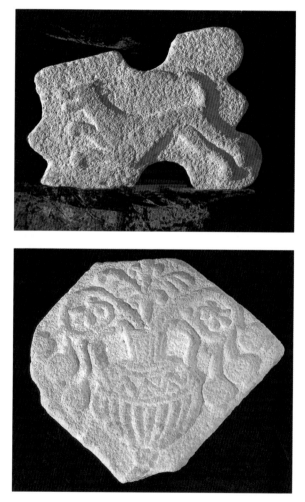

Irbid. Open from 10 am-5 pm on class days, summer semester and Ramadan from 10 am-3 pm. No entrance fee. The exhibitions are thematically and chronologically arranged from prehistory to the Ottoman period. As a teaching institution, the exhibitions emphasise technological development and the growth of settlements and urbanisation. Information: Museum of Jordanian Heritage 02-7276277 Ext. 4275.

Basalt reliefs from Azraq

The three basalt reliefs from the water reservoir of Azraq are a fine illustration of the "minor arts", which take their themes from the classical world prior to the Islamic conquest. During the Umayyad period this genre experienced a revival from a much earlier period, the Hellenistic era, which was imitated frequently in Jordan. The hunting dog (1a), Pegasus (1c) and the amphora decorated with flowers (1b) find their parallels not only in earlier Byzantine mosaic church floors and in contemporary mosaics of the $1^{st}/7^{th}$-$2^{nd}/8^{th}$ centuries but more in Greek and Roman art from which they originated. Pegasus is the most fabulous of the three and relates directly to the mythological creature, which was supposed to have carried Perseus across the Aegean Sea to populate Halicarnassus on the western coast of Asia Minor (Turkey). Especially noteworthy is the skill with which these carvings have been rendered on the basalt slabs, giving them a lively, even playful, appearance. The "spirit" of the age of the Umayyad princes

Basalt relief from Azraq, vase with flowers, Museum of Jordanian Heritage, Yarmouk University, Irbid.

and had to make do with the common pottery oil lamps.

I. K.

IV.3.b Museum of Jordanian Heritage

Is part of the Institute of Archaeology and Anthropology of the Yarmouk University,

*Basalt relief from
Azraq, Pegasus,
Museum of Jordanian
Heritage, Yarmouk
University, Irbid.*

can also be felt here, where simplicity and charm are combined with esoteric allusion.

Carved relief from al-Qastal

Carved stone reliefs became a favourite form of architectural decoration in the Umayyad period, notably for the residential palaces and castles. Again, it is a forceful reminder of times gone by when temples and rich villas were decorated in a similar manner. At Qasr al-Mushatta, al-Qastal and elsewhere in Jordan, this form of interior decor flourished during the Umayyad period and gave rich evidence of the refined craftsmanship that existed in that time, no doubt based on the established skills displayed on the numerous public buildings from the Roman period onward. The innovation is the selection of geometric and vegetal motifs, almost to the exclusion of all else. The rosette set in a circle surrounded by simple flowers became a favourite among the wide range of images available for inspiration through remains of earlier architectural decor.

I. K.

IV.4 UMM QAYS (GADARA)

Lies in the northwest corner of Jordan, 120 km. from Amman and 30 km. northwest of Irbid and is close to the borders between Jordan, Israel and Syria. The site can be reached on the well-marked road via Irbid heading northwest following the signs along the route.

A Local bus is available from Irbid but it is easier to go by taxi or car. Bus services run between Amman, Umm Qays, Jerash and Irbid and local bus tours are available. The site can be visited daily for an entrance fee, which includes a visit to the museum housed in one of the Ottoman buildings on the site. Tickets can be bought at the parking lot of the main entrance to the site. Information: Dept. of Antiquities Office at Umm Qays 02-7500071 or the Archaeological Museum 02-7500072.

Carved relief from al-Qastal, Museum of Jordanian Heritage, Yarmouk University, Irbid.

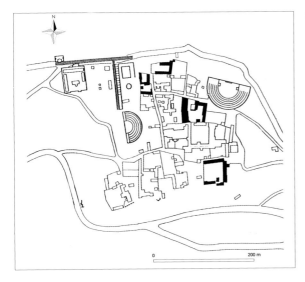

IV.4.a **Archaeological Site of Umm Qays**

A high-up place of culture and arts, Gadara (Umm Qays) was renowned in the Mediterranean basin for its poets, philosophers and rhetoricians. Dramatically perched on a hilltop (378 m. above sea level), overlooking the Sea of Tiberias, the Golan Heights and the hot baths of Hammath Gader in the Yarmuk gorge, the city was famous in the Hellenistic period for its strategic impregnable position. Polybius first mentioned Gadara historically in 218 BC. He referred to it as the "strongest of all places in that region". The Seleucid king, Antiochus III, who conquered Syria and Palestine from the Ptolemies, laid siege to the city, which soon capitulated. The Hellenistic city walls, reinforced by slightly articulated semicircular towers, were exposed by

recent excavations on the southern flank of the city.

Gadara, like many of the Roman cities east of the Jordan such as Pella, Abila and Gerasa was reorganised according to the Hippodamian urban system and became centres of Hellenism, adopting Greek as the official language and the pantheon of pagan gods for their veneration. To orthodox Jews, the Hellenisation of occupied cities was a threat to their religious traditions. After the creation of a Hellenised party in Jerusalem, headed by the High Priest Jason, a revolution broke out during the reign of Antiochus IV, in 167 BC. The revolt was led by the Hasmonaean priest Mathathias and his sons. The Seleucid cities of Jordan were severely attacked and Gadara suffered destruction by Alexander Jannaeus in the early 1st century BC, but it recovered its independence when the Roman general Pompey overran the East in 63 BC. Gadara was rebuilt by Pompey to please Demetrius, one of his favourite freedmen. This was the beginning of a new era for the city, the *Decapolis* era, in which most of the remaining monuments were built. The Hellenised cities became the nucleus of the later *Decapolis*, created probably under Tiberius as a control against further uprisings and to check Nabataean expansion to the north. In 30 BC, Augustus granted Gadara to Herod the Great together with Hippos in the Golan Heights. According to the Gospels, Jesus visited the territory of Gadara and healed two men possessed by demons (Matthew, 8:28-34). The

164

site of this miracle is believed to have been near the city gate, where a basilica was built over a mausoleum. After the death of Herod the Great, Gadara came under the province of Syria. In the 2nd century, after the annexation of the Nabataean kingdom in 106, Gadara reached its Golden Age with colonnaded streets, theatres, basilica, *nymphaeum*, hippodrome, baths, etc. A Greek inscription, transliterating the Arabic name of the *caliph,* informs the reader that the hot bath of Hammath Gader, called "Hammata" by the Romans was renovated in the Umayyad period under Mu'awiya Ibn Abi Sufyan.

In the 3rd century, when Diocletian reorganised the Roman Empire, Gadara became part of *Palestina Secunda*. Christianity had begun to make its mark in the city, and some Christians suffered martyrdom. Under Constantine the Great, Christianity became the official religion and Gadara was made the See of a bishop. In the Umayyad period, the city was reduced to a small village, famous for its wine celebrated by the Arab poets.

The archaeological site of Umm Qays, Gadara, can be entered from the southern gate where the city wall with its circular towers has been excavated. The path leads to the two-storey West Theatre, built of basalt stones. The lower story has 14 rows of seats while the upper one has only 10 rows. A gallery separates the two

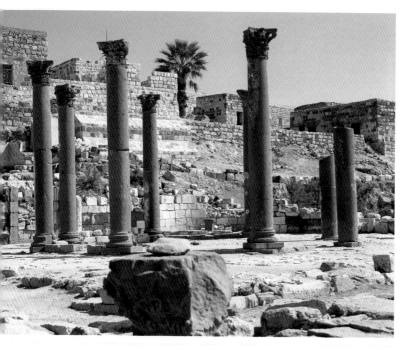

Octagonal Church,
Umm Qays.

stories while seven stairs divide the auditorium into sections. The marble statue of a seated Tyche, which was in the first row of seats, has been removed to the museum.

A northsouth street (*cardo*) runs from the theatre to the basilica terrace which measures 95 x 32 m. The eastern side of the terrace is cut in the bedrock, while the western side, along the street, is supported by barrel vaulted chambers, which were used as shops. Originally a civic centre, the basilica was converted into a Byzantine church in the 5th century and continued to be used in the 2nd/8th century. The east-west paved street (*decumanus*) runs north of the Basilica and leads to the *Nymphaeum* and the public baths. The baths on the southern side of the street continued to be in use until after the Byzantine period. The paved street continues to the west to meet with the Tiberias Road. Recently, it has been excavated and the pavement, with dramatically fallen columns, exposed. It leads to the remains of a circular tower, which once protected the city gate.

An underground mausoleum, accidentally discovered in 1986 through shelling, was built south of the street and was used from the Roman to the Byzantine period. A five-aisle irregular basilica was built over the mausoleum and continued to be in use in the Umayyad period.

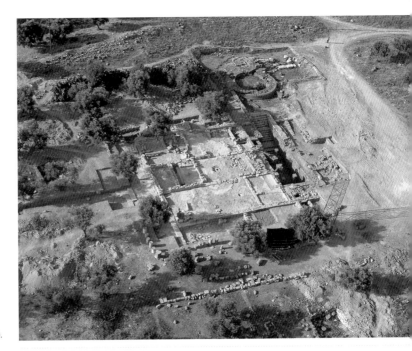

Aerial view of the mausoleum and the church, Umm Qays, (Courtesy of J. Taylor).

Beyond the mausoleum and the basilica, the street continues west to the city wall and a tower, discovered in the surrounding olive groves. Beyond the city wall lies a 225 m. long hippodrome and about 43 m. west of the race course, a monumental gate. It measures 45 x 13.50 m. and has a central passageway with two smaller vaults on each side. On the eastern side of the city, near the gate, a Graeco-Roman family tomb belonged to the *Germani*, as per the inscription on the entrance of the tomb. The road passes by the North Theatre, which is badly ruined. It is larger than the West Theatre (outer diameter 85 m.). Only a few vaults of the *cavea* can still be seen. To the north of this theatre lies the forum or public place of the city. A temple, dating from the Hellenistic period, was excavated on the western side of the forum. A marble statue of Zeus Olympios, discovered in the forum, indicates that the temple was dedicated to this deity. The statue is now exhibited in the archaeological museum, opened in the Russian House, a tradiational Ottoman building. In this museum, a Greek inscription on a basalt lintel reads: "To you I say, Passer-by, as you are, I was; as I am you will be. Enjoy the life as you are going to die", written by the undoubtedly renowned poet of Gadara, Arabios (355-356).

<div align="right">F. Z.</div>

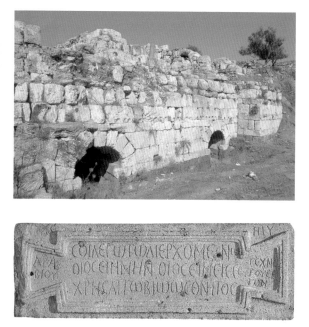

the site is by the car driving from Umm Qays to the site through the Jordan Valley. This route of scenic beauty opens up to a view towards the Yarmuk River and the Golan Heights. The visit to the site is free. The rest house opposite the Tell overlooks the archaeological site. Five modern Holy Shrines of the Companions are situated in the Jordan Valley along the road between Umm Qays and Tabaqat Fihl. Information: Dept. of Antiquities Office at Tabaqat Fihl 02-6560849.

IV.5 TABAQAT FIHL (PELLA)

The Tell is in the Jordan Valley and 95 km. northwest of Amman. The easiest way to reach

IV.5.a Archaeological Site of Tabaqat Fihl

Pella (Tabaqat Fihl) is located 4 km. east of the River Jordan, on the foothills of

the Jordan Valley, south of the Sea of Galilee, overlooking the plain of Esdraelon. In antiquity, the site of Pella lay close to the main junction of two of the major communication routes of the ancient Levant. The first, a north-south route, linked the Arabian Peninsula with Damascus, and the second, a north-west route, linked the Jordanian plain to the Mediterranean coast. The archaeological site of Pella is dominated by an oval mound on the north side of Wadi Jirm al-Moz, a small valley that descends from the highlands that lies to the east of the site. On its steep eroded southern slope, the mound rises 30 m. above the floor of the valley. A perennial spring runs at the foot of the mound. On the south side of Wadi Jirm al-Moz a large dome-shaped natural hill rises known as *Tell* al-Husn, which was used both for burials and settled occupation spanning several millennia until the 1st/7th century. Most of the archaeological excavations, which began in 1958 and continued into the 1990's, have focussed on the main mound of Pella and *Tell* al-Husn and have shown Pella to be one of the richest archaeological sites in Jordan. Surveys and excavations have brought to light that the site and its immediate surroundings have been occupied from the Lower Paleolithic Period (about a million years ago) until the present.

Pella was first mentioned under its old Semitic name, *Pihil*, in Egyptian texts of the 19th century BC. Subsequent references in Egyptian annals show that the city prospered throughout the middle to late Bronze Ages (14th-13th centuries BC)

when, as several excavated tombs have shown, the inhabitants used many luxury items imported from Egypt, Cyprus and Greece. The population and size of the city of Pella decreased during the Iron Age. Pella received no mention in the Old Testament (unless it appears there under another name). Excavations have revealed very few datable structures or objects in Pella from the later Iron Age in the 7th through the 4th centuries BC of the Hellenistic period. The paucity of material evidence from this period has led archaeologists to believe that Pella was virtually uninhabited then.

After the conquest of the Levant by Alexander the Great in 332-331 BC and the subsequent reconfigurations in government, economy, and culture, Pella began to revive as a Greek town. It started to rebuild its population and participate in Hellenistic commerce under Ptolemaic rule.

Following the Seleucid conquest of the southern Levant in 200 BC, Pella experienced a century of expansion and prosperity. Many new structures were built. Greek became the language of culture and commerce. The ancient Semitic name of the city, *Pihil* or *Pihir*, was Hellenised to *Pella*, in honour of the birthplace of Alexander the Great in Macedonia. Late Hellenistic artefacts found at the site include large numbers of both imported objects and locally produced pottery. In 83-82 BC, according to the historian Flavius Josephus, the Hasmonaean ruler Alexander Jannaeus invaded Pella and destroyed the city. Josephus' account was confirmed by evidence of extensive

Grand staircase of civic centre including the church and theatre, Tabaqat Fihl (Zohrab).

burning present in the late Hellenistic stratum of the mound. In 63 BC, the Roman general Pompey brought an end to Hasmonaean and Seleucid domination. Pella became one of the group of Hellenised cities in southern Syria and northern Jordan that became known collectively as the *Decapolis* (see The *Decapolis* in the Umayyad period; Gadara; Jerash). Pella underwent considerable development during the Roman period from the late 1st BC to early 4th centuries and in 82-83, the city issued its first bronze coins. Excavations have uncovered several major buildings, which date from the Roman period, including public baths and a small theatre in the civic complex near the spring, as well as a forum in Wadi Jirm al-Moz. Inscribed milestones indicate that the road connecting Pella to Gerasa-Jerash, another city of the Decapolis, was improved during 160-161.

Pella flourished during the Byzantine period (early 4th-early 7th centuries), when churches and monastic complexes abounded and domestic areas expanded to adjoining slopes. By the end of the 4th century, Pella had become a bishopric seat and Christianity had displaced most (if not all) of the city's former religions. Excavations have uncovered three large churches, one of which, probably the cathedral, is located in the civic complex, another on the west side of the town and a third on a high eastern slope. Evidence from excavations dates the civic complex church to the early 5th century and shows that it was remodelled in the first half of the 6th century. Both the East Church and the West Church date from the 5th century. In the 6th century, Pella reached its maximum size of about 21 hectares and supported a population of 5,000-7,000 people.

169

Domestic quarter,
Tabaqat Fihl (Zohrab).

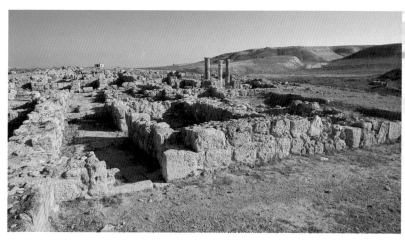

Forecourt of domestic
unit, Tabaqat Fihl
(Zohrab).

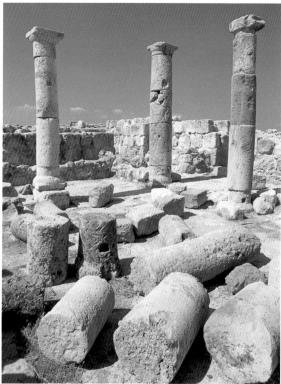

This era of prosperity was interrupted in the early 7th century by the short-lived Persian invasion sometime between 614 and 628. In 14/635, after the Muslim army defeated the Byzantine army at the nearby plain of Fihl, a peace treaty was drawn up and the Muslim army occupied Pella. This treaty permitted the inhabitants of Pella to retain their personal and civic rights and responsibilities upon payment of a personal tax and a land tax. The non-violent conquest of Pella was confirmed by the archaeological record, as excavations at the three Byzantine churches and the residential quarter showed an uninterrupted transition from Byzantine to Muslim rule. Under its new Muslim rulers, Pella became known as Fihl (after its original Semitic name).

The Muslims restructuring the provincial territories in 18/639 preserved an administrative role for Fihl. That role continued into the 3rd/9th century when

everal books on geography, including Ibn
hurdadhbah's *Kitab al-Masalik*, list Fihl
s a district centre in *Jund al-Urdun* (the
dministrative and military province of
ordan (see Umayyad Administrative
ystem). Excavations have uncovered sub-
antial remains of large domestic quar-
ers and associated material assemblages
f the Umayyad and Abbasid period in a
umber of areas.
uring the Umayyad period, the popula-
on of Pella seems to have declined.
verall reduced civic wealth may be indi-
ated by the decay of many public and resi-
ential buildings. In contrast to this are
e wide range and generally well-made

Umayyad pottery and other domestic
artefacts and the considerable wealth repre-
sented by the numerous animal skeletons
which have been unearthed. All point to
a measure of domestic prosperity for
some of Pella's citizens.

Several of the mid-2nd/8th century living
quarters reflect the reasonably high stan-
dard of living enjoyed by some in the
Umayyad period at Fihl. A **domestic
quarter** on the main mound was
re-designed following an earthquake in
39/659-660. These two-storey houses
were arranged around a large forecourt
and were constructed sturdily having lower
walls of stone blocks with rubble and clay

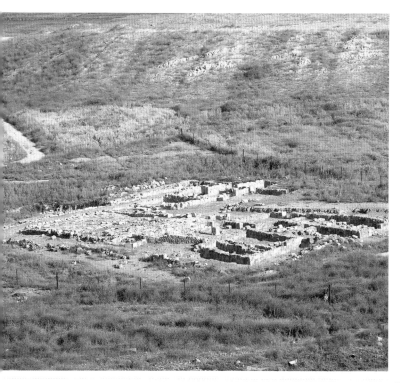

*View of residential
suburb, Tabaqat Fihl
(Zohrab).*

171

The Dead Sea, Jordan Valley (Zohrab).

(857/1453-1335/1917) periods. Durin the Mamluk period a mosque was con structed on top of the mound, but th city itself was never rebuilt.

L. 1

filling, upper walls of unbaked mud-brick, and roofed with wooden beams, matting and clay. The main living rooms were located on the second floor and were in some instances finished with plastered and painted walls and white tessellated floors. The ground floor was used as the work area of the household, with a small work-shop in one unit and other rooms for sta-bling animals, particularly cows, sheep and goats and equids. Many of these animals were trapped in the houses during the earthquake of 131/749 along with the human occupants and their possessions. Although Pella was destroyed in a violent earthquake of 131/749, it was not entirely deserted. Excavations to the northeast of the mound have uncovered substantial buildings from the Abbasid period in the 3rd/9th and 4th/10th centuries. There was some occupation of the site during Mam-luk (647/1250-923/1517) and Ottoman

The Dead Sea
The Dead Sea lies 50 km. west of Amman. To reach the area from Tabaqat Fihl, follow the main route along the Jordan Valley to al-Shounah al-Janobia. Taxis and cars for hire are available at al-Mashari'; from al-Shounah taxis go to the Dead Sea resorts. Entrance fees are required and accommodation is available.

The lowest point on earth, 392 m. below sea level, the Dead Sea today is sought after for its healing properties. Even in the dawn of history, the Dead Sea was well known and the earliest settlements grew around the shores of the inland sea. Apart from salt, one of the main natural products of the sea is bitumen, a rare commodity and thought worth trading by ancient Egyptians, Sumerians and Canaanites. The earliest known Chalcolithic settlement, Talaylat Ghassul, once thought by the first excavators to have been Sodom and Gomorrah, flourished on the east bank (not far from the modern Government Rest House). The same shore is home to another recently discovered site, that of the Baptismal site of St. John (al-Maghtas) and on its opposite shores, the caves of Qumran (The Dead Sea Scrolls) renowned in biblical history.

172

EARLY ISLAMIC COINAGE

Ghazi Bisheh

Following their swift military victories in Syria, Iraq and Egypt, the Arab-Muslims found themselves in control of peoples and territories where the economy had for many centuries been characterised by a sophisticated monetary system. This system consisted of gold coinage (*Solidi*), which constituted an imperial monopoly of the Byzantine State, and of silver coinage (*Drahms*) of the Sassanid Empire. The mints of Syria, however, ceased to function long before the appearance of the Arabs in Syria; there was no recent precedent, therefore, for minting coins in Syria. Lacking the experience to issue their own coins, the Arabs wisely adopted the administrative machinery and financial system of the conquered lands. In the western provinces (Syria, Palestine and Egypt), they imitated the Byzantine coin types circulating in those areas in the early 7th century, while in the eastern provinces (Iraq and Iran), the Sassanian silver coins became the model. For this reason early Islamic coins are usually classified into two broad divisions:

Obverse of bronze coin of Arab-Byzantine type, (Courtesy of N. Goussous).

Reverse of bronze coin of Arab-Byzantine type, (Courtesy of N. Goussous).

The **Arab-Byzantine type** denotes Islamic coins with images and legends in Greek, Latin or Arabic, and struck after the Byzantine model.

The **Arab-Sassanian type** refers to the early Islamic coins with Pehlavi (middle Persian) and/or Arabic legends, and struck after the Sassanian prototype with the conventional portrait of the Sassanian king, often Khosru II, on the obverse, and the Zoroastrian fire-altar flanked by two attendants, on the reverse.

Sometime later (the length of time is subject to debate among numismatists) various anonymous Arab adaptations of the local coinages began to appear in Syria, especially in Damascus. While it has been generally assumed that the Arabs started minting coins soon after the conquest, Michael Bates of the American Numismatic Society, argued that the Arab newcomers issued no coins at all until 71/691-72/692. Before that date, Bates explains, Syria used gold and copper imported from Byzantium, and silver coins from Iraq and Iran. Whatever the case, it was during the reign of the

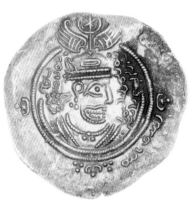

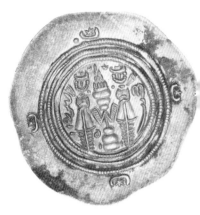

caliphate of 'Abd al-Malik Ibn Marwan (65/685-86/705), the builder of the Dome of the Rock in Jerusalem, that a series of experimental issues was introduced. These issues clearly reflect efforts on the part of the Arabs to devise an iconography of their own. A new distinctly Arab coin-type, that of the standing *caliph,* appeared in Damascus with issues dating from 74/694-77/697. These issues show the standing sword-belt, a figure of the *caliph* on the obverse. He is bearded and dressed in a long robe with an Arab headdress (*Kufiyyah*). In the margin is the Arabian legend written in *Kufic* character, "In the name of God, there is no God but Allah, He is alone, Muhammad is the messenger of Allah". On the reverse side was placed the transformed cross-on-steps and in the margin the Arabic legend, "In the name of Allah, this *dinar* was struck in the year (…)".

In 77/696-697 'Abd al-Malik introduced his coinage reform, which drastically changed the style of the main currencies and, thereafter, became purely epigraphic.

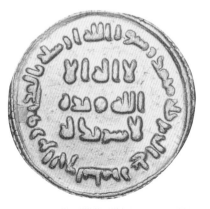

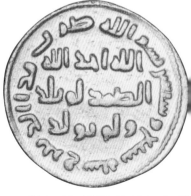

The earliest silver coin of the new type, however, did not appear until 79/698. The legends on the reformed *dinar* (the gold currency unit) included the profession of the faith (*Shahada*) and part of *Qur'an* CXII, the prophetic mission (*Qur'an* IX:33) and a formula stating the date of minting, written in words.

The coinage reform of 'Abd al-Malik was a manifestation of his policy to Arabise the Umayyad administration and an expression of the ideological and economic warfare against the Byzantine enemy. Its success, however, could not have been assured without a strong economic foundation.

Traders and Pilgrims

Fawzi Zayadine, Ghazi Bisheh, Ina Kehrberg, Mohammad al-Asad

First day

V.1 GHAWR AL-SAFI / ZOAR
V.1.a Dayr 'Ayn 'Abata (Monastery of St. Lot)

V.2 AQABA
V.2.a Islamic City of Ayla
V.2.b Aqaba Region Archaeological Museum

SCENIC OPTION
Wadi Ramm (Wadi Iram)

Roman Legionary Camps and City Planning

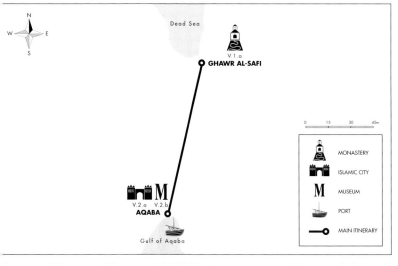

The Pillar of Lot's Wife, Dead Sea Road.

The plateau of Jordan was crossed, from north to south, by two main trade routes. The most famous is the King's Highway, which has been known since the 2nd millennium BC, at least, when it was followed by the four kings of the Old Testament who attacked the five cities of the Dead Sea plains (Genesis 14). This road began at Damascus, passed by Amman (Philadelphia), crossed the Wadi al-Mujib (the Arnon), the Moabite highlands, Edom and terminated at Aqaba (Ayla) on the Red Sea. The Nabataean caravans used this road to bring spices to Syria.

After the annexation of the Nabataean kingdom to the Roman Empire (106), and between 111-114, Trajan had this road paved all the way from Ayla on the Gulf of Aqaba to Bostra in the Hawran (modern Syria). Petra, a trading centre and a place of pilgrimage to the shrine of Aaron, was at the junction of three caravan routes. In addition to the *Via Nova Traiana* and the route to Udhruh and Ma'an, a third route followed the edge of the plateau by Ras Dilagha and al-Qanah and was called "Darb al-Rasif", a pilgrimage bypass to Ayla in the Islamic periods, through al-Humayma (Avara). This latter *caravanserai* was founded by Aretas III (r. 87-62 BC) as a stopover between Ayla, Wadi Ramm (Wadi Iram) and Petra. Recent excavations there revealed an ingenious hydraulic system installed by the Nabataeans, a Roman camp and four Byzantine churches, some of them continued to be in use during the Umayyad and Abbasid periods.

In the Umayyad period, during the reign of *Caliph* 'Abd al-Malik Ibn Marwan (65/685-86/705), 'Ali Ibn 'Abd Alla Ibn al-'Abbas built a palace and a mosqu at al-Humayma for his family and hoste pilgrims bound for the holy cities c Islam. His son Muhammad claimed th caliphate and it was his successors wh overthrew the Umayyads in 132/750 (se The Umayyads: The Rise of Islamic Ar and al-Humayma).

The caravan routes traverse the scenic val ley of Wadi Iram, famous for its colour ful and towering sandstone outcrops From the 5th century BC on, it was th place of contact between the Thamudic 'Adite and Nabataean tribes. The valle remained a crossroads in the Islamic peri ods and several Islamic graffiti an remains of a mosque still can be seen i Wadi Rabigh.

After passing Wadi al-Yutm, the roa reaches Aqaba where the Islamic City o Ayla was uncovered recently. The harbou town was planned by *Caliph* 'Uthman Ib 'Affan in 29/650 and a great mosque nea the Damascus Gate was built under th first *caliphs*, and continued to be in us long after the 4th/10th century.

A second alternate road, parallel to the *Vi Nova,* starts at Yadudeh, continues south o the edge of the steppe and, passing b Umm al-Rasas (Mayfa'a), continues t Lejjun and Udhruh (see Udhruh). The lat ter, a caravan stop between Petra, Ma'ar and Arabia was first occupied by the Nabataeans and under Trajan, the Roman built a military camp, which was re-occu pied by the armies of the Byzantine rulers In 8/630, Ayla, Udhruh and the nearby al Jarba signed a peace treaty with the Prophet Muhammad at Tabuk, which

*Wadi Ramm (Iram),
general view.*

owed the Muslim traders to pass through
is area. The arbitration between 'Ali Ibn
bi Talib and Mu'awiya Ibn Abi Sufyan also
ok place at Udhruh in 37/658.

F. Z.

I GHAWR AL-SAFI / ZOAR

he site of ancient Zoar is located at Khir-
t Sheikh 'Isa, near Ghawr al-Safi, at the
utheast end of the Dead Sea, about
3 km. southwest of Karak. Zoar was
entioned for the first time in the bibli-
l narratives in Genesis 14:2, in the
isode of the four kings from the East
ho invaded the five cities of the Dead
a plain. The city appears in this episode
der the name of Bala'. The campaign of
e four kings occurred, supposedly, in
e time of Abraham, in the 2nd millenni-

um BC. The renowned biblical scholar de
Vaux argued that the stories in Genesis
14, however, are difficult to place in the
history of the Middle East and were writ-
ten largely to associate Abraham with the
historical events of the country.

Zoar is mentioned again in the account of
the punitive destruction of Sodom and
Gomorrah. In Genesis 19, the story relates
that Lot, the nephew of Abraham, prayed
for the little town near Sodom to be
preserved and Yahweh granted him
this favour after which the town was
named Zoar, "the little one". From there,
Lot fled to the hill-country and made his
home in a cave (see Monastery of St. Lot).
According to the story here one daughter
gave birth to Moab, the father of the
Moabites and the other to Ben 'Ammi,
the ancestor of the Ammonites. A recent
survey of Ghawr al-Safi located the ruins
of Khirbat Sheikh 'Isa, which include an

179

Monastery of St. Lot, volumetrical restitution, Ghawr al-Safi.

Hasmonaean prince Alexander Jannae in 83-82 BC, but given back to Aretas by Hyrcanus II. Following the annexatio of the Nabataean kingdom in 106, Roman garrison was posted at Zoar. Th Roman camp was located above Khirb Sheikh 'Isa, at the site of Umm al-Tawabi Under Hadrian (117-138), Zoar is me tioned again in the Babatha archives. Th Babatha was a wealthy lady of Jewish or gin who was living at Maoz, the port Zoar on the Dead Sea. When the revolt Bar Kokhba broke out in 132, she took h documents to hide them in a cave near E Gedi. She married twice, but it appea from the archives that she had proble with her second marriage as the wife of h second husband refused a divorce. Babat sued this wife as well as John, son of Jose Eglas and Abodobodas, son of Elloutha guardians of her orphaned son Jesus. H cases were heard by the governor at Pet or at Areopolis-Rabba.

When Diocletian reorganised the Rom Empire at the end of the 3rd century, Zo was attached to *Palestinia Tertia.* On th mosaic Map of Madaba, a church is d picted at Zoar, to the right of a palm gro Its name appears as "Balak".

In the Medieval Islamic periods, Zoar (Ar bic Zaghar) enjoyed great prosperity and oasis was famous for the production of date indigo, syrup, sugar and balsam.

F.

impressive stretch of a town wall, and identified the site with Zoar.

In the prophecies of Jeremiah 48 and Isaisah 15, Zoar is mentioned again in events of the mid-6th century BC: "Why the heart of Moab is groaning, why its fugitives are as far afield as Zoar?". This oracle refers to the invasion of the Babylonians, either under Nebuchadnezzar II in 598 or under Nabonidus in 552 BC. On his way to Tayma in Arabia, Nabonidus, the last king of Babylon, conquered Moab and Edom and he has been memorialised in a relief carved on the rock of Sela', south of Tafilah.

Under the Nabataeans, the city was certainly a major stopping point on the road from Petra to the Dead Sea, where bitumen was collected and sold to Egypt for mummification. Because of its location on a strategic road, Zoar was captured by the

V.1.a Dayr 'Ayn 'Abata
(Monastery of St. Lot)

Lies 170 km. south of Amman in a villa called Safi, 2 km. north of the phospha

180

mining town. The site can be reached from the Dead Sea following the Araba route heading south for about 60 km. Visitors from Amman are advised to follow the Dead Sea road from Na'ur and continue south to Ghawr al-Safi. The best transport is by private car. The site can be visited during the day and the entrance is free. Information: Dept. of Antiquities office at the southern Jordan Valley 03-378845.

This ancient pilgrimage site is associated with the biblical story of Lot and his family who escaped the destruction of Sodom and Gomorrah. He was instructed by Yahweh neither to stop in the plain, nor to look behind him "(…) but the wife of Lot looked behind and was turned into a pillar of salt" (Genesis, 19:26). Lot passed by the town of Zoar, "the little one" (Khirbat Sheikh 'Isa), and took refuge in the hill-country. There, it is told, he made his home with his two daughters in a cave.

On the Madaba Mosaic Map (6th century; see Concept of Byzantine and Umayyad Iconography) the monastery of St. Lot is represented above the city of Zoar, modern Ghawr al-Safi. The building on the mosaic map is rectangular with a pediment, a circular opening over the entrance and three side windows.

The actual site is 63 km. south of Karak, above Ghawr al-Safi and overlooking the southern end of the Dead Sea. The ruins extend on a steep ragged mountain slope, covered with huge dark-coloured rocks with several hollowed out hermits' cells. At the foot of this mountain, gushes the spring known by the Arab geographer

Yaqut al-Hamawi as "'Ayn Raya", named after one of Lot's daughters. Excavations brought to light a monastery and a tri-apsidal church. Two panels of mosaics in the central nave are adorned with geo-metrical designs and birds among vegetal scrolls and by an inscription dated 71/691, i.e. to the early Umayyad period. A pulpit, decorated with small columns and panels carved in soft steatite stone, was discovered in the area north of

Church of St. George, Mosaic Map, Ghawr al-Safi / Zoar and Lot's Church, Madaba.

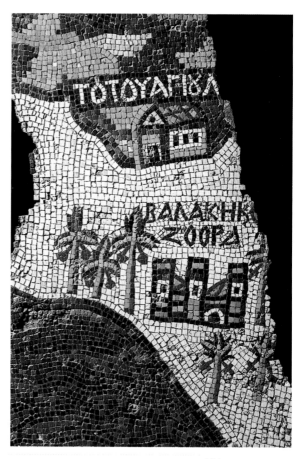

Monastery of St. Lot, aerial view, Ghawr al-Safi.

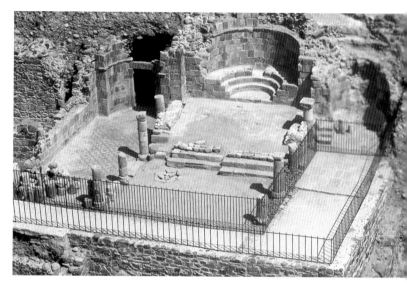

the central apse. Adjacent to the apse lies a cave which, originally an early Bronze Age tomb, is believed to have been the shelter where Lot and his two daughters took refuge after the destruction of Sodom by fire. The story is reported in the Old Testament (Genesis 19) and in the Holy *Qur'an* (*Surat Hud* 11, 276-83). In front of the cave, the geometrically patterned mosaic floor has been dated from the periods during which the Bishop Jacob and the Abbot Sozimos presided over the church and monastery. Firm archaeological evidence dates an earlier mosaic, lying under the mosaic floor pertaining to the Umayyad rebuilding of the church in *Dhu al-Hijja* 71/May 691, from April 606. Additional evidence indicates that the site was used as a religious sanctuary already in the early 6th century. North of the cave, the excavations uncov-

ered a hostel for pilgrims, consisting of several rooms and a meeting hall with a large oven. A communal shaft tomb was uncovered also in the same area. To the south of the church, a large water reservoir collected rain water through a plastered channel, cut into the hillside.

Driving on the newly built road along the eastern shore of the Dead Sea, one can see, south of the Wadi al-Mujib bridge, standing on a high cliff, what is popularly believed to be the petrified form of Lot's wife.

F. Z.

V.2 AQABA

Is 340 km. south of Amman. To reach Aqaba from Dayr 'Ayn 'Abata, it is best to continue along the Araba route to the South Tell of

Aqaba, either by taxi or private car. From Amman, organised bus tours or local buses are available from Abdali or the 7ᵗʰ Circle, taking about 4 hours. Information: Dept. of Antiquities Office at Aqaba 03-2019063 or Visitors Centre 03-2013731.

V.2.a Islamic City of Ayla

The ruins of the ancient city are situated in the heart of town near the Aqaba Gulf Hotel. The site is open during the day and the entrance is free. Information: Dept. of Antiquities Office at Aqaba 03-2019063 or Visitors Centre 03-2013731.

The modern port resort of Aqaba (the name given to the ancient site in the 7ᵗʰ/13ᵗʰ century) lies in the northeastern corner of the Gulf of Aqaba and is situated within the region of the Great Rift Valley in close proximity to the southern end of Wadi Araba. Subterranean waters run down this *wadi* and enter the sea beneath the modern town; thus fresh water is made available through tapping underground water, a few metres below the surface of the earth. The town is surrounded by desert and high mountains: Sinai to the west, Negev to the north, Hisma and Wadi Ramm to the northeast. When the soldiers of the Great Arab Revolt marched with Lawrence of Arabia from Wadi Ramm to the shores of the Gulf in 1917, Aqaba was a primitive village with a few mud-brick huts and palm groves. Beneath its soil, however, was concealed a long history that stretched back to the 4ᵗʰ millennium BC.

The spelling of the name of the site varies in historical sources as Aila, Ailana, Elana, Haila, Ailath, Elath, Ayla and Wayla. A procession of biblical peoples, Edomites, Israelites, Nabataeans, Romans and Arabs inhabited the town. Recent archaeological research has shown that the focus of settlement through the numerous historical periods tended to shift from north to south. The Iron Age II and III (8ᵗʰ-5ᵗʰ centuries BC) site was located at *Tell* al-Kaliefeh, some 500 m. north of the shoreline inside the Jordanian border with Elath.

The site was identified initially with the biblical Ezion-Geber, where King Solomon built a fleet that sailed to Ophir (Somalia) and returned with 420 talents of gold. Recent excavations cast doubt on this identification and have shown that the site was not founded prior to the 8ᵗʰ century BC. The site, instead, served both commercial and industrial purposes as a trading post for caravans and for smelting copper from Wadi Faynan. In the 1ˢᵗ century BC, Ayla and its region were inhabited by the Nabataeans who raised livestock and also engaged in piracy, attacking merchant ships in the Red Sea. In the same period, merchants from "Ailana" were found in southern Arabia (Yemen) buying frankincense, myrrh and other aromatics. In 106 Trajan, the Roman emperor, annexed the Nabataean kingdom to the newly created *Provincia Arabia*, hence bringing Ayla under direct Roman rule. The *Via Nova Traiana*, which extended from Bostra in southern Syria to Ayla, was completed between 111 and

Islamic City of Ayla, city gate leading to the suq and the central pavillion, Aqaba.

from which he had evicted the Byzantine customs officers. Later, Amorkesos visited the emperor in Constantinople, received gifts and was officially recognised as a *phylarch* over *Arabia Petraea*. How this could have happened while the Tenth Legion was still in Ayla is difficult to explain. It is likely, however, that Amorkesos was won over to the Byzantine side and entrusted with the duty of securing the trade routes that led from southern Arabia to the Mediterranean world. Several bishops were attested at Ayla beginning in 325 when its bishop attended the Council of Nicaea. Excavations, begun in 1994, located the Nabataean-Roman City of Ayla at a distance of 2 km. from *Tell* al-Khaliefeh, in the circular area of modern Aqaba. In the course of excavation, a massive mud-brick basilica structure, dated from the early 4th century and identified by the excavators as a church, was discovered. If this identification proves correct, it is then the earliest church building yet known in Jordan and Palestine. In 8/630, Ayla surrendered peacefully to the Prophet Muhammad who guaranteed security for the city's ships and caravans. In the mid-1st/7th century the Muslims founded a new walled-in settlement, to the south of the Roman-Byzantine town. This town, a rare example of early Islamic urban planning, was discovered in the course of excavations, begun in 1986. The plan of the Islamic city (165 x 140 m.) is laid out in axial streets leading to four gates, the intersection in the middle marked by a tetrapod. This central building was later transformed into a luxurious residence

114. The administrative and military reforms of Diocletian (r. 284-305) partitioned *Provincia Arabia* into two parts, with the southern part (the area east of the Dead Sea) being transferred to *Palestina Tertia*. At the turn of the 3rd century, the *Legio Fretensis* was transferred from Jerusalem to Ayla where it remained at least until the end of the 5th century. During the reign of the Byzantine emperor Leo I (457-474), an Arab chief by the name of "Amorkesos" (Imru' al-Qays) occupied the island of Iotabe (identified with the Isle de Graye and presently known as Jazirat Fir'aun or with Tiran at the mouth of the Gulf of Aqaba)

decorated with frescoes. To the northeast of this residence and occupying a large portion of the northeastern quadrant was a mosque. Its plan shows a wide courtyard with colonnades around the sides, the southwestern side being two columns deep. In the centre of this side was a deep niche, the *mihrab*.

The whole city was surrounded by substantial walls and U-shaped towers. The regular plan follows closely that of Roman legionary camps as those of nearby Udhruh and Lejjun, and may have been inspired by the Byzantine camp in Ayla itself, which has yet to be discovered (see Roman Legionary Camps and City Planning). In addition to serving as a transhipment point for goods, Islamic Ayla benefited from the annual pilgrimage to Mecca and continued to prosper until the end of the $6^{th}/12^{th}$ century. Soon after, the city suffered from a series of disasters in the form of earthquakes,

Bedouin raids and attacks by Crusaders. The process of site migration from north to south continued in the late medieval period when a new settlement around the Mamluk fortress was established about 1 km. to the south of early Islamic Ayla.

G. B.

V.2.b Aqaba Region Archaeological Museum

Is next to Aqaba Castle (the historical residence of Sharif Hussein Ibn 'Ali). Open daily, including public holidays, from 8 am-6:30 pm in summer and from 8 am-5:30 pm in winter, during Ramadan from 9 am-4 pm. There is a small entrance fee. The exhibits include archaeological finds from Ayla and al-Humayma and other sites in the Aqaba region, spanning the Chalcolithic to Late Islamic periods.
Information: Aqaba Region Archaeological Museum 03-2013861.

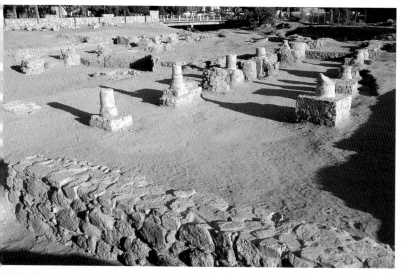

Islamic City of Ayla, view of a mosque, Aqaba.

185

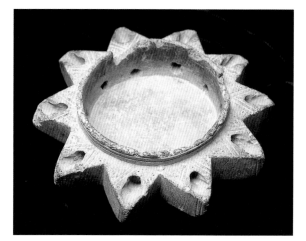

Steatite oil lamp from Islamic Ayla, Aqaba Region, Archaeological Museum, (Inv. Num. AM 10).

Bronze weights from Islamic Ayla, Aqaba Region, Archaeological Museum, (Inv. Num. AM 51).

choice of this stone. The saucer-like lamp in the shape of a star dates back to ancient times (the star featured in many Assyrian reliefs symbolising "Assur" and even today the star with an eye in the centre (to ward off evil!) is visible and leaves no doubt as to its Near Eastern origin. Each point is a nozzle for the wick to bring forth light, the centre being the receptacle for oil.

Steatite oil lamp from Islamic Ayla, Inv. Num. AM 10

The oil lamp is unusual in style, material and form and uniquely Umayyad or early Islamic. Steatite was much sought after by wealthy Umayyads and most objects made of this soft dark stone are richly embellished. In fact, steatite was known from early Oriental cultures, used in particular for cylinder and other seals where carving delicate designs dictated the

Bronze weights from Islamic Ayla, Inv. Num. AM 51

The eight bronze weights of different sizes (and weights) vary little in shape as may be expected with such commodities. In fact, they are more or less the same as the first known metal weights of the Bronze Age, often pierced in the centre and either in bead form or conical. The hole in the centre is for safe-keeping, probably stringing them on a leather thong, to keep them together as a unit and to move them about easily.

Bronze appliqués from Islamic Ayla, Inv. Num. AM 47, 45, 46,546, 44

These small appliqués were once part of vessels or other household goods. The cock is often found as handle on the lid of the Arabic coffee pot (seen today), the rosette might have belonged to a brazier, the double hook served to hold a scale or perhaps a metal cooking pot over the fire. Bronze appliqués are known in all cultures, in all periods and are not easily

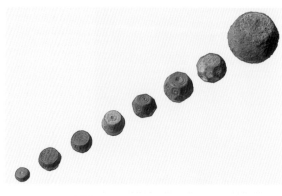

dated by themselves. The spot where they were found and parallels from other sites and objects make these bronzes distinctly Islamic, nowadays easily confirmed by physical examination of the metals and smelting techniques which varied from period to period.

Gold coin from Islamic Ayla, Inv. Num. AM 654

The gold coin found at the Islamic City of Ayla is a rare piece not only because it is of gold but more importantly, because it illustrates the transition between the Byzantine and Islamic cultures. The coin was struck at the end of the late Byzantine period bearing on the obverse an image of Heraclius and his sons holding a scep-tre with a cross. On the reverse is a large cross with a Greek inscription. Heraclius (r. 610-640) was the next to the last Byzantine emperor around the middle of the $1^{st}/7^{th}$ century and his reign is syn-onymous with the changeover from a

Christian to a Muslim world in the Near East.

White-ware pottery jug from Islamic Ayla, Inv. Num. AM 633

The white-ware of this humble jug has been subject to much academic discussion because the form as well as the distinctly white Islamic ware without slip or other

Bronze appliqués from Islamic Ayla, Aqaba Region, Archaeological Museum (Inv. Nums. AM 47,45, 46, 546,44).

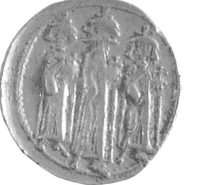

Obverse of gold coin from Islamic Ayla, Aqaba Region, Archaeological Museum (Inv. Num. AM 654).

Reverse of gold coin from Islamic Ayla, Aqaba Region, Archaeological Museum (Inv. Num. AM 654).

Aqaba

White-ware pottery jug from Islamic Ayla, Aqaba Region, Archaeological Museum (Inv. Num. AM 633).

Ivory objects from Islamic Ayla, Aqaba Region, Archaeological Museum (Inv. Num. AM 52).

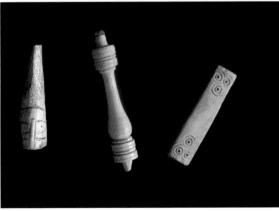

surface finish has been associated both with the Umayyad and Abbasid dynasties, i.e from later in the $1^{st}/7^{th}$ to the end of the $3^{rd}/9^{th}$ century. Whatever its true origin, this type of jug found its home in many households of the early Islamic period. Wares are recurring fashions, like so many others, and white-ware was already popular in the early Roman period and especially in the south at Petra and Aqaba where the jug was made or used to pour wine or water many centuries since.

Ivory objects from Islamic Ayla, Inv. Num. AM 52

Ivory was then, as before and now, a precious material used to embellish furniture as inlays or made into small ornate objects. One of the three items is a Coptic doll or the head thereof with its huge incised and painted eyes. The doll is important because it provides material evidence of the trade that existed between the ports of Egypt and Aqaba or Ayla as it was then called. The other pieces are decorated in the formal manner of long standing tradition of ivory work in the Near East, the famous Nimrud ivories of the later Iron Age being a prime example. The three objects can be placed generally in the earlier Islamic period.

I. K

Wadi Ramm (Wadi Iram)

Wadi Iram is 340 km. south of Amman or Aqaba, drive north for about 25 km. and then, following the route, branching east of the Desert Highway for about 35 km. to the site. The area is open for visits during the day for an entrance fee. A 4-wheel drive is essential. Accommodation is available. Information: The Rest house 03-2018867. The vast stretches of the "Red sand" desert with large craggy rocky outcrops are of rare scenic beauty. It is this part of Jordan where Nabataean caravan routes were dotted with caravanserais and not far-off early settlements. Of special interest are the intricate irrigation systems installed by the Nabataeans, which made the desert region habitable for the Nabataean settlers and travellers and which were adapted in later historical times to serve more recent travellers, as for instance, the Umayyads from Humayma.

Wadi Iram is known, in particular, for carvings and early North Arabian inscriptions (Safaitic and Thamudic) on rocks indicating movements and distribution of tribes from the Saudi Arabian desert in the north (Meda'in Saleh and al-Ulah) to Aqaba and beyond (the Sinai) in the south. It is also the site of Lawrence of Arabia's conflicts in the fight for independence.

ROMAN LEGIONARY CAMPS AND CITY PLANNING

Ghazi Bisheh

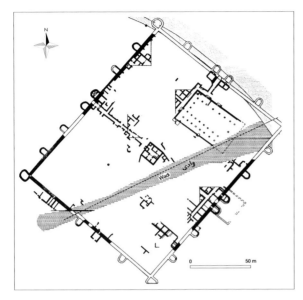

Islamic City of Ayla, Aqaba (Whitcomb, SHAJ 5, 1995).

The "Islamic City" conjures up in the minds of contemporaries a picture of irregular winding streets, which often end in a *cul-de-sac*. These streets lead to segregated residential quarters where houses always face inward for the protection of private family life. In the centre of the city is the market-bazaar buzzing with noise and the shouts of retail merchants. In the words of a noted scholar, "(...) irregularity and anarchy seem to be the most striking qualities of Islamic cities. In social terms, the Islamic city represents an agglomeration of disjointed groups and individuals with conflicting interests".

According to some commentators, these characteristics resulted from the absence of municipal institutions (*Curia*) and local self-government in the Islamic cities, which in this imagined model are represented as static, timeless and unchanging.

Such a picture, however, is far from being accurate because it does not take into consideration regional differentiation or the factor of time and the concomitant nature of urban growth.

For reasons of convenience the Islamic cities are divided sometimes into two types: "created" and "spontaneous" cities, i.e. cities created in Islamic times by the deliberate will of a ruler or dynasty, and those that have survived and grown "organically" from earlier periods. Prime examples of the first category are *Dur al-Hijra* (the abodes of immigration) like Basra and Kufa in Iraq, Fustat in Egypt and Kairouan in Tunisia. These were initially mass encampments of tents or makeshift settlements of migrating tribes, established to control the non-Arab populations of occupied countries and to function as springboards for further expansions. Within two generations at most, these settlements grew into permanent garrison towns (*amsar*, sg. *misr*) and as the state encouraged populating them by Arabs, they soon became the foci of cultural and social-political activities. The enduring growth of these *amsar* confirms the success of their original creation. The configuration of these garrison towns is known largely from Arabic historical sources. Recent research has shown that far from being haphazard, their layout was thought out carefully on a regular plan. In each *misr*, the land was divided into residential quarters (*khitat*) along tribal lines. In the centre was an open space (*rahba, sahn*) which served the needs of the local government. In it was located the Friday mosque (*Jami'*) and next to it on the south

190

(*qibla*) side was the governor's house (*Dar al-Imara*). Their proximity to each other represented the unity of state and religion. From the centre radiated major thoroughfares (*Manahij*) 40 cubits (20 m.) wide, and main streets (*Turuq*) 20 cubits (10 m.) wide, which separated the various *khitat*. These, in turn, branched off into a labyrinth of lanes (*Zuqaq*) 7 cubits wide. The streets were regular, though not necessarily orthogonal, forming a grid of major and minor avenues with the residential quarters between them. The division of the city into *khitat* according to tribal lines was a matter of convenience since it facilitated control over the tribes, recruitment for the army and the payment of stipends for the soldiers.

In Syria, Jordan and Palestine, the Arab-Muslims came to countries, which had long been urbanised. By the time they arrived, however, the Graeco-Roman cities with their broad colonnaded streets, temples, theatres and market places had already had been transformed into less grandiose entities; monumental baths had disappeared, grand temples had fallen into decay, the colonnaded streets had been encroached upon by shops and poor housing, and the autonomous civic councils had disappeared as bishops and their clergy filled their place and took charge of the affairs of cities. As newcomers with little or no experience in town-planning, the Arabs did not initiate major modifications to the existing cities, but introduced new functions, which reflected the dynamic forces of Muslim society. For this reason, is all the more remarkable that in found-

ing a new settlement like Ayla (Aqaba) the Arabs adopted a regular plan along the lines of a typical Roman legionary camp with two streets intersecting at right angles in the centre (see Islamic City of Ayla). Nor was Ayla an unique example, for a similar regular plan can be seen at 'Anjar in Lebanon and Qasr al-Khayr in eastern Syria. These examples show that contrary to the prevalent view, irregularity has been from the beginning alien to Islamic art, architecture and town planning where symmetry and harmony were the overriding principles. The absence of municipal autonomy did not prevent numerous Islamic cities from flourishing, nor did it preclude the formation of integrated communities with a distinctly strong sense of solidarity and social cohesion. In early Islamic philosophy the city was a prerequisite for the individual to achieve moral and cultural perfection.

Military camp, Roman period, Lejjun (Parker, SHAJ 5, 1995).

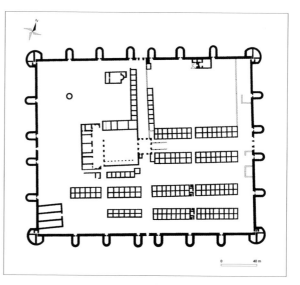

191

Traders and Pilgrims

Fawzi Zayadine, Ghazi Bisheh, Ina Kehrberg, Mohammad al-Asad

Second day

V.3 AL-HUMAYMA

V.4 UDHRUH

SCENIC OPTION
Dana Nature Reserve

The Land of the Prophets and Companions
The Syrian Pilgrimage Road to the Holy Cities of Islam

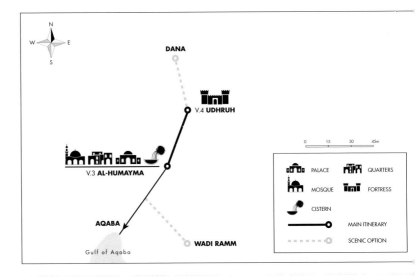

V.3 AL-HUMAYMA

The site lies 280 km. south of Amman and can be reached from Wadi Ramm or Aqaba by car driving north for about 60 km. It is advisable to hire a 4-wheel drive, as the route to the site is a rough track. There is no entrance fee and the site can be visited during the day. Information: Society for the Preservation of al-Humayma 03-2014385.

The settlement of al-Humayma is of historical importance since it was there that the Abbasid family was based during the first half of the $2^{nd}/8^{th}$ century and where they planned their revolution against the Umayyads. Substantial excavations since the late 1980's have uncovered much information about the patterns of human settlement that have taken place at al-Humayma over the past two millennia. Al-Humayma dates back to the Nabataean Arabs when it was founded as Avara (from the Arabic *al-Hawra'*) by the Nabataean king, Aretas III (*al-Harith*) (r. 87-62 BC), whose kingdom was based in Petra. Excavations at al-Humayma have revealed a number of Nabataean tombs and a house, but the most impressive Nabataean remains consist of the hydraulic system built by the occupants. The system at al-Humayma demonstrates as elsewhere the ingenuity of the Nabataeans in intercepting and collecting water. The network of aqueducts carrying water to the site extended over a length of 33 km. Surveys have brought to light over 50 Nabataean cisterns and two dams

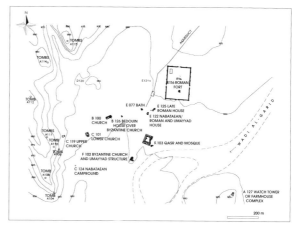

in the 240 square kilometres area around al-Humayma. Two of the cisterns located in al-Humayma itself have a capacity of over 900 cubic m. for water. The **smaller cisterns** are circular, being more economical and easier to build and to waterproof. The **larger cisterns** were usually rectangular and were easier to cover with a roof. The water systems

Al-Humayma (Avara) (Oleson, et al., ADAJ 43, 1999).

Nabataean cistern, al-Humayma.

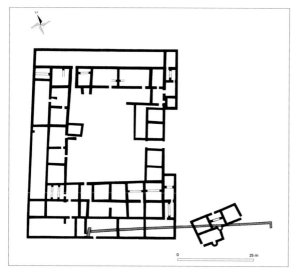

Abbasid Palace, al Humayma (Oleson, et al., ADAJ 43, 1999).

General view of two small mosques: mosque in foreground and background, al-Humayma.

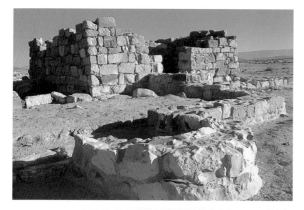

installed by the Nabataeans proved to be so efficient that they continued to be used in subsequent periods.

After the Roman annexation of Nabataea in 106, al-Humayma continued to be of some importance due to its location along the route of the *Via Nova Traiana*. This Roman road, which crossed the Roman province of Arabia from north to south to the port of

Aqaba, was completed under Trajan, as the name indicates, and the earliest dated milestones are from 111 and 114.

The occupants of the Roman period elaborated the Nabataean hydraulic systems and constructed an imposing fort at the northern edge of the site. The fort has been dated from the second half of the 2nd to the early part of the 3rd century. The fort measured about 205 x 150 m. and had four corner towers and a series of intermittent towers. In the region of Roman Arabia, the fort was second only in size to the one in Bostra (in modern Syria). Excavations have revealed remains to the southwest of the fort believed to have been Roman baths. The site continued to play a role during the Byzantine period of the 6th and the early 7th centuries to date, four contemporary churches have been excavated.

According to historical texts, the Abbasid 'Ali Ibn 'Abd Allah Ibn al-'Abbas purchased the site of al-Humayma in the Umayyad period during the reign of the caliphate of 'Abd al-Malik Ibn Marwan (65/685-86/705). Other sources indicate that the Umayyads granted it to him. It was after 'Ali's death that his son Muhammad began to plan the Abbasid uprising against the Umayyads.

'Ali Ibn 'Abd Allah built a *qasr* and a small mosque in al-Humayma. He also planted a grove of 500 olive trees. The *qasr*, built on earlier remains, was about 64 x 50 m. large and consisted of a central courtyard surrounded by domestic quarters. The *bayt* arrangement, rooms arranged around a smaller courtyard common in Umayyad palaces, however, is absent here. The

walls of the *qasr* do not have any towers and it has a recessed entry. These features provide a departure from other $2^{nd}/8^{th}$ century Umayyad palaces in *Bilad al-Sham* and indicate an influence from the Arabian Peninsula rather than Byzantium. This is not surprising since 'Ali Ibn 'Abd Allah came to al-Humayma from the city of Ta'if in the *Hijaz*.

The functions of the rooms of the *qasr* are not yet clearly understood, except for one room that has been identified as a bakery. A room in the middle of the west side had extensive frescoes, but much of this decoration was destroyed by fire. In the course of excavations many precious objects have been found including an Umayyad coin of 115/733-734 and thousands of ivory fragments.

Some of these fragments have been re-assembled and show a panel about 30 cm. long depicting a frontal view of a male military figure carrying a spear and his head in profile. Stylistically, the carving reveals Persian influence or of regions further east. Other items include an ostrich eggshell painted in red, iron handles and leather fragments. All this suggests that the owners of the palace led a luxurious life style. In this context, it should be added that the Abbasid family traded far afield and regularly received in al-Humayma travellers from Syria and the *Hijaz*.

A **small mosque** about 10 m. from the southeastern corner of the *qasr* was rebuilt early in the 20th century, only the first three courses of the original building still exist. The mosque is rhomboidal in plan with its *mihrab* visible from the outside, and the dimensions of its sides range from 5.60 to 5.75 m. The mosque is not properly oriented in the direction of Mecca, but this is not unusual in early mosques, a number of which have rather approximate orientations.

The mosque is among the smallest to survive in *Bilad al-Sham* from the early Islamic period, and its small size indicates that it was for private use. A second mosque has been excavated to the southeast of the

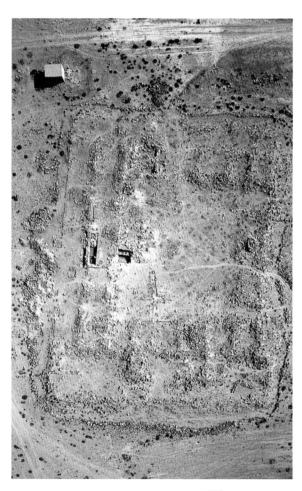

Abbasid Palace, aerial view at al-Humayma.

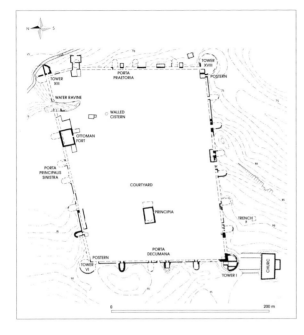

Legionary camp, Roman period, Udhruh (A. Killick, prelim. rep. 1983, n. p.).

V.4 UDHRUH

Lies 120 km. north of Aqaba and 20 km. west of Ma'an. The site can be reached from al-Humayma by car, following the Desert Highway and continuing north toward Udhruh through the city of Ma'an. There is no entrance fee and the site can be visited during the day.

Udhruh lies 20 km. northwest of Ma'an and east of Wadi Musa and is situated in an arid region where the annual precipitation rate is less than 200 mm. A perennial spring near the site makes up for the scarcity of rain water, and seems to have been the decisive reason for choosing this particular spot. The main feature of the site is a large Roman legionary camp, trapezoidal in plan and measuring 246 m. on the north side, 248 m. on the south, 177 m. on the west and 207 m. on the east. Along the outer walls projecting defensive towers are still intact but the interior is strewn with collapsed stones and building debris. Astride the north perimeter wall is an Ottoman fort with walls standing 6 m. high.

Outside the southwest corner tower is a Byzantine church. The east wall is curved before its northern end to enclose the spring, which had to be protected. Apparently, the area within the enclosure was divided originally into four quadrants by two axial streets intersecting at the centre and leading to

first mosque and even abuts part of the first mosque's *qibla* wall. As yet, it has not been possible to date this mosque. Interestingly enough, al-Humayma does not have a congregational mosque, and none of its numerous churches from the Byzantine period were converted into mosques during the Islamic period. This suggests that, at least during the early Islamic period, not many Muslims inhabited al-Humayma and that most of its inhabitants continued to be Christians. The Abbasid family left al-Humayma for Iraq in the first half of the 2nd/late 740's. The site continued to be occupied in subsequent periods, even after the Ottomans established their control over the area in 923/1517.

M. A.

our entrance gates. In addition to these main gates, there are three barrel-shaped postern passages; if other posterns existed, they have long since been destroyed.

The site of Udhruh was settled because of its proximity to Petra and its location on a major trade route. The network of roads constructed in the Roman period, especially the *Via Nova Traiana*, increased the strategic importance of Udhruh. The earliest reference to Udhruh occurs in the work of Ptolemy (2nd century) who referred to it as a town in *Arabia Petraea*. The Justinianic edict from Beersheba referred to Udhruh as paying 650 gold pieces, the highest on the list of all towns of *Palestina Tertia*, thus indicating its importance in the 6th century, the period of the ascendancy of the Ghassanid Phylar-

chate, when the security of the region was entrusted to them. It is interesting that a 4th/10th century Arabic source attributes the rebuilding of Udhruh to the Ghassanid Phylarch, "al-Harith Ibn Jabala". In 8/630, when Heraclius triumphantly entered Jerusalem, after its recovery from the Sassanians, the Prophet Muhammad arrived at Tabuk. While he was there, a delegation from Ayla, Udhruh and the nearby town of Jarba met the Prophet and negotiated a peace treaty with him. In this accord, Udhruh agreed to pay a tax of 100 *dinars* (gold pieces), a sum much less than the tax. It had to pay during the reign of Justinian, perhaps due to a diminished population. When the battle of Siffin (36/657) raged between the forces of 'Ali Ibn Abi Talib the fourth Orthodox *caliph,* and the supporters of

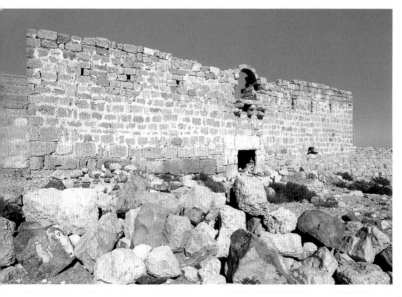

Fort in legionary camp, Udhruh.

197

General view of the traditional village, Dana.

Mu'awiya I Ibn Abi Sufyan, the governor of Syria, both sides agreed to resort to arbitration to end the fighting. The arbiters with their large retinues met at Udhruh and ended in a fiasco for the supporters of the *Caliph* 'Ali. In 41/661, Hassan, the elder son of 'Ali submitted to Mu'awiya in the same location and assured him of his allegiance, consequently, paving the way for the establishment of the Umayyad dynasty with its capital in Damascus. In 67/687-68/688 'Ali Ibn 'Abd Allah Ibn al-'Abbas and other members of the Abbasid family settled in Udhruh. Their stay at Udhruh was not long, for they soon moved to al-Humayma (see al-Humayma), the site from which the Abbasid revolution and missionary movement was initiated, and eventually led to the overthrow of the Umayyad dynasty in 132/750.

G. B.

Dana Nature Reserve
Dana lies about 25 km. south of Tafilah and just north of Shobak on the Kings Highway. The site can be reached from Udhruh by car driving north toward Tafilah. The reserve is one of six natural protected reserves in Jordan looked after by The Royal Society for the Conservation of Nature (RSCN). The Dana natural park is perhaps the purest and richest area for the observation and study of indigenous flora and fauna and its kaleidoscopic beauty remains unchallenged. The project is one of the largest in the Middle East combining seven different habitats starting about 250 m. below sea level and rising to 1500 m. in its mountainous terrain. In early days, villagers of Dana depended on trade via the Wadi Araba. The Dana project has encouraged local inhabitants to revive village life by restoring traditional Ottoman houses and practices of trades and crafts. Information: Dana Nature Reserve 03-368497.

THE LAND OF THE PROPHETS AND COMPANIONS

Mohammad al-Asad

The area of modern Jordan contains numerous sites of considerable importance to the followers of the three monotheistic faiths, Judaism, Christianity and Islam. The sites are connected to events and figures mentioned in the Old and New Testaments, in the *Qur'an* and in major histories of the three religions. Considering the continuity that exists between Islam, and Christianity and Judaism, it is not surprising that many of the biblical sites are also important to Muslims.

The historical remains on most of these sites are primarily the result of modern restoration or renovation. Consequently, such sites yield more in the collective memories they house, than from the architecture they contain.

Tradition has linked sites in Jordan to a number of biblical figures such as Noah, Abraham, Lot, Isaac, Moses, Aaron, Joshua, Elijah, David, Solomon, Job, John the Baptist and Jesus Christ. Mount Nebo near Madaba is believed to be the place where Moses died. Mukawir, located south of Madaba and overlooking the Dead Sea, is thought to be the place where John the Baptist was beheaded. The eastern bank of the River Jordan, identified with Wadi al-Kharrar, is considered to be the location where John baptised Jesus. A cave in the Jordan Valley, "Lot's cave", along the slopes of the mountains facing the Dead Sea, are widely held to be the place where Lot and his daughters lived after escaping the destruction of Sodom and Gomorrah. The site contains the recently excavated 6th century Byzantine monastery and church of St. Lot (Dayr 'Ayn 'Abata). In addition, certain traditions have placed the tombs of Aaron, Joshua and Job there in Jordan. According to these traditions, the tombs

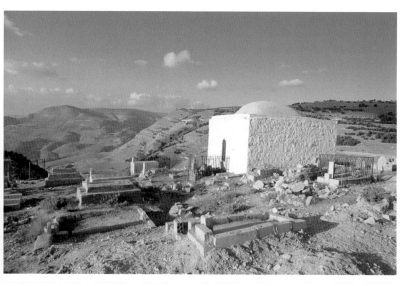

Shrine of Noah,
near Karak.

199

Dab'a castle.

Mosque on battlefield of Mu'ta, near Karak.

by Christian pilgrims to Jordan have come down to us, such as that of the 5th century Peter the Iberian, and the 6th century anonymous pilgrim from Piacenza. These early accounts hold valuable information relating to the archaeology and history of the Holy Land. Jordan, also, contains many sites of importance to early Islam. Two decisive battles took place between Muslim and Byzantine forces at Mu'ta and Yarmuk. The tombs of about 14 of the Companions of the Prophet Muhammad (those who met the Prophet as Muslims) are located in Jordan. Many of the companions had fought in the two battles and the tombs or mausoleums are distributed throughout the country and are visited by Muslims from different parts of the Islamic world.

The **First Battle at Mu'ta**, near Karak in southern Jordan, took place in 7/629. The Prophet had sent an army of about 3000 men and appointed his adopted son, Zayd Ibn Haritha, as its leader. The second in command was Ja'far Ibn Abi Talib, the cousin of the Prophet and brother of 'Ali. The third in command was 'Abd Allah Ibn Rawaha, a Christian convert to Islam whom the Prophet trusted greatly. The Muslims were defeated and the three commanders died in battle. Their tombs are located in the village of *al-Mazar* ("place of visitation") near Mu'ta. The village houses, also, a recently completed large religious complex.

The **Battle at Yarmuk** occurred in 15/636, four years after the death of the Prophet. It is named after the Yarmuk River, a tributary of the Jordan River where the fighting took place. The Muslim army

of Joshua and Job are located close to the city of Salt and that of Aaron is near Petra. The importance of the area of modern Jordan for Christian pilgrimages emerged during the early Christian period. The first documented example of such a pilgrimage is of a woman by the name of Egeria, whom scholars believe to have been a Spanish nun who lived during the late 4th century. Egeria wrote very detailed letters to her sisters about her travels. Since then, a number of accounts

Tomb of 'Abd Allah Ibn Rawaha, Mazar, near Karak.

...as led by the brilliant general Khalid Ibn
...-Walid. Khalid had fought at Mu'ta, and
...anaged to bring back safely the remaining
...efeated Muslim army to Madina after the
...eath of its three commanders. Although
...e Muslims were outnumbered by at least
...o to one at Yarmuk, they were able to
...cure a decisive victory over the Byzantine
...rces and with this victory, Syria's fate as a
...uslim province was sealed.

...number of the Companions of the
...rophet who fought in the battle of
...armuk and in other battles that took
...ace in Syria against Byzantine forces set-

tled in the area of modern Jordan. The
most important of these is probably Abu
'Ubayda al-Jarrah, one of the first con-
verts to Islam and who the Prophet
named *al-Amin* ("the trustworthy one"). The
caliph 'Umar Ibn al-Khattab appointed
him leader of the Muslim army in Syria to
succeed Khalid Ibn al-Walid and the first
Muslim governor of Syria. In fact, it is
reported that 'Umar intended to nomi-
nate him as his successor except that Abu
'Ubayda died before 'Umar as a result of
the plague around 18/639. His tomb is
located in the Jordan Valley.

201

THE SYRIAN PILGRIMAGE ROAD TO THE HOLY CITIES OF ISLAM

Fawzi Zayadine

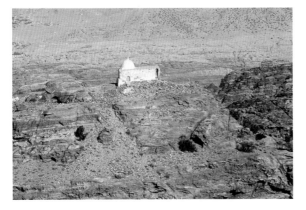

Tomb Aaron, near Petra.

Al-Qatrana castle.

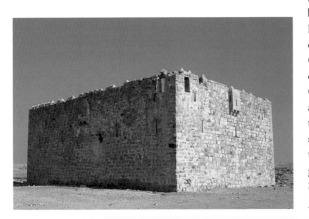

Pilgrimage is one of the five duties of Islam. Every adult Muslim must go to Mecca at least once in his life. In fact, this tradition goes back to the pre-Islamic period, because the *Ka'ba* of Mecca was sacred to Quraysh and other tribes before Islam. Mecca was not the only place sacred to the Arabs, and other *Ka'bas* existed in the *Hijaz* during the *Jahiliya* or period of paganism. There was a *Ka'ba* in the valley of Hurad, near Mecca, dedicated to al-Uzza, and another one at Ta'if for the goddess Allat. The *Ka'ba* of Mecca, how ever, was the holiest of all sanctuaries because it was founded by Abraham and his son Isma el, before the appearance of Judaism and Christianity. After the Prophet Muhammad had conquered Mecca in 8/630, he entered the *Ka'ba*, destroyed the idols, performed the *'Umra* (small pil grimage) and established this *Ka'ba* as one of the religious centres of Islam.

The Syrian pilgrimage road was the first to be established officially, after the Umayyad caliphs made Damascus their capital in 41/661. The caravan of pilgrims was organised during the months of *Shawwal, Dh al-Qi'da* and the first ten days of *Dh al-Hijja*. The pilgrims were due to arrive in Mecca on the ninth day of *Dhu al-Hijja*. A commander of the pilgrimage was designated (*amir al-hajj*) and the caravan proceeded south, followed by friends and relatives of the pilgrims. In a later development on the night of departure of the caravan, a procession of the "baldaquin" (*mahma*) carrying the veil of the *Ka'ba* was held.

The first station was at Kisweh south of Damascus. The Muslims revered this site because it was where messengers of the Prophet Muhammad, sent to the emper or of Byzantium, were martyred by the Ghassanids. After this station, the caravan continued south to Khan Danun and Gabagheb. From this village, the pilgrimage arrived at Sanamayn and from there to Muzyrib. This town, with abundant springs and markets, was organised for the pilgrims to purchase the necessary goods for the journey. The last station in Syria was Der'a, now on the border of Jordan.

In Jordan, the pilgrimage followed the route marked by the modern railway, to al-Fudayn (Mafraq), which was an Umayyad settlement (see al-Fudayn). The road went from Mafraq along the ancient highway to Khirbat al-Samra, Zarqa and Amman. There, the best stop was downtown, in the *Nymphaeum* and the al-Husseini Mosque area (see Amman Citadel).

On the desert highway, which became the main pilgrimage road in the Ottoman period, a chain of Ottoman forts was built. Zizya, near the Amman Airport, is 30 km. south of Amman and Dab'a, the next station (50 km.), were both provided with a fort and a reservoir. Qatrana was an important station because it was at the junction of the Amman and Karak roads. The fortress was restored in the 1970's. The water reservoir is huge and collects the rain water of the *wadi*. At this station, upon the arrival of the caravans from Mecca, a messenger was sent to Damascus to announce the arrival of the pilgrims. Hasa is another station supplied with a fort and a water well. A bridge was built in the Mamluk period to allow the caravans to cross the *wadi* and the road was paved. The bridge of Hasa was also a stopping point where taxes were collected from the caravans.

At Ma'an, an ancient city founded by the Minaean (Ma'in), the pilgrims assembled at a hostel. From there, they departed at the station of Mudawwara for Arabia. Ma'an has two quarters: Ma'an al-Shamiya, to the north where the Damascene pilgrims were stationed and Ma'an al-Hijaziya, reserved for the Hijazi travellers. In Ma'an a market was organised and the pilgrims could leave their unnecessary baggage in storage.

View of a palm grove, Ma'an.

From Ma'an, the road proceeds to al-Shidiyya (28 km.) and to the citadel of Fassu'a, and from there to Batn al-Ghul, halfway between Ma'an and Mudawwara. This was the last station in Jordan where a fortress (19 m. long) and a water reservoir were built in the Ottoman period. From there, the road crosses the Saudi border to Halat 'Ammar.

Three roads lead from the Jordanian borders to the holy cities of Islam. The first road is the Tabuki road, which went along the ancient caravan tracks from Meda'in Saleh (Hegra) to Tabuk, through Wadi al-Qura. This was the oldest road followed by the Nabataeans. They left vestiges of stone at Hegra, already then an important Nabataean station, where the typical Nabataean tomb façades were carved in the sandy cliffs. The second road followed the coast of the Red Sea from 'Aynuna to meet with the Tabuki road. The third road passed directly from Ayla-Aqaba to Jedda and Madina.

GLOSSARY

Ajnad	(Sing. *jund*) Military provinces.
'Amil	Governor.
Amir	A military commander, prince or senior official.
Amsar	(Sing. *misr*.) Originally Muslim military camps, later became towns such as Basra, Kufa and Wasit.
Apodyterium	Changing or disrobing room.
Arcosolia loculi	(Sing. *arcosolium loculus*) A niche cut in the rock and used as a grave.
Auditorium	Seating for spectators.
'Ayn	Spring.
Badiya	Semi-desert or the edge of the desert. During Umayyad times, it referred to as "estates in the countryside".
Baqara	Cow.
Bayts	Self-contained units, arranged around a courtyard. Each *bayt* is made up of four to five rooms.
Bazaar	(In Persia, covered market with doors.) In the Orient, public market or designated place for commerce.
Bilad al-Sham	Area, which includes contemporary Jordan, Palestine and Syria.
Caldarium	Hot room.
Calibè	Syrian monument of the Roman period, probably dedicated to honour the imperial family.
Caliph	From Arabic *Khalifa,* meaning the supreme head of the Muslim community in the line of the Prophet's successors.
Caravanserai	A hostel accommodating travellers and safeguarding their goods (merchandise).
Cardo Maximus	North-south Roman street.
Castellum	Barracks.
Castrum	Legionary camp.
Cavea	Seats in the *auditorium* of a theatre.
Ciborium	Small chest to preserve the Christian liturgical vases.
Curia	Municipal council or assembly.
Dar al-Imara	Governor's house.
Day'a	Agricultural estate.
Decapolis	Union of cities in Syria, Palestine and Jordan, originally 10 in number as the name indicates.
Decumanus	East-west Roman street.
Deiknutai	Greek verb meaning "is shown".
Deuteronomy	Book of the Old Testament, fifth and last of Pentateuch, in which Moses proclaimed, for the second time, the Jewish law.
Dinar	Islamic gold coin.

Drahms	Silver coinage.
Dur al-Hijra	Abodes for immigrants.
Dux Arabiae	Governor of Arabia.
Funduq	In Northern Africa, hostelry for merchants and their pack-animals; warehouse for merchandise and commercial centre, equivalent of a *caravanserai* or a *jan* in Oriental Islam.
Germani	Surname of a Roman family.
al-Ghawr	Rift (Jordan valley).
Hammam	Bathhouse.
al-Haram al-Sharif	Noble sanctuary.
Hijaz	District in the Arabian Peninsula.
Hijra	Departure from one's country and friends; any exodus or departure; Muhammad's flight from Mecca to Madina in the year 622 of the Christian era (Arabic *hijra*).
Hypocaust	Floor and wall heating system by steam in Roman baths and villas.
Imam	One who presides Islamic prayer. A guide, chief, spiritual model or cleric, and sometimes also a politician, in a Muslim society.
Imaret	Turkish, a soup kitchen for the poor.
Iwan	Vaulted hall walled on three sides.
Jabal	Mountain, mountainous terrain.
Jahiliya	Period of paganism.
Jami'	Main mosque where daily prayer is celebrated and that of Friday.
al-Jawf	Name of a modern city in Saudi Arabia, meaning "depression".
Jizya	Personal tax.
Jund al-Urdun	An administrative and military province of Jordan.
Ka'ba	(Literally "cube".) Temple of Mecca converted into an Islamic centre.
al-Khadra'	Green domed palace in Damascus.
Khalifa	Successor or lieutenant.
Khan	(*Han* in Turkish.) Inn, *caravanserai*, lodging place for travellers and merchants.
Khanqa	Monastery or hostel for *sufis* or dervishes.
Kharaj	Higher land tax.
Kharijite movement	Puritanical and highly militant religious Muslim sect that opposed both 'Ali and Mu'awiya.

Khitat	Residential quarters in the *amsar* along tribal lines.
Kufic	Angular form, stylised, often highly decorated, Arabic script used in early *Qur'ans* and foundation inscriptions supposedly attributed to Kufa in Iraq.
Kufiyya	Arabian male headdress.
Kuras	Small administrative units.
Lapidarium	Open enclosure to expose architectural elements.
Legio Fretensis	Roman legion.
Limes	Roman fortified frontier.
Madrasa	Islamic School of Sciences (theology, law, Koran, etc.) and dormitory for students.
Mahmal	Baldaquin.
Manahij	Streets or thoroughfares.
Maqsura	Precinct reserved in a mosque for the *caliph* or the *imam* during public prayers.
Mawat	Wasteland.
al-Mazar	Place of visitation.
Mihrab	Niche in the *qibla* wall, indicating the direction of Mecca toward which worshippers face when praying.
Minbar	Pulpit in a mosque where the *imam* preaches his sermon *(khutba)*.
Muqarnas	Stalactite or honeycomb ornament which adorns cupolas or corbels of a building.
Nymphaeum	Public fountain and a temple to the Nymphs.
Onomasticon	Geographical list of sites in the Holy Land.
Orchestra	Semicircular floor of a Greek or Roman theatre in front of the stage.
Pax Romana	Peace which reigned between nationalities within the Roman empire, during the rule of Augustus Octavius and which continued during Roman occupation of the Orient.
Phylarch	Arabian leader under the protection of the Roman Empire or the Byzantines.
Poleis	(Pl. *polis*), ancient Greek city-state.
Praetorium	Administrative seat and governor's palace where Roman praetors or the elected provincial magistrates lived and judged causes brought to court. Monumental gateway to a temple.
Provincia Arabia	Arabian province created by Trajan in 106 after the annexation of the Nabataean kingdom to the province of Syria.

Qa'id	Commander responsible for the administration of a province.
Qasr	Palace, castle, from Latin *Castrum*.
Qibla	Direction of the Ka'ba, towards which believers orient themselves for prayer. Wall of the mosque in which the *mihrab* is situated.
Qubba	Dome. By extension, monument erected upon the grave of a saint.
Qur'an	(From the root *qr'*, "to recite, to read".) Sacred text of the Islamic revelation, transmitted by the Archangel Gabriel to the Prophet Muhammad.
Qusayr	Diminutive form of *qasr*.
Rahba	Open space.
Ribat	Fortified enclosure for religious warriors (North Africa); a hospice for pilgrims (Mamluk Egypt, Palestine and Syria).
Sahn	Open space.
Saqiya	Water-pumping mechanism and irrigation canal.
Shahada	Profession of Muslim faith.
Shaykh	Elderly man respected for his age and knowledge. Tribal chief or brotherhood leader.
Shi'a	"Scission, division, split". Properly *Shi'at 'Ali,* meaning "the party of 'Ali". The Shi'ies rejected the legitimacy of all *caliphs* who succeed after the assassination of Ali.
Solidi	Gold coinage.
Spolia	Stones taken from earlier monuments.
Sufi	Mystical or ascetic order in Islam.
Sunni	Orthodox Islam.
Suq	Market place.
Sura	Chapter of the *Qur'an*.
Tabula ansata	Rectangular tablet generally used for inscriptions having triangular handles.
Tell	Artificial hill formed by successive layers of ruins of settlements.
Temenos	Sacred courtyard or enclosure of a sanctuary.
Tepidarium	Warm room.
Turbe	Mausoleum, tomb.
Turuq	Main streets.
Umra	Small pilgrimage.
Ushr	Tithe paid for the new and undeveloped land.
Via Nova Traiana	Roman road, crossing the Roman province of Arabia from

north to south to the port of Aqaba, completed and repaved under Trajan, between 111 and 114.

Wadi	Watercourse, often temporary, in arid regions.
Waqf	An endowment in perpetuity, usually land or property, from which revenues were reserved for the upkeep of pious foundations.
Zarif	Beautiful.
Zawiya	Edifice for religious teaching, dedicated to prepare men to become *shaykhs*, which includes the shrine of a saint and built in the place of his birth.
Zellij	Small glazed ceramic tiles used to decorate monuments and interiors.
Zoar	Little one.
Zuqaq	Back alleys or footpaths.

Orthodox or Rightly Guided Caliphs:

Abu Bakr (r. 11/632-13/634)

Umar Ibn al-Khattab (r. 13/634-23/644)

Uthman Ibn 'Affan (r. 24/644-35/656)

Ali Ibn Abi Talib (r. 35/656-40/661)

Umayyad Caliphs:

Mu'awiya I Ibn Abi Sufyan (r. 41/661-60/680)

Yazid I (r. 60/680-64/683)

Mu'awiya II (r. 64/683-84)

Marwan I Ibn al-Hakam (r. 64/684-65/685)

Abd al-Malik (r. 65/685-86/705)

Al-Walid I (r. 86/705-96/715)

Sulayman (r. 96/715-99/717)

Umar Ibn 'Abd al-'Aziz (r. 99/717-101/720)

Yazid II (r. 101/720-105/724)

Hisham (r. 105/724-125/743)

Al-Walid II (r. 125/743-126/744)

Yazid III (r. 126/744)

Ibrahim (r. 126/744)

Marwan II (r. 127/745-132/750)

HISTORICAL PERSONALITIES

'Abd al-Rahman II
Andalusian Umayyad ruler (r. 206/822-238/852).

'Abd Allah Ibn al-Zubayr (2/624-73/692)
Leader of revolt against the Umayyads.

'Abd Allah Ibn Rawaha (d. 8/629)
Early Muslim military commander.

Abu al-Faraj al-Isfahani (284/897-356/967)
Chronicler.

Abu 'Ubayda al-Jarrah (581-18/639)
Early Muslim military commander.

Al-'Abbas Ibn 'Abd al-Muttalib (565-32/653)
Uncle of the Prophet Muhammad.

Alexander Jannaeus (103-76 BC)
Hasmonaean ruler, attacked the Hellenised cities of the *Decapolis* in Jordan but was defeated by the Nabataean King Obodas I.

Alexander the Great (356-323 BC)
Succeeded to the throne after King Phillip of Macedonia (r. 336-323 BC), defeated the Persians and occupied Syria and Palestine in 332-331 BC. Hellenised the East and founded the city of Alexandria in Egypt. Died at Babylon.

Al-Hajjaj Ibn Yusuf al-Thaqafi (41/661-95/714)
Umayyad governor of Iraq.

Al-Harith Ibn Jabala
Ghassanid Phylarch contemporary with Justinian, is credited with building Udhruh, Qastal and al-Qanatir.

'Ali Ibn 'Abdullah Ibn al-'Abbas (40/661–117/735-36)
Predecessor of Abbasid *caliphs*.

Al-Ma'mun
Abbasid *Caliph* (r. 197/813-218/833).

Al-Muqaddasi (d. 375/985)
Born in Jerusalem, he was an early geographer and explorer of Islamic countries. He wrote a general geographical book: *Ahsan al-Taqsim fi Ma'rifat al-Aqalim*.

Amorkesos (Imru' al-Qays)
An Arab chief who evicted the Byzantine customs officials and occupied the strategic island of Iotabe in the Gulf of Aqaba. He visited Constantinople and was officially recognised by Leo I as Phylarch of Arabia Petraea.

Anastasius
Byzantine emperor (r. 491-518), issued an edict for the reorganisation of the Byzantine Empire.

Antiochus III the Great (243-187 BC)
Seleucid king (r. 223-187), conquered Syria and Palestine from the Ptolemies in 198 BC.

Antiochus IV Epiphanes (215-163 BC)
Seleucid king (r. 175-163), invaded Egypt and Jerusalem in 168 BC. He introduced the cult of Zeus Olympius in the Hellenised cities of the East.

Arabios
Poet of Gadara (Umm Qays) in the 4th century.

Aretas III
Nabataean king (r. 87-62 BC).

Ashurbanipal
King of Assyria (r. 668-630 BC), occupied Egypt, Syria and Palestine.

Augustus (Caius Octavius, 63 BC-14 AD)
Nephew of Julius Caesar, first declared Roman emperor (r. 27 BC-14 AD).

Capitolinus
Probably a governor of the Province of Arabia in the mid-3rd century.

Constantine the Great (285-337)
Roman emperor (r. 306-337), became the sole emperor of the Roman Empire in 306 and declared Christianity as state religion in 324.

Diocletian (245-313)
Roman emperor (r. 284-305), reorganised the Roman Empire of the East by creating the three Palestine's: *Prima, Secunda, Tertia.*

Egeria
Roman pilgrim, wrote chronicle to the holy sites of the Middle East from Palestine to Jordan, Mesopotamia and Asia Minor from 381-384.

Eusebius of Caesarea (c. 260-340)
Bishop, exegete, polemicist and historian whose accounts of the first four centuries of Christianity have been of great value for historians. His major works include the *Ecclesiastical History* and the *Onomasticon.*

Flavius Josephus (c. 37-38 – 100)
Jewish-Roman historian, his best-known works are *History of the Jewish Wars* (75-79) and the *Antiquities of the Jews* (93).

Hassan Ibn 'Ali (c. 3/624-25 – 49/669-70)
Eldest son of 'Ali Ibn Abi Talib, the third Orthodox *Caliph.*

Hassan Ibn Ibrahim
A commander of Amman probably in the time of the Fatimids.

Heraclius
Byzantine emperor (r. 610-640).

Herod the Great (c. 73 - 4 BC)
Of Idumaean origin, took refuge in Rome. He was named king of the Jews and
conquered Judaea, named Samaria Sebaste as his capital.

Hyrcanus (209-168 BC)
Son of Joseph the Tobiad, succeeded his father as a tax collector in Jordan and built
palace for himself at Iraq al-Amir.

Husayn (4/626-60/680)
Son of 'Ali Ibn Abi Talib.

Ibn 'Abd al-Rabbihi (246/860-328/940)
Chronicler.

Ibrahim Ibn Muhammad al-'Imam
Member of the Abbasid family, organised from his residence at al-Humayma the over
throw of the Umayyad dynasty. He was arrested and killed at Harran in 132/749-50

Jacop
Bishop of the Monastery of St. Lot in Ghawr al-Safi (6th-7th century).

Ja'far Ibn Abi Talib (d. 8/629)
Cousin of the Prophet Muhammad and early-Muslim military commander.

Jason
High priest of Jerusalem where he introduced Hellenism in 168 BC but th
Hasmonaean revolt brought his priesthood to an end in 167 BC.

Justinian
Byzantine emperor (r. 527-565).

Khalid Ibn al-Walid (d. 21/642)
Early Muslim military commander.

Khalid Ibn Yazid Ibn Mu'awiya
Son of the second Umayyad Caliph Yazid (60/680-64/683), bought the estate o
al-Fudayn in exchange for *al-Khadra',* the Green Domed Palace in Damascus.

Khosru II Parvis
Sassanian king (r. 591-628).

Leo I
Byzantine emperor (r. 457-474).

Ma'bad Ibn Wahab (d. 125/743-44)
Musician and singer.

Malchus of Philadelphia
Byzantine historian, wrote a history of Byzantium in about the year 500.

Mathathias
High priest of the Jerusalem temple, declared the Jewish revolt against Antiochus IV in 167 BC.

Peter the Iberian (2nd half of 5th century)
Bishop of Gaza.

Pompey (106-48 BC)
Roman general, conquered the East in 63 BC and created the Province of Syria. He was assassinated in Egypt in 48 BC.

Ptolemy II Philadelphus (306-246 BC)
King of Egypt (r. 283-246 BC).

Rheetorius
A monk who built the 6th century Church of Elijah in the Jordan Valley.

Rodorik
Visigothic king of Spain (r. 710-711).

Sa'da
Daughter of Sa'id Ibn Khalid, owner of al-Fudayn and wife of al-Walid II .

Sa'id Ibn Khalid Ibn 'Amr Ibn 'Uthman
Great-grandson of the Orthodox Caliph 'Uthman Ibn 'Affan, owned al-Fudayn and tenement apartments in Damascus. Two of his daughters were married to the Umayyad *caliphs* Hisham and al-Walid II.

Salma
Daughter of Sa'id Ibn Khalid, was engaged to al-Walid II but died before the latter's murder in 131/749.

Solomon
Prophet and king of Israel (r. 970-928 BC), built the temple in Jerusalem with the aid of both craftsmen and material supplied by Sidon and Tyre.

Sozimos
Abbot of the Lot's Monastery in Ghawr al-Safi.

Sufyan Ibn Yazid al-Sa'di
Governor of al-Belqa district at the end of the Umayyad dynasty, arrested Ibrahim al-'Imam at al-Humayma.

Theodosus of Philadelphia (late 2nd BC)
Infamous Hellenistic ruler of Amman ("tyrant"), fled to Gadara and Gerasa.

Theophane
Bishop of Madaba in the late Byzantine and early Umayyad period (7th century).

Tiberius (42 BC-37 AD)
Roman emperor (r. 14-37 AD), adopted son of Augustus.

Tobiyah
Governor of the Ammonite district in the 5th century BC, then under Persian rule.

Trajan (53-117)
Roman emperor (r. 98-117), put down the 2nd Jewish revolt and annexed the Nabataean kingdom in the year 106 to the Roman Empire. He consolidated the *Decapolis,* extended and paved the *Via Nova Traiana.*

Yahya Ibn Salih
Commander of the army sent to al-Belqa to crush the revolt of Sa'id al-Fudayni during the caliphate of al-Ma'mun.

Yaqut al-Hamawi (d. 626/1229)
Arab geographer; his famous book *Mu'jam al-Buldan* is an encyclopedia of ancient historical sites.

Zayd Ibn Haritha (574-8/629)
Early Muslim military commander.

Zenobia
Queen of Palmyra (Tadmur, in Syria) (r. 266-272), revolted against Rome and occupied Egypt, but was defeated by Emperor Aurelius.

Ziryab (d. 236/850)
Musician.

FURTHER READING

ALMAGRO, M. et al., *Qusayr Amra*, Madrid, 1975.

ALMAGRO GORBEA, A., *El Palacio, Omeya de Ammán*, vol. I, *La Arquitectura*, Madrid, 1983.

BAGATTI, B., *The church of the Gentiles in Palestine*, Jerusalem, 1971.

BAKHIT AND ABBAS (eds), "Bilad al-Sham during the Early Islamic Period", *Udhruh and the Early Islamic Conquests*, Amman, 1987.

BOSWORTH, C. E., *The Islamic Dynasties*, Edinburgh, 1980.

BOWERSOCK, G. W., *Roman Arabia*, Cambridge, Massachusetts, 1983.

BROWNING, I., *Jerash and the Decapolis*, London, 1982.

BUJARD, J. and SCHWEIZER, F., *Entre Byzance et l'Islam: Umm er-Rasas et Umm el-Walid. Fouilles Genevoises en Jordanie*, Musée d'art et d'histoire, Geneva, 1992.

BUTLER, H.C., *Ancient Architecture in Syria. Princeton University Archaeological Expedition to Syria*, II, Brill, Leiden, 1907.

CHARBONNEAUX, J., "Sculpture",*Grèce Hellénistique,* Paris, 1970.

CONDER, C.R., *The Survey of Eastern Palestine*, London, 1889.

CRESWELL, K. A. C., *Early Muslim Architecture*, 2 vols., 2nd ed., Oxford, 1969.

CRESWELL, K. A. C. and ALLAN, J. W., *A Short Account of Early Muslim Architecture*. Cairo, 1989.

DJAIT, H., *Al-Kufa: Naissance de la ville islamique*, Paris, 1986.

Encyclopaedia of Islam, Brill, Leiden, from 1954.

ESTABLET, C. and PASCAL, J.P., *Ultime voyage per al-Mecque*, Damas, 1998.

ETTINGHAUSEN, R., *Arab Painting*, Geneva, 1962.

ETTINGHAUSEN, R. and GRABAR, O., *The Art and Architecture of Islam: 650-1250*, New Haven, 1992.

EUSEBIUS, *Das Onomastikon der biblischen Ortsnamen*, transl. G. Olms, Hildesheim, 1966.

GRABAR, O., *The Formation of Islamic Art*, New Haven, 1988.

AL-HAMAWI, Y., *Mu'jam al-buldan*, Beirut, 1957.

HARDING, G. L., *The Antiquities of Jordan*, London, 1967.

HARRISON, T. et al., *Madaba: Cultural Heritage*, Amman, 1996.

HAYES, J. R., (ed.), *The Genius of Arab Civilization: Source of Renaissance*, 2nd ed., Cambridge, Massachusetts, 1983.

HILLENBRAND, R., *Islamic Art and Architecture*, London, 1999.

HITTI, P. K., *History of the Arabs*, 10th ed., New York, 1970.

HOURANI, A. and Stern, M., (eds.), *The Islamic City*, Oxford, 1970.

JAUSSEN, A. and SAVIGNAC, R., *Mission archéologique en Arabie*, 3 vols, Geuthner, Paris, 1909 and 1914.

Jerash Archaeological Project, vol. I, 1981-1983, Amman, 1986; vol. II, 1984-1988, Amman-Paris, 1989.

KHOURI, R. G., *The Desert Castles. A Brief Guide to the Antiquities*. Amman, 1992.

KING G. R. D. and CAMERON, A., (eds.), "The Byzantine and Early Islamic Near East", *The Misr of Ayla: Settlement at al-'Aqaba*, II, Princeton, 1994.

KOCH, G., *Early Christian Art and Architecture*, London, 1996.

KRAELING, C.H. (ed.) et. al., *Gerasa. City of the Decapolis*, New Haven, 1938.

LAPIDUS, I., *Muslim Cities in the Later Middle Ages*, Cambridge, 1967.

LE STRANGE, G., *Palestine under the Moslems: a Description of Syria and the Holy Land from A. D. 650 to 1500*, Beirut, 1965.

LEWIS, N. (ed.), *The Documents from the Bar Kokhba Period in the Cave of Letters*, Jerusalem, 1989.

MANNS, F. and ALLIATA, E., (eds.), "Early Christianity in Context: Monuments and Documents", *Umm al-Rasas*, Jerusalem, 1993.

MCNICOLL, A. W. et. al., "Pella in Jordan 1: an Interim Report of the Joint University of Sydney and College of Wooster Excavations at Pella 1979-1981", *MeditArch* Suppl. 1, Sydney, 1982.

MCNICOLL, A. W. et al., "Pella in Jordan 2: an Interim Report of the Joint University of Sydney and College of Wooster Excavations at Pella 1982-1985", *MeditArch* Suppl 2, Sydney, 1992.

AL-MUQADDASI, *Ahsan al-Taqsim fi Ma'rifat al-Aqalim*, 2nd ed., Leiden, 1967.

NORTHEDGE, A., *Studies on Roman and Islamic Amman*, B. A M. A., 3, Oxford, 1992.

OLAVARRI-GOICOECHEA, E., *El Palacio Omeya de Amman*, vol. II, *La Arqueologia*, Valencia, 1985.

PICCIRILLO, M., *The Mosaics of Jordan*, Amman, 1993.

PICCIRILLO, M. (ed.), *The Madaba Mosaic Map Centenary 1897-1997*, S. B. F., Jerusalem, 1999.

PICCIRILLO, M. and ALLIATA, E., *Umm al-Rasas-Mayfa'a I: Gli Scavi del Complesso di Santo Stefano*, Jerusalem, 1994.

PICCIRILLO, M. and SAQAF, H., *The Holy Sites of Jordan*, Amman, 1996.

SALLER, S. J., *The Memorial of Moses on Mount Nebo.*, 2 vols., Jerusalem, 1941.

SARTRE, M., *Trois Études sur la Syrie Romaine et Byzantine*, Bruxelles, 1982.

Al-Sayyad, N., *Cities and Caliphs: On the Genesis of Arab Muslim Urbanism*, New York, 1996.

SCHICK, R., *The Christian Communities of Palestine from Byzantine to Islamic Rule: A Historical and Archaeological Study*, Princeton, 1995.

SMITH, R., *Pella of the Decapolis*, vol. I, *The College of Wooster Expedition to Pella*, London, 1973.

SMITH, R. and PRESTON DAY, L., *Pella of the Decapolis*, vol. II, *Final Report of Wooster Excavations in Area IX, the Civic Complex 1979-1985*, London, 1989.

TALBOT RICE, D., *Byzantine Art*, Penguin Books, 1968.

The Decapolis, ARAM Third International Conference, September 1992, ARAM 4:1 & 2, Oxford, 1992.

VAUX, R., de, *Histoire ancienne d'Israël*, Paris, 1971.

VRIES, B., de, *Umm el-Jimal: A Frontier Town and its Landscape in Northern Jordan*, vol. II, J. R. A., Suppl. Ser. 26, Portsmouth, Rhode Island, 1998.

WALKER, J., *A Catalogue of the Arab-Byzantine and Post-Reform Umayyad Coins*, London, 1956.

WHITCOMB, D., *Ayla, Art and Industry in the Islamic Port of Aqaba*, Chicago, 1994.

WHITCOMB, D. and KHOURI, R., *Aqaba: Port of Palestine on the China Sea*, Amman, 1988.

ZAYADINE, F., *The Frescoes of Queseir Amra*, Amman, 1977.

ZAYADINE, F., "Amman-Philadelphie", in *Le Monde de la Bible* 22, 1982.

AUTHORS

Mohammad al-Asad

An Architect and Architectural Historian, he has been appointed as Assistant Professor at the University of Jordan, Dept of Architecture. He received his BA and MA at the University of Illinois at Urbana-Champaign, and obtained his Ph.D. on Islamic Architecture from Harvard, Cambridge, Massachusetts. He was visiting lecturer at the Massachusetts Institute of Technology and at Princeton University, and held post-doctoral research positions at Harvard and the Institute for Advanced Study, Princeton. He has served also as board member for the Aga Khan Award for Architecture. He is widely respected for his studies on *Architecture of the Islamic World* and his publications appeared in both Arabic and English. His most recent monograph is *Old Houses of Jordan: Amman 1920-1950*, Turab, Amman, 1997. He is member of various Associations and in 1999 he has been elected President of the CSBE Foundation (The Centre for the Study of the Built Environment).

Ghazi Bhiseh

Born in Amman in 1944, he obtained his BA in Archaeology at the University of Jordan in 1967. He served as Inspector in the Department of Antiquities from 1967-1969. In 1970, he completed a graduate course in Islamic Art and Architecture at the University of Michigan, (Ann Arbor). He returned to the Dept. of Antiquities holding a position in the Registration Centre from 1970 to 1974. After having been awarded his Ph.D. in Islamic Art in 1979 (Ann Arbor), he was appointed Director of Archaeological Projects in the Dept. of Antiquities, a post he held from 1979 to 1981. During those years he participated in many excavations and directed his own at Hallabat. In 1982, he did a postgraduate course in Conservation of Historic Buildings at the University of York, Institute of advanced Architecture Studies. After his diploma of the same year, he returned to his previous position as Director of Projects at the Dept. of Antiquities, where, in 1985, he was appointed Deputy-Director-General. Dr Bisheh held this post until 1988 when he was named Director-General of the Department. He was freed of his duties in 1992 to become Associate-Professor at the Yarmouk University, Irbid, and at the same time Director of the Madaba Archaeological Park Excavations. From 1995 until September 1999, he has been reappointed as Director-General of the Department of Antiquities. He has been honoured, as member of numerous international institutions Ghazi Bisheh is an authority on Umayyad Culture and Architecture and known from his publications and many contributions at international conferences.

Ina Kehrberg

Born in 1945, she graduated from the University of Sydney. She received the BA Honours both in Classical and Near Eastern Archaeology including Fine Arts, Ancient

Languages and History. Having obtained her MA in Classical Archaeology, she completed her Doctoral Thesis on Early and Middle Bronze Age Ceramics in Cyprus in 1987, which was published in SIMA vol.108 (1995). She is bilingual in English and German, fluent in French and has a basic knowledge of Arabic. From 1975-1979 she became first Research Assistant and then Lecturer at the Dept. of Archaeology, University of Sydney. From 1980-1982 she was Editor/Research Fellow at the Deutsches Archeologisches Institut in Berlin (DAI). She came to Jordan in January of 1983 having been appointed as archaeologist and ceramist for the Jarash Archaeological Project and later from 1995-1998 as Co-Editor for the publications of the Dept. of Antiquities (ADAJ and SHAJ). Since 1997 she is Research Fellow at the Institut Français d'Archéologie du Proche-Orient (IFAPO) in Amman. As Director of the Jerash Hippodrome Research and Publication Project, she holds an honory Fellowship with the British Institute of Archaeology and History at Amman (BIAAH). She participated in many international excavations and archaeological conferences. Her publications include books and numerous articles mostly on pottery and glass manufacture and chronology.

Lara G. Tohme

She studied Art History specialising in Early Christian and Medieval Art. She is currently completing her doctorate on the history of Early Islamic Architecture and is an Aga Khan Scholar of Islamic Architecture at the Massachusetts Institute of Technology (M. I. T.) in Cambridge, Massachusetts. She has held also the Samuel H. Kress Fellowship at the American Center For Oriental Research (ACOR) in Amman, Jordan.

Fawzi Zayadine

Born at Smakieh, Karak district, in 1938, he received a diploma in Oriental and Islamic Antiquities at l'École du Louvre and a license in Semitic Languages and Islamic Studies at the Sorbonne, Paris. His Ph.D at the Sorbonne was on the Oriental Origin of Rupestral Architecture at Petra. In 1967 he was appointed Assistant-Director for Research and Publications and head of the Department of Publications (ADAJ and later SHAJ). From 1971-1975 he became head of the Registration Centre at the Dept. of Antiquities. His several scores of articles and books on various archaeological aspects spanning subjects from Hellenistic sculpture to Umayyad art are published widely in Arabic, English, German and French, but Fawzi Zayadine is perhaps best known for his many contributions in Hellenistic (Iraq al-Amir) and Nabataean (Petra) Studies. His most recent contribution is with the publication of Qasr al-Bint. He participated in and has directed numerous excavations and is currently collaborating with a French Epigraphical Survey in Wadi Ramm. His authoritative contributions to Classical studies have been sought by many organizers of international conferences. His participation in many archaeological research projects has been recognised through honorary

membership of foreign and national institutions, including the Writers Associations, Friends of Archaeology in Jordan and Ordinary Member of the Deutsches Archeologisches Institut (DAI). At present he is Deputy Director-General of the Dept. of Antiquities.

Bill Lyons

Bill Lyons has been working as a professional photographer for over 25 years. After having been the assistant to Philadelphia-based (USA) commercial photographer William Cross-Dunning in the early 1970's he began his own career photographing works of art exhibited in the state of Florida. He was posted to Beirut, working as photographic reporter for the MER News Service. In 1975 he moved to Amman where he has been based as freelance photographer since. His wide-ranging work has appeared in numerous publications in Aramco World, *Archaeology Today, Businessweek, The Economist, Epoca* (Italy), *Figaro* (France), *GEO* (German Edition), *Insight Magazine, L'Express, Life Magazine, Maclean's, National Geographic* (Books and magazines), *Newsweek, New Scientist, New York Times Magazine, Panorama* (Italy), *Der Stern, Time* and many others. Books for which Bill Lyons was sole or principal photographer are *Petra. A Traveller's Guide*, published by Garnet Guides, UK and *Old Houses of Jordan*, Turab, Amman, 1997. His work has been commissioned by corporate, government and non-government agencies including American Express, Bechtel, British Airways, Canadian International Development Agency (CIDA), CNN International, Coca-Cola, DHL Worldwide Express, Marconi Microsoft, Nikon, Pepsi-Cola International, UNDP, USAID and The World Bank.

ISLAMIC ART IN THE MEDITERRANEAN

This international cycle of Museum With No Frontiers Exhibitions permits the discovery of secrets in Islamic Art, its history, construction techniques and religious inspiration.

Portugal
IN THE LANDS OF THE ENCHANTED MOORISH MAIDEN. Islamic Art in Portugal.
Eight centuries after Christians reconquered their lands from the Muslims, towns of the ancient "Garb al-Andalus" (western Andalusia) preserve the legion of the beautiful enchanted Moorish maiden whose spell was broken by a Christian prince; the artistic route of Muslim presence in Portugal also expresses, through a subtle interdependence between constructive techniques and decorative programs, popular regional architecture. The exhibition gives the visitor a clear view of five centuries of Islamic civilisation (the Caliphate, Mozarabic, Almohade and Mudejar Periods). From Coimbra in the confines of the Algarve, palaces, Christianised mosques, fortifications and cities affirm the splendour of past glories.

Turkey
EARLY OTTOMAN ART. Legacy of the Emirates.
Highlighting this exhibition are the works and monuments most representative of the finest period of western Anatolia, the cultural and artistic bridge between European and Asian civilisations. In the 14th and 15th centuries, the transition to a Turkish-Islamic society led artists of the Turkish Emirate to elaborate on a brilliant artistic union culminating in Ottoman art.

Morocco
ANDALUSIAN MOROCCO. Discovery in Living Art.
From the beginning of the 8th century, Islamic Moroccans looked beyond the Pillars of Hercules (Gilbraltar) and settled in the Iberian Peninsula. From then on, both shores shared the same destiny. From continual cultural, social and commercial exchange animating this extreme of the Maghreb, for more than seven centuries, sprang one of the most brilliant facets of Muslim civilisation. Authentic Hispano-Maghreb art left its stamp not only on resplendent, monumental architecture, but also in the characteristics of the cities and traditions of extreme refinement. The exhibition reflects the historic and social wealth of the Andalusi (Andalusian) civilisation in Morocco.

Tunisia
IFRIQIYA. Thirteen Centuries of Art and Architecture in Tunisia.
Since the 9th century, without breaking with traditions inherited from the Berbers, Carthaginians, Romans and Byzantines, Ifriqiya was able to assimilate and reinterpret influences from Mesopotamia, through Syria and Egypt, and from al-Andalus (Andalusia). This is a unique form of syncretism, of which numerous vestiges prevail even today in Tunisia, from the majestic residences of the Muslim sovereigns in the capital to the architectonic rigor of the "Ibadism of Jerba", existing as observed in the

ribats, mosques, *medinas, zawiyas* and *gurfas* (large rooms containing bedroom suites) their imprint on a land abounding with history.

Spain I- Andalusia, Aragon, Castilla La Mancha, Castille and Leon, Extremadura, Madrid.
MUDEJAR ART. Islamic Aaesthetics in Christian Art.
The art of the Mudejars (Muslim population remaining in Andalusia after the Reconquest) has an unquestionably unique place among all expressions of Islamic art. It deals with the visible manifestation of a splendidly cultured cohabitation with comprehension between two civilisations that, in spite of their political and religious antagonism, lived a fructiferous artistic romance. Applying schemes, although rigorously Islamic, the masters of works and Mudejar artisans, famous for their outstanding knowledge in the art of construction, erected for the newly arrived Christians innumerable palaces, convents and churches. The selected works, chosen for their variety and abundance, testify to the exuberant vitality of Mudejar art.

Jordan
THE UMAYYADS. The Rise of Islamic Art.
Following the Arab-Muslim conquest of the Middle East, the seat of the Umayyad Dynasty (661-750) was moved to Damascus, where the new capital inherited a cultural and artistic tradition dating back to the Aramaean and Hellenistic Periods. Umayyad culture benefited by this move from the frontier between Persia and Mesopotamia and between the countries of the Mediterranean world. The position was favourable for the emergence of an innovating artistic language, in which the subtle mixture of the Hellenistic, Roman, Byzantine and Persian influences, produced architectural order and decorative originality. Through the diversity of the works presented, the exhibition also offers the opportunity to reflect on the iconoclastic phenomena.

Egypt
MAMLUK ART. Splendour and Magic during the Reign of the Sultans.
Under Mamluk domination (1249-1517), Egypt became a prosperous commercial route-crossing centre. Great riches came to the country. Cairo was one of the most powerful, secure and stable cities of the Mediterranean basin. Scholars from all over the world came to settle there, attracting their followers and students. The architecture and Mamluk decorative art display the vitality of commerce, the intellectual energy and the military and religious force of this period. Characterised by elegant and vigorous simplicity, the purity of lines are similar to modern models. The works selected between Cairo, Rosetta, Alexandria and Fua represent the height of Mamluk Art.

Palestinian Authority
PILGRIMAGE, SCIENCES AND SUFISM. Islamic Art in the West Bank and Gaza.
During the reigns of the Ayyubid, Mamluk and Ottoman dynasties, numerous pilgrims, from all over the Muslim world came to Palestine. This strong tide of religious fervour

gave a decisive impulse to the development of Sufi thought, through the *zawiyas* an‹
ribats, which multiplied all over the country. Various study centres welcomed the mos
distinguished scholars. In this way, they obtained considerable prestige and condition‹
became favourable for the expansion of refined art, which conserves its power of fas‹
cination, even today. The monuments and Islamic architecture proposed for th‹
exhibition clearly reflect these great dimensions of pilgrimages, science and sufism.

Israel
SHARING THE SACRED. The Secular and Religious Life of Three Civilisations.
The singularity of the Holy Land, where even in case of conflict, always knew how t‹
maintain cultural exchange between the three religions of the Old Testament are here
brought to light in a magnificent way through the Islamic trail. From the arrival of th‹
Muslims in the 7th century during the era of the Crusades, vestiges and architectura
monuments display cultural continuity, mixed with manifestations of originalit‹
integrating the heritages of the Romans, Byzantines and successive Muslim dynasties

Italy - Sicily
ARAB-NORMAN ART. Islamic Culture in Medieval Sicily.
In the middle of the Mediterranean, Sicily is a land of encounter, where various cul‹
tures have coincided and adjusted mutually, reaching a new harmony. Unique in th‹
European panorama, Arab-Norman architecture, relatively speaking, is different fron
that found in the Islamic world. The exhibition presents it from the standpoint of it
uniqueness and provides some codes for interpretation permitting better identifica
tion. An attentive visitor will better appreciate the admirable fusion of elements, orig
inating from Byzantine, Arab and Norman cultural spheres, employed in this art, whic‹
is as original as it is refined.

Algeria
WATER AND ARCHITECTURE IN THE DESERT. The Pentapolis of the Mzab.
More than 1000 years ago, 600 km south of Algeria, the capital, a structured urba‹
nucleus was founded, which with time and the enormous tenacity of its inhabitants
became the present Mzab. The Ibadites settled there in the beginning of the 9th centur
when it was an inhospitable, extremely arid desert region. Between 1012-1353, the
constructed five cities with a sophisticated irrigation system. Inspired by a rigorou‹
philosophy rejecting ostentation and superficiality, Ibadite architecture produce‹
authentic masterpieces of such pureness and functional nature that it inspired master
like Le Corbusier. The exhibition permits one to discover the exemplary managemen
of space and water through the history of the Pentapolis.

Spain II- Catalonia
ISLAM IN CATALONIA. Bisagra Culture in a frontier region.
As a product of the expansion of Carolingian countries toward Islamic Andalusian ter
ritories, Catalonia was born on a frontier, in an area where mutual fertilisation of tw‹
cultures became evident. The innumerable castles and towers located on the fringe ‹

bordering Islamic territories witnessed not only the conflictive nature of the residents, cultural interchange and reciprocal influences, traces of which are patent in the architecture, art of gardens and decoration, but also in linguistics and the toponymy and even some popular traditions today. The proposed trail underlines these particulars and shows examples of neo-Arab architecture as those produced by Antonio Gaudi, Catalan, renowned architect of the 20th century.